6⁵⁰

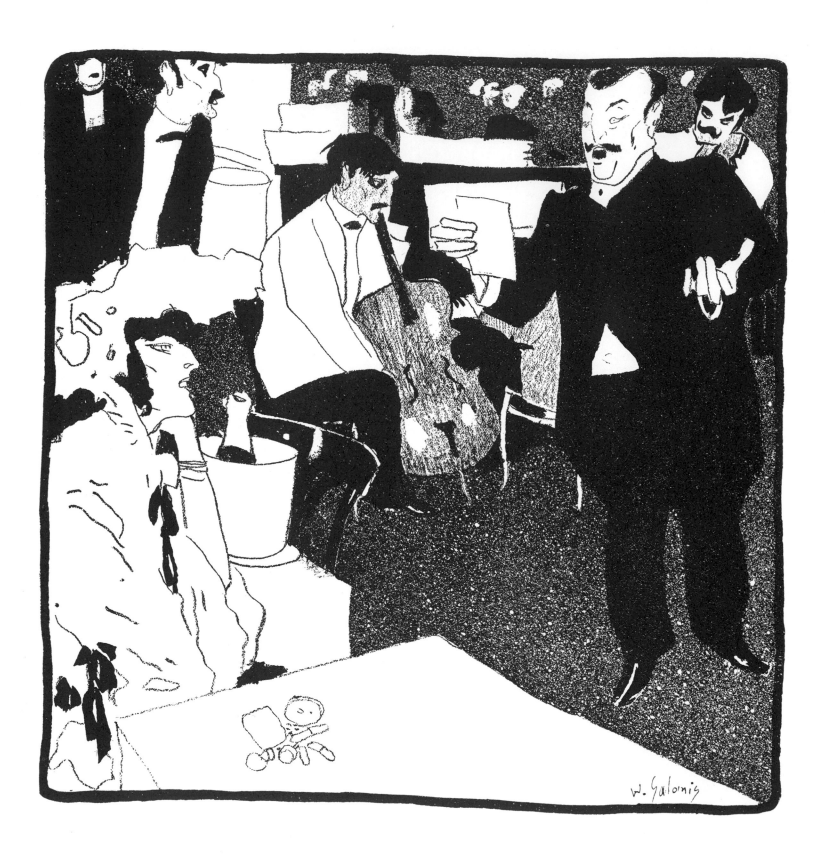

FRENCH SATIRICAL DRAWINGS
FROM
"L'Assiette au Beurre"

Selection, Translations and Text by
STANLEY APPELBAUM

Dover Publications, Inc.
New York

PREFACE AND ACKNOWLEDGMENTS

First and foremost, the thanks of publisher and editor are given to

MR. BENJAMIN BLOM,

who conceived of this anthology and made its realization possible through the loan of his complete run of *L'Assiette au Beurre*.

The magazine is of great rarity in the United States. Even the largest libraries and art institutions lack it or have very partial holdings. Only the New York Public Library has a complete run catalogued, but their issues are largely in tattered condition. The periodical is seldom found on the open market, except for occasional expensive single issues.

To examine a full set in as good condition as Mr. Blom's is a scholarly necessity, because almost nothing has been written about *L'Assiette*. Information about the periodical can best be gathered from internal evidence. Whereas the German weekly *Simplicissimus* has justly been treated as a national treasure by German historians of art and culture, *L'Assiette* has been almost totally neglected. Much primary research remains to be done in Parisian archives.

The few mentions of the magazine that do occur in standard French reference books and specialized works contain such gross errors that one is disinclined to believe any statements. Some light is thrown onto this situation by the abstract of Gisèle Lambert's Ecole du Louvre dissertation printed in No. 23 (Sept.–Oct. 1975) of *Nouvelles de l'estampe*. Even though her dissertation seems to be primarily a catalogue of the allegories used by *L'Assiette* artists, the abstract does furnish some facts and figures on which I have drawn in the second half of the Introduction.

FRONTISPIECE: Drawing by Dimitrios Galanis, from No. 220 of *L'Assiette au Beurre*, June 17, 1905, an issue on night life. Original caption: "LA ROMANCE. — Mon Dieu! Qui pourrait supposer qu'un si bel homme possède une femme et treize enfants!" (THE SONG. "Dear me! Who would imagine that such a good-looking man has a wife and thirteen children!")

Copyright © 1978 by Dover Publications, Inc.
All rights reserved under Pan American and International Copyright Conventions.

French Satirical Drawings from "L'Assiette au Beurre" is a new work, first published by Dover Publications, Inc., in 1978.

International Standard Book Number: 0-486-23583-1
Library of Congress Catalog Card Number: 77-84742

Manufactured in the United States of America
Dover Publications, Inc.
180 Varick Street
New York, N.Y. 10014

INTRODUCTION

Indeed it is undeniable that in the near future, pictures will constitute the best weapon; they have the advantage of not tiring a mind occupied by everyday worries, and of offering relaxation, while at the same time reaching out to more people than do the best newspaper articles, which often leave the most serious reader indifferent. (From an editorial statement in No. 20 of *L'Assiette au Beurre*, August 15, 1901)

For hundreds of years Paris has been a rallying place for those who wish to better the lot of their fellow men. In eighteenth-century Paris, political and social thinkers from many countries helped pave the way for the great Revolution. In the nineteenth century, the city was a center for significant experiments in socialism, syndicalism and anarchism. In our century, the word *engagé*—committed to a cause—has become a French word everyone knows. These liberal activities have usually been undertaken by individuals or small groups making a courageous stand against great odds.

Though all professions have had their share in this work of conscience, in the nineteenth and twentieth centuries graphic artists have been conspicuous in the forefront. The tradition of popular satirical prints in France goes back to the invention of the woodcut and the engraving in the late Middle Ages, but the Revolution of 1789 created a vastly increased demand for such pictures. In the first decades of the nineteenth century it was found that the picture magazine was an ideal vehicle for this anti-establishment art. In its brief life between 1830 and 1835, Charles Philipon's journal *La Caricature,* to which Daumier contributed, set a standard for such magazines. After the defeat of Napoleon III by Prussia and the establishment of the Third Republic in 1871, censorship became less severe and a horde of new publications became available to the Parisian public.

The last quarter of the nineteenth century was the golden age of the French illustrated magazine. This was the era in which Gill, Robida, Steinlen, Willette, Caran d'Ache, Forain, Ibels and so many others made their reputations. Magazines came and went, lampooning the numerous political and financial scandals and upheavals of the Republic. By 1901 one would think that another magazine would be no novelty. Nevertheless *L'Assiette au Beurre* was immediately recognized at home and abroad as something unusual—at once the hardest-hitting and the most visually compelling of its type. Its very first page, the cover of No. 1 (April 4, 1901; see page 130), called attention to the plight of striking workers and to the failure of the government to keep its promises to labor. The magazine, which continued until the fall of 1912, never ceased to strike out against the alleged crimes of the establishment, of the privileged few who had possession of the *assiette au beurre.*

Though this phrase also has certain colloquial connotations, such as "cushy job," the editors and artists of *L'Assiette* had in mind a literal butter dish. This symbolized the "fat of the land," the wealth cornered by those in power, who ought by rights to share it equally with all. The butter dish appears in various guises throughout Willette's little drawings accompanying his manifesto article in the first issue (see figures, p. vi), and recurs in the work of many contributors during the run of the magazine.

In the realm of politics, any enemy of the republican form of government was open game for the *L'Assiette* crew. But the republic's elected ministers could also be regarded as a menace. In that decade and a half before the First World War, the French government was fully committed to the system of defensive alliances in which all the major powers saw a hope for security. It was an era of unremitting state visits and summit conferences. The leaders of France might be willing to forget colonial rivalries with Britain and their denunciation of that nation as an aggressor in the Boer War, but *L'Assiette* remained adamant and depicted Edward VII as a monster. Ties between France and Russia grew constantly closer, but *L'Assiette* unswervingly branded Nicholas as a tyrant, and rejoiced when he was defeated by the Japanese. Germany was a traditional enemy that was not spared in the magazine's pages, while Turkey was reviled as a benighted backwater. *L'Assiette* also had important Iberian contributors who kept close watch on tyranny in Spain, and Central European artists who chafed under the yoke of the Austro-Hungarian Empire.

The French Army and Navy were taken to task in the magazine for monarchist tendencies, severity of punishments and abuse of privileges. Government monopolies were scourged for their profiteering, inefficiency and callousness to their employees' welfare. The municipal authorities of Paris were called to account for police corruption and brutality. Capital punishment was assailed.

In business and private life, hardly any abuse pased unnoticed. It was the Edwardian Age, outwardly characterized in France as in England and America by tranquility, prosperity and the pursuit of pleasure. But in France there was serious labor unrest. Catastrophes and disasters such as mine and factory explosions and subway fires were carefully documented in *L'Assiette,* not for cheap sensationalism or cheaper sentimentality, but in order to accuse the capitalists and the authorities of criminal negligence. Other topics on which *L'Assiette* spoke out fiercely included the exploitation of women and children (prostitution, child abuse in homes and institutions, molestation of boys and girls), inhuman treatment of nonwhite people throughout the world, food adulteration, rigging of commodity prices, fake charity schemes, alcoholism, the contrast between the playboy and the ragpicker, self-appointed censors of public morality, vivisection and cruelty to animals, and the innumerable monstrosities of human society.

In one area of denunciation, no special courage was needed, since *L'Assiette* was here following government policy and the majority opinion of the time. The magazine constantly attacked the Roman Catholic Church and the rural areas where Church influence remained strong. A surprisingly large number of drawings in *L'Assiette* are anticlerical.

Much more surprising is the infrequency of antisemitic humor,

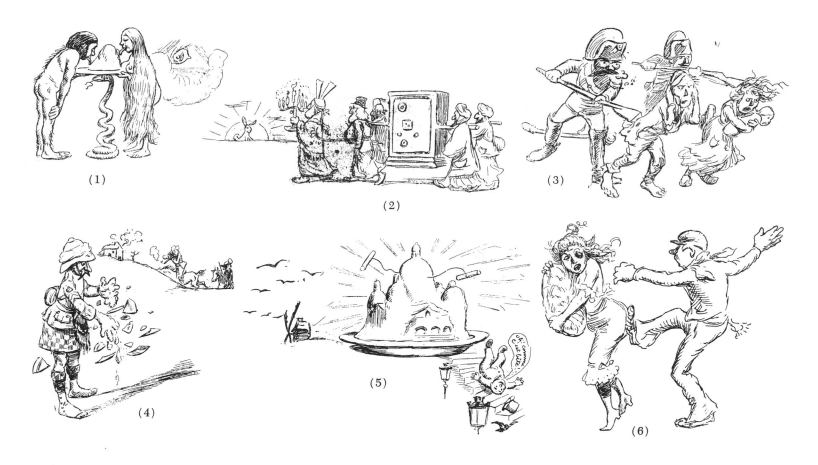

Drawings by Willette in No. 1 of *L'Assiette,* accompanying a facetious history of the butter dish that symbolizes the wealth of nations: (1) Adam and Eve are expelled from Paradise for tasting God's butter dish; (2) on leaving Egypt, the Hebrews carry the butter dish with them in the Ark of the Covenant; (3) what happens when the French populace demand their share of the butter dish; (4) the English have the butter dish shot out of their hands by the Boers (that war was going against them at the moment); (5) Sacré Coeur on Montmartre depicted by the anticlerical artist as the huge butter dish of the Church; (6) a Parisian apache delicately asking his moll for his share of her butter cake (*galette*="cake" and "money").

since this attitude was popular at the time. Such contributors to *L'Assiette* as Forain, Caran d'Ache and Willette had been rabidly antisemitic during the Dreyfus controversy. Perhaps the theme had been overworked; perhaps the Jewish founder and first editor of the magazine, Samuel Schwarz, curbed it to some extent.

Though practically no information about Schwarz is available, it is clear that he was a hard-headed businessman as well as a crusader. In a letter of 1903 the artist Steinlen warned a prospective contributor that Schwarz was sly, tough, miserly and a stealer of other men's ideas. But this diatribe ended in an unconscious tribute to the man through praise of his magazine: "If *L'Assiette au Beurre* weren't the only periodical in which one can express certain things freely, we would all have abandoned it. By staying on, we make a sacrifice to Art and the Idea."

Schwarz is certainly deserving of our admiration for assembling such a magnificent team of artists, many of whom remained loyal to *L'Assiette* throughout its existence. Such veterans of magazine work as Steinlen, Léandre and Willette guaranteed high quality from the outset. (For brief individual biographies of the artists mentioned here, and all the others included in this anthology, see the section "The Artists" following this Introduction.) Other established cartoonists, such as Forain, Caran d'Ache and Robida, made fewer, but welcome, appearances. A number of the artists associated with the poster craze of the turn of the century are represented: Ibels, Gottlob, Faivre, Gerbault, Poulbot, Guillaume, Grün. The Italian-born Cappiello, whose reputation as a poster artist would soon outshine theirs, was famous primarily as a caricaturist and cartoonist at the time of his contributions to *L'Assiette.* Members of the so-called school of Montmartre—illustrators, muralists and others connected with the bohemian life in that section of Paris—found the pages of *L'Assiette* open to them: Balluriau and Malteste, for instance, as well as the more famous Steinlen and Willette.

There were some contributors whose names mean even more to us today. Among them was the Swiss painter Vallotton, who was already acclaimed as a master of illustration and woodcut when he made his few appearances in the magazine. But worldwide fame still awaited a number of younger artists from many parts of Europe who studied in Paris and earned funds by selling satirical drawings to periodicals. Their contributions to *L'Assiette* may not resemble their later Fauvist, Cubist or nonrepresentational productions, but their talent is already in evidence. One of the artistic treats of leafing through *L'Assiette* is to discover this early work of Juan Gris, František Kupka, Jacques Villon, Louis Marcoussis and Kees van Dongen.

Not so well remembered, but with successful careers as painters or illustrators ahead of them, were Galanis, Kirchner, Carlègle, Naudin and Chas Laborde. Nor are such typical *L'Assiette* artists

as, for instance, Grandjouan, Roubille, d'Ostoya and Léon Georges to be spurned; with a high degree of ability, they sustained the quality of the magazine over the years.

II

L'Assiette au Beurre, issued weekly, was a quarto in format, measuring 12¼ by 9½ inches untrimmed. In its first two years or so the number of pages fluctuated, averaging 16, while the newsstand price during the same time rose from 25 centimes (equivalent to five cents in American money) to an average of 40 centimes. By the middle of the third year, stability had been attained, and from No. 125 (August 22, 1903) through the end of the run in the fall of 1912, only three issues exceeded 16 pages. From mid-1903 to mid-1904 the newsstand price was steady at 40 centimes, rising then to a definitive 50 centimes. This price, equal to a pre-World War 1 dime, made *L'Assiette* clearly a connoisseur's magazine, most of its competitors selling for much less.

In its best days the main pages of *L'Assiette* were almost entirely pictorial. It featured one large picture per page, and often there was a single double-page picture in the centerfold. From time to time one or two pages were occupied by a brief essay concerning the theme of the issue. After the first few issues, readers also received a four-page supplement on cheaper paper carrying ads, editorial statements and other odds and ends, as well as a number of smaller cartoons by younger, not yet established artists.

In the main pages the drawings were well reproduced by zinc etching or photogravure. Many were in black and white, but there was lavish use of color, ranging from a mere added tint to a "full-color" treatment. This color was not especially outstanding even for the time, but it was pleasant and often quite effectively applied. The eight color plates included in the present volume give a good idea of the feeling of *L'Assiette* color and the effects that were achieved.

With regard to production, the first year of the magazine was an experimental period. The grade and color of paper changed from week to week, and there were numerous complex foldouts. One issue—No. 48, of March 1, 1902, with artwork by Vallotton—was produced in the form of 23 authentic lithographs, printed on one side of the sheet only. This extravagance could not continue. After the first year the physical aspect of *L'Assiette,* though handsome, grew predictable. Its editors did not fear to assert (in No. 149, of February 6, 1904) that it was the world's leading satirical magazine, "the most beautiful artistic document of the era, and ABSOLUTELY UNIQUE in the annals of illustrated journals."

One of the truly distinctive features of *L'Assiette* began with No. 14, of July 4, 1901: the practice of devoting an entire issue to a single theme. From then on, most issues were handled in this manner; in the present volume, the English captions not only include a translation of the French captions, but also indicate the theme of the issue from which each drawing was selected. Many single-theme issues were drawn by a single artist, some were shared by two, some by three, while others were omnibus issues with many artists invited. The average fee paid to an artist for an entire issue was 1000 francs ($200); it might be as low as 200 francs, whereas Steinlen might receive 2000; we know that Van Dongen was paid 800 francs for one of his issues. There was a pro rata system for single pages, and the letterpress contributions, such as forewords and captions, also had a complicated scale of remuneration. Some artists, such as Jossot, Ibels and Forain, enjoyed writing their own captions; others, such as Florès, Sancha and no doubt many of the young foreigners, were unable to. There are even cases reported of one artist being hired to color the drawings of another.

The idea for an issue often came from Schwarz or another editor, but sometimes an artist, such as Grandjouan, would conceive of the theme. The magazine was carefully produced, and the staff liked to allow at least a month from first thoughts to bound copies. But at times things moved much more quickly: the powder-factory explosion at Issy-les-Moulineaux occurred only 13 days before the appearance of No. 13, of June 27, 1901 (see page 135), and the subway fire that formed the subject of No. 125, of August 22, 1903 (see page 140), had taken place only 12 days previously.

A number of issues are particularly interesting for the large number of artists represented. Two such omnibus issues stand out as peaks in the history of the magazine. The 48-page special issue No. 46 *bis* (published sometime in February 1902), which assailed distributors of adulterated milk that had claimed the lives of several infants, was the longest in the whole run of *L'Assiette.* This issue marked the first appearance in its pages of Faivre (see page 24), Gerbault (see color plate C), Grandjouan, Iribe (see page 88) and Vallotton. No. 423, of May 8, 1909, was on the general subject of "Artists," but had a very specific purpose: to pay homage to the contributor Aristide Delannoy, who had been fined 3000 francs and sentenced to a year in jail for his attacks on high public figures. The original drawings were offered for sale by the contributors, the proceeds to benefit Delannoy's family. This issue marks the last appearance in *L'Assiette*'s pages of Willette, Naudin, Carlègle (see page 12), Villemot, Florane, Vadász, Gallo, Mirande and Hermann-Paul. The magazine was never again quite so incisive, and generally dwelt on more innocuous topics until its demise in 1912.

Although Delannoy's imprisonment was probably the greatest blow dealt to *L'Assiette,* the magazine had constantly been in trouble with the authorities. The elective republican French rulers of the time, supported by booming industry, commerce and finance, defended the status quo with a heavy hand. For official reasons of politics or morality, several issues were impounded, banned or removed from newsstands. Several of the contributions to issue No. 263, of April 14, 1906, were prepared in the prisons of the republic. Repeatedly during 1907, the supplements carried a notice urging magazine dealers throughout France to eject from their premises unauthorized snoopers engaged in private "investigations" of immorality.

It is hoped that this anthology will serve as a record of one of the landmarks of graphic social protest and a tribute to those men who courageously involved themselves on both an artistic and political level.

THE ARTISTS

ADARAMAKARO (*page 1*). Most likely a Japanese studying or active in Paris, this artist combined many characteristics of the Japanese popular print of the *ukiyo-e* genre ("floating world" color woodcuts of the seventeenth through nineteenth centuries) with European perspective and caricatural conventions. His work appears in only one issue of *L'Assiette*, the entire No. 151 (Feb. 20, 1904), about the startling defeat of the Russians (a standing target for *L'Assiette*) by the Japanese in the Far East. Either the artist or the editors were keen observers of historical trends, for other drawings in this issue point unmistakably to the aspirations of the Japanese military toward further expansion.

PAUL BALLURIAU (*pages 2 and 3*). Born at Oullins, near Lyons. This draftsman, reportedly self-taught, became a member of the "school of Montmartre" in Paris. His contributions to the magazine *Gil Blas illustré* in the decade before the creation of *L'Assiette* were known for their imaginative grace and frequent use of classical allegories—in fact, Balluriau was called "the Boucher of the modern press"—but his work for *L'Assiette* (which first appeared in No. 7, of May 16, 1901, and only infrequently thereafter) shows him in a more realistic and incisive vein.

JACQUES BASEILHAC (*page 4*). Born at Trebours (in the French Pyrenees), 1874; died at Savigny-sur-Orge (outside Paris), 1903. Baseilhac was a painter who exhibited at the Salon de la Société Nationale des Beaux-Arts, where in 1901 he showed several illustrations of Jean Richepin's poem "Beggar's Song." In the following year, the year preceding the artist's death, 16 drawings on this subject constituted No. 81 (Oct 18, 1902) of *L'Assiette*, Baseilhac's only contribution to the magazine. The locale of the cover drawing, reproduced in this volume, appears to be one of the cheerless industrial outskirts of Paris.

RENÉ BERGER (*page 5*). No biographical information available. His cartoon-like work appears in No. 304 of *L'Assiette* (Jan. 26, 1907) and in No. 592 (Sept. 15, 1912; entire issue by Berger).

EDOUARD BERNARD (*page 6*). Little information is available, though he contributed frequently to *L'Assiette* between No. 277 (July 21, 1906) and No. 495 (Sept. 24, 1910). He exhibited drawings at the Salon des Humoristes, contributed to the prestigious but short-lived magazine *Les Humoristes* in 1911, did book illustrations and worked in advertising from 1925 to 1933. A 1937 source reports him as still alive and active.

LÉOPOLD BRAUN (*page 7*). The work of this skillful, if somewhat academic, draftsman appeared in *L'Assiette* between No. 2 (April 11, 1901) and No. 460 (Jan. 22, 1910).

BRUNNER, ZYG: *see* Zyg.

LEONETTO CAPPIELLO (*page 8*). Born in Livorno, Italy, in the late 1870s; died in Provence, 1942. Although chiefly remembered for his posters (some 3000), proclaimed as the first original breakthrough in French advertising art after Chéret, and for his paintings and murals, Cappiello began his career as a celebrated caricaturist and humorous draftsman. In 1896, still in Livorno, he produced a small album with text by G. Targioni-Tozzetti, co-librettist of *Cavalleria Rusticana* (1890). In 1898, on a visit to his brother, a stockbroker at the Parisian Bourse, Cappiello persuaded Puccini, in town for the successful French première of *La Bohème*, to sit for a caricature. The artist's career was then consolidated in 1899 when he began contributing to *Le Rire*. Other French papers and magazines that published his work were *Le Figaro*, *Le Gaulois*, *Le Journal* and *Le Cri de Paris*. Cappiello drawings appeared in *L'Assiette* from No. 5 (May 2, 1901) to No. 84 (Nov. 8, 1902). The artist's specialties, before he finally abandoned caricature for posters in 1904, were portraits of celebrities, especially theatrical, and scenes of the *haut monde* and the *demimonde*.

THOMAZ LEAL DA CAMARA (*color page A*). Born at Panjim, near Goa, in what was then Portuguese India, 1876; died in Lisbon, 1948. Leal da Camara, whose name generally appears in *L'Assiette* merely as "Camara," was one of the steadiest contributors to the magazine, ranging from No. 2 (Apr. 11, 1901) to No. 536 (July 8, 1911), with many issues devoted to his work alone. He specialized in portraits of celebrities, especially rulers and statesmen, and in the interpretation of Iberian affairs. He had come to Lisbon when still quite young, and studied art in Madrid and Paris. With Francisco Sancha (q.v.) he had founded the Spanish humor magazine *Madrid cómico*. After working for several Parisian journals, he moved to Brazil in 1922. He also worked in Brussels for a time. In 1945 he went back to Madrid, and when a republic was proclaimed in Portugal, he returned to Lisbon for his last years.

CARAN D'ACHE (*Emmanuel Poiré; pages 9 and 10*). Born in Moscow, Russia, 1858 or 1859; died in Paris, 1909. The artist's paternal grandfather had come to Russia in Napoleon's army and had settled there. Poiré moved to Paris when about 20. During a five-year army stint, he started submitting drawings to magazines and, needing a pseudonym, he hit upon the Russian word for pencil (*karandásh*). Though he had a little training at the Ecole des Beaux-Arts, he was chiefly self-taught and profoundly influenced by the German cartoonists Wilhelm Busch and Adolf Oberländer. Eventually he contributed to numerous Parisian magazines, co-founding some of them himself—the most notorious being the anti-Dreyfus and violently antisemitic *Psst!*, illustrated throughout its run by Caran d'Ache and Forain (q.v.) only. Caran d'Ache's humorous albums and posters became world-

famous, as were his shadow plays produced at the Chat Noir cabaret in Montmartre. His work appears in only two issues of *L'Assiette*, the entire No. 40 (Jan. 4, 1902), about illicit traffic in government decorations (bribery scandals of this nature were frequent during the Third Republic), and No. 46 *bis* (Feb. 1902), the great omnibus issue on adulterated milk (see Introduction).

CHARLES-EMILE CARLÈGLE (*Charles-Emile Egli; pages 11 and 12*). Born at Aigle in French-speaking Switzerland, 1877; died 1940. The artist moved to Paris in 1900 and became a French citizen in 1927. He exhibited at shows of humorous drawings from 1909 on, but soon transferred his talents to book illustration, in which he gained great celebrity. His contributions to *L'Assiette* begin with No. 187 (Oct. 29, 1904) and end with No. 423 (May 8, 1909), the important omnibus issue on artists for the benefit of an imprisoned colleague, Aristide Delannoy (q.v.).

CHAS LABORDE: *see* Laborde.

EUGÈNE COURBOIN (*page 13*). Born at La Fère (in northern France, halfway between Amiens and Rheims). Chiefly remembered for historical paintings on military themes exhibited at salons from 1878 to 1895, Courboin was also an illustrator. His only work for *L'Assiette* was the entire No. 128 (Sept. 12, 1903), one of the magazine's frequent diatribes on the alleged barbarism of French rural areas.

ARISTIDE DELANNOY (*pages 14–16*). Born in Béthune (near Lille, in northernmost France), 1874; died in Paris, 1911. Delannoy studied at the Ecole des Beaux-Arts and painted landscapes and pictures of miners. He had drawings published in the magazines *Le Rire*, *La Guerre sociale* and *Les Hommes du jour*, as well as *L'Assiette*, where his work first appears in the supplement to No. 11 (June 13, 1901) and his full-fledged contributions range from No. 18 (Aug. 1, 1901) to No. 508 (Dec. 24, 1910). A keen and outspoken opponent of government policies, Delannoy was sentenced in 1908 to a year in jail and a fine of 3000 francs; the immediate cause is said to have been an attack on a French general in Morocco published in *Les Hommes du jour*, although his drawings in *L'Assiette* had also been extremely provoking just at that time—reminding Clemenceau and Briand, then in power and enjoying it, of the promises they had made years before as ardent young socialists! No. 423 of *L'Assiette* (May 8, 1909) consisted of unpaid contributions by many artists for the benefit of Delannoy's family. It is possible that this imprisonment was a factor in shortening the life of the artist, who died at the age of 37.

DONGEN, KEES VAN: *see* van Dongen.

NOËL DORVILLE (*page 17*). Born at Mercurey (in the Burgundy wine region); a 1954 source implies that the artist was then still living. Dorville, also a painter, worked for *Le Rire*, *L'Echo de Paris* and *The Illustrated London News*, as well as for *L'Assiette* (sporadically, beginning with No. 4, of Apr. 25, 1901). He published political and antisemitic albums.

D'OSTOYA (*pages 18–20*). No biographical information available; the name is apparently Polish in origin. D'Ostoya was one of the most frequent contributors to *L'Assiette*, from No. 13 (June 27, 1901) to No. 591 (Sept. 1, 1912). Though his subject matter is quite varied and his style eclectic, it is easy to recognize a frequent borrowing, sometimes amounting to plagiarism, from the German artist Eduard Thöny, who specialized in military drawings for the Munich magazine *Simplicissimus*. On one occasion only does an acknowledgment "d'après Thöny" appear on one of d'Ostoya's pieces.

GEORGES DUPUIS (*also appears as Géo-Dupuis; pages 21–23*). Born in Le Havre, 1875; reported as still alive in a 1953 source. Dupuis moved to Paris at 17, studied for a while at the Ecole des Arts Décoratifs, worked as a commercial designer and ran a painting supplies store until attaining success as a book illustrator in 1900. In his drawings and paintings he specialized in proletarian types and in crowd scenes. His relatively few contributions to *L'Assiette*—the two complete issues No. 146 (Jan. 16, 1904) and No. 153 (Mar. 5, 1904, on crowds)—are characterized by a highly developed decorative sense that does not detract from the explosiveness of the subjects treated.

JULES-ABEL FAIVRE (*page 24 and color page B*). Born in Lyons, 1867; died in Paris, 1945. Faivre is perhaps best remembered today for his posters, especially the stirring "On les aura!" done during the First World War, but he was also a busy cartoonist contributing, from 1895 on, to *Le Rire*, *Le Journal*, *Le Figaro* and *L'Echo de Paris*, among other periodicals. As a painter (he executed church murals at Saint-Maixent in western France) he was noted for renderings of pink-cheeked girls and babies, whereas his humorous drawings are on the grotesque side. His contributions to *L'Assiette* consist of only one item in the adulterated-milk issue, No. 46 *bis* (Feb. 1902), and the entire No. 51 (Mar. 22, 1902), on doctors (the artist's father was a science professor and his brother was a physician). No. 51 proved to be one of the most popular issues of *L'Assiette*, and the magazine editors republished some of Faivre's medical drawings in the form of postcards.

PIERRE FALKÉ (*pages 25 and 26*). Born in Paris, 1884; died at Coutevroult (not far from Paris), 1947. Falké, who at one period in his life traveled to Australia and Borneo, was a book illustrator as well as a magazine cartoonist. His work appears in *L'Assiette* from No. 449 (Nov. 6, 1909) to No. 558 (Dec. 23, 1911).

FLORANE (*page 27*). Little biographical information; mentioned as living in a 1954 source. His drawings, skillfully executed in crayon and wash, appear in several issues of *L'Assiette*, from No. 122 (Aug. 1, 1903) to No. 423, the omnibus issue on artists (May 8, 1909). He was associated with *Le Rire* from 1901 to 1910, and also did book illustrations.

RICARDO FLORÈS (*pages 28 and 29*). Born 1878 (probably at Alençon, of a Peruvian father, though one source calls him Spanish); died at Rennes, 1918, of a war wound. Florès contributed to *Le Rire* (1898–1914), *Le Journal*, *Le Sourire*, *Le Cri de Paris* and other periodicals, as well as to *L'Assiette*, from the supplement to No. 9 (May 30, 1901; his first full-fledged contribution appeared in the adulterated-milk issue, No. 46 *bis*, of Feb. 1902) to No. 511 (Jan. 14, 1911).

JEAN-LOUIS FORAIN (*pages 30 and 31*). Born in Rheims, 1852; died in Paris, 1931. A painter, etcher and lithographer of the "School of Montmartre," and one of the most distinguished French humorous draftsmen, Forain was associated with *L'Assiette* for just a couple of the earliest issues, but his long and brilliant career had begun in 1876 and he contributed to a great number of maga-

zines, some of which he founded himself (*Le Fifre*, 1889; *Psst!*, 1898–99, with Caran d'Ache, q.v.). His drawings, characterized by great economy of line and by the weight and power of the individual figures and groups of figures—he has been called "the preeminent linear Impressionist"—were collected into a number of successful albums dealing with political scandals, the theater, the *demimonde* and many other facets of Parisian life.

LÉON FOURMENT (*pages 32 and 33*). No biographical information. His amusing work appears sporadically in *L'Assiette* beginning with No. 112 (May 23, 1903).

DIMITRIOS GALANIS (*frontispiece and pages 34–45*). Born in Athens, 1880; died there, 1966. This brilliant artist, whose work ranks with the very best published in *L'Assiette*, was a published cartoonist in his native city by the time he was 15. In 1899 he won a cartoon competition sponsored by *Le Journal* and came to Paris to study. While still at the Ecole des Beaux-Arts, he began contributing to Parisian journals, and was associated with *Le Rire*, *Le Journal du dimanche*, *Le Sourire*, *Le Matin* and others. His work appeared in *L'Assiette* from No. 107 (Apr. 18, 1903; already an entire issue) to No. 553 (Nov. 18, 1911). From 1907 to 1909 he lived in Germany and worked for *Lustige Blätter*, but at the outbreak of war in 1914 he signed up in the French Foreign Legion, was at the Battle of the Marne and in 1918 served as an interpreter for French troops in Greece. His debut as a book illustrator having already taken place in 1913, after the war he turned away from humorous work and concentrated on painting (he had started by 1903), specializing in portraits. From 1945 to 1952 he taught at the Ecole des Beaux-Arts.

ARMAND GALLO (*page 46*). Little biographical information; mentioned as still alive in 1954. His drawings, in a light cartoon style, appear in *L'Assiette* from No. 280 (Aug. 11, 1906) to No. 423, the omnibus issue on artists (May 8, 1909). He also contributed to *A la Baïonnette* in 1916, and published albums in 1931 and 1936.

GEORGES GAUMET (*pages 47 and 48*). No biographical information. Only one (entire) issue of *L'Assiette* contains his work —No. 589 (Aug. 4, 1912; the magazine was about to expire)— but it is a masterly one, and Gaumet's worldly-wise bellhops, with their many extracurricular duties, are figures worthy of the best days of *L'Assiette*.

LÉON GEORGES (*pages 49–53*). No biographical information, other than that he contributed drawings to *Le Rire* in 1901. In *L'Assiette* he is represented infrequently beginning with No. 98 (Feb. 14, 1903). His style is extremely decorative, with obvious influences from such "Nabi" painters as Vuillard, and his compositional skill is impressive.

HENRY GERBAULT (*color page C*). Born at Châtenay, outside Paris, 1863; died at Roscoff, in Brittany, 1930. This extremely popular cartoonist, illustrator and poster artist contributed only one drawing to *L'Assiette*, for the omnibus issue on adulterated milk, No. 46 *bis* (Feb. 1902), but it epitomizes his saucy, "naughty" style.

FRANCISCO JAVIER GOSÉ (*pages 54 and 55*). Born in Lérida, in Catalonia, 1876; died there, 1915. Gosé, a painter and illustrator, studied art in Barcelona and (from about 1900) in Paris. His pictures glorified society ladies and *demimondaines*, and he

was interested in fashions. Some of his drawings were published in the famous German magazine *Jugend*. His appearances in *L'Assiette* begin with No. 12 (June 20, 1901).

FERNAND-LOUIS GOTTLOB (*page 56*). Born in Paris, 1873; death not reported in 1955 sources. A lithographer and painter of portraits, Parisian cityscapes and landscapes (Normandy and Brittany), a book illustrator and poster designer, Gottlob also contributed to Parisian humor magazines, including *Le Rire*, *Le Sourire* and *Le Journal amusant*, from 1897 on. His appearances in *L'Assiette* begin with No. 2 (Apr. 11, 1901).

JULES-FÉLIX GRANDJOUAN (*pages 57–73 and color page D*). Born in Nantes, 1875; still alive in 1956. In 1897 he abandoned law studies for art, and two years later, still in his native city, wrote and illustrated the book *Nantes la grise*. In 1900 he moved to Paris and his humorous drawings, which were eventually to total about 2000, began to appear in *Le Rire*. He also worked for *Le Canard sauvage*, *Le Sourire*, *Le Cri de Paris* and such outspokenly anarchistic journals as *Le Libertaire* and *Les Temps nouveaux*. His work for *L'Assiette* is particularly extensive, ranging from No. 46 *bis*, the milk issue (Feb. 1902), to No. 584 (June 23, 1912). It is strange that Grandjouan, who was probably the most frequently published artist in *L'Assiette*, with the most covers to his credit, and perhaps its most representative contributor, should be so poorly documented. In a 1961 publication (*La Caricature et la presse sous la III^e République*, by Jacques Lethève) he is reported as having died of tuberculosis in jail in 1912, but not only did work by him appear in other journals during the First World War: the artist's signature leaves no doubt that the Grandjouan of *L'Assiette* is the same Grandjouan whose drawings of Isadora Duncan were exhibited in San Francisco in 1956, when he was mentioned as being "now in old age"! Combining information from various sources: Grandjouan is said to have begun sketching Isadora when he first saw her perform at the Trocadéro in Paris in 1901; he published 25 drawings of her in 1912; he visited her sister Elizabeth in Darmstadt, presumably before the First World War; saw Isadora in Paris again in 1915–16; and illustrated her *Ecrits sur la danse* with six plates in 1927. He is also said to have made a drawing trip to Russia in 1925. Grandjouan's drawings in *L'Assiette*, on a multitude of topics, are perhaps too eclectic in style to be acknowledged as a major artist's oeuvre, but many of them are strong and effective.

JUAN GRIS (*José Victoriano González; pages 74–77*). Born in Madrid, 1887; died at Boulogne-sur-Seine (Paris), 1927. Gris is internationally acclaimed as one of the great masters of Cubist painting, especially of that phase known as Synthetic Cubism, and his stage designs and sculptures are also familiar. But it is not generally known that he began his career as a humor-magazine artist. While still studying in Madrid, he contributed to *Blanco y negro* and to *Madrid cómico*, the magazine founded by Camara and Sancha (qq.v.). After moving to Paris in 1906, Gris published drawings in *Le Charivari*, *Le Cri de Paris*, *Le Témoin* and other journals. His work, which appeared sporadically in *L'Assiette* from No. 386 (Aug. 22, 1908) to No. 545 (Sept. 16, 1911), already shows the strong feeling for composition with flat planes and textures that would characterize his Cubist and abstract painting, for which he abandoned humorous illustrations in 1912.

JULES-ALEXANDRE GRÜN (*page 78*). Born in Paris, 1868; died 1934. A joyous member of the "school of Montmartre"—he

decorated a number of cabarets in that quarter—Grün is known for his Belle Epoque posters, magazine cartoons (in *La Caricature, La Fin de siècle, Le Courrier français* and others) and paintings and pastels. His work for *L'Assiette* begins in No. 2 (Apr. 11, 1901) and recurs infrequently thereafter.

ALBERT GUILLAUME (*pages 79 and 80*). Born in Paris, 1873; died at Fontaine-lès-Chaalies (near Senlis, north of Paris), 1942. Cartoonist, poster artist, painter in oils and watercolors, Guillaume was celebrated for his numerous albums and countless contributions to a host of humor magazines from the late 1880s on. His connection with *L'Assiette* lasted for only one issue, the entire No. 37 (Dec. 14, 1901), but this lighthearted and fanciful prediction of the wonders of air travel is especially well drawn and memorable.

HERMANN-PAUL (*René-Georges-Hermann Paul; pages 81–83*). Born in Paris, 1864; died at Saintes Maries de la Mer, on the Mediterranean, 1940. Hermann-Paul was the son of a wealthy doctor but refused to follow his father's profession. One of the most respected draftsmen of his day, he was represented in the very first issue of *L'Assiette* (Apr. 4, 1901) and quite frequently through its entire run; his last signed piece in the magazine is in No. 423, the omnibus issue on artists (May 8, 1909), but there is unsigned work in No. 510 (Jan. 7, 1911) that is exactly in his style (was he being cautious after Delannoy's imprisonment?). In addition to his portrait paintings, wood-engraved caricatures and book illustrations, Hermann-Paul found time to contribute to a number of other magazines as well (*Le Courrier français, Le Sifflet, Le Cri de Paris, Le Rire,* etc.). His style was very spare, featuring great simplification of forms; when not under firm control, it tended to become facile and diffuse.

HENRI-GABRIEL IBELS (*pages 84–87*). Born in Paris, 1867; died 1936. Also active as a dramatist and art historian, Ibels was largely self-taught as a painter and illustrator. In 1893 he shared an album of lithographs, *Le Café-concert,* with Toulouse-Lautrec, in whose shadow he always remained artistically, especially when choosing similar subjects for prints and posters. In 1899, at the height of the Dreyfus controversy, when many of the most important artists (Forain, Caran d'Ache, Willette) were turning out rabidly antisemitic work, Ibels founded his own short-lived pro-Dreyfus magazine, *Le Sifflet.* In *L'Assiette,* Ibels' appearances begin with the first issue (Apr. 4, 1901) and end with No. 501 (Nov. 5, 1910).

PAUL IRIBE (*pages 88 and 89*). Born in Angoulême, 1883; died in Menton, 1935. Best remembered today for his fashion drawings for Paul Poiret, Iribe was also a jewelry designer and a cartoonist. During the First World War he published the magazine *Le Mot,* to which artists like Raoul Dufy, André Lhote and Jean Cocteau contributed. In the 1920s he was an art director in Hollywood. Iribe's drawings in *L'Assiette* begin with the adulterated-milk issue, No. 46 *bis* (Feb. 1902), and appear only infrequently later.

GUSTAVE-HENRI JOSSOT (*page 90*). Born in Dijon, 1866; reported as still alive in a 1926 source. Jossot, whose graphic talents were used in commercial art, posters, playing cards, invitations, book ornament, tapestries and furniture inlays, as well as in drawings for several magazines, was also a painter and printmaker. His extremely numerous drawings for *L'Assiette,* beginning in the

very first issue (Apr. 4, 1901), are in a personal stylization—actually, an extreme simplification that easily becomes tiresome—of the curvilinear Japanese-inspired manner popular in the late nineteenth century. About 1925 he converted to Islam, called himself Abdul Karim Jossot and produced Asiatic motifs.

RAPHAEL KIRCHNER (*pages 91–93*). Born in Vienna, 1876; died in New York, 1917. Already established as a portraitist of elegant ladies in Vienna, Kirchner came to Paris about 1900 and did magazine drawings and book illustrations. His work in *L'Assiette* (starting with No. 293 of Nov. 10, 1906) is not extensive but very choice. For a while he lived in London and drew for *The Sketch.* At the outbreak of the First World War he moved to New York, where once again he painted society women. His name remained popularly attached to one of his artistic creations, the Kirchner Girl, a type of female figure romantically based on the "gun molls" of Montmartre.

FRANTIŠEK KUPKA (*page 94*). Born at Opočno, Bohemia, 1871; died at Puteaux, near Paris, 1957. After studies in Prague and Vienna, Kupka came to Paris in the mid-1890s. Up to about 1907 he submitted drawings, often with an anarchist slant, to numerous magazines, including *Cocorico, Le Canard sauvage* and *Le Rire,* did book illustration and produced fashion drawings for the big department store Les Magasins du Louvre and for *Harper's Bazar.* His work for *L'Assiette*—beginning in the first issue (Apr. 4, 1901) and ending in No. 258 (Mar. 10, 1906)—featured three entire issues devoted to rather overblown cycles of allegories on money, peace and religion (the latter so outspokenly opposed to every imaginable creed that even the *Assiette* editors toned it down). His drawings for these cycles were shown in a traveling exhibition in Bohemia, where they created a sensation. His painting, which had earlier been decidedly realist, changed rapidly after 1910 to Symbolist, Fauve and Cubist (in a special manner known as Orphist), and then to abstract, geometrical and "absolute." Kupka counts as one of the earliest nonrepresentational painters, having formulated his style somewhat later than, but independently of, Kandinsky, though parallel with Robert Delaunay (also an adherent of Orphism, along with Louis Marcoussis and Jacques Villon [qq.v.]; Villon was Kupka's good friend and neighbor, first in Paris, then from 1906 in the suburb of Puteaux). During the First World War, Kupka served France in the Foreign Legion.

CHAS (CHARLES) LABORDE (*pages 95 and 96*). Born in Buenos Aires (of French parents), 1886; died in Paris, 1941. Laborde, who studied at the Académie Julian and the Ecole des Beaux-Arts, had drawings accepted in Parisian humor magazines when he was only 15. During the First World War he did pictorial reportage at the front and was gassed in 1917. After the war he concentrated on book illustration and became one of the most distinguished practitioners of that art. He is represented in *L'Assiette* from No. 558 (Dec. 23, 1911) to No. 586 (July 7, 1912).

LEAL DA CAMARA, THOMAZ: *see* Camara.

CHARLES-LUCIEN LÉANDRE (*pages 97–99*). Born at Champsecret, near Alençon, 1862; died in Paris, 1930. Léandre was best known for his portraits, both the serious fashionable ones done in pastels and the bitingly satirical ones done for magazines in lithographic crayons (like most of his humorous drawings). He

gained intimate knowledge of political circles from his uncle, who was a Deputy. Léandre drew for a number of important periodicals and was one of the founders of Le Rire in 1894 (his work was represented in the very first issue of L'Assiette). He also produced posters and book illustrations. The sculptural quality of the heads in his drawings has been attributed to his early training in plaster modeling.

LOUIS MALTESTE (page 100). No dates available. Malteste, a careful draftsman, did artistic reportage at the time of the Dreyfus affair, and worked for Le Monde illustré, L'Illustration, La Vie en rose and Le Rire. He also did paintings and posters. Only one (entire) issue of L'Assiette is by Malteste, No. 295 (Nov. 24, 1906).

LOUIS MARCOUSSIS (Ludwig Casimir Markus; color page E). Born in Warsaw, 1878; died at Cusset (near Vichy, in central France), 1941. The artist's family were carpet makers who had converted from Judaism to Catholicism. In 1901 the talented young man went to study art in Krakow, and already placed humorous drawings in a local magazine. In 1903 he moved on to Paris, where he studied at the Académie Julian. Painting was always his main interest (from 1904 to 1906 he progressed from Impressionism to Fauvism), but he was constantly compelled to raise money by drawing for the Parisian humor magazines. From 1907 to 1910 he had to do this almost exclusively. His appearances in L'Assiette, signed merely "Markous," range from No. 390 (Sept. 19, 1908), a Slavic issue, to No. 562 (Jan. 20, 1912). But well before the latter date—in 1910—he had met Braque, Picasso and the art-loving poet Guillaume Apollinaire, under whose influence he changed his name to Louis Marcoussis and became a Cubist. For a while his work was tinged with Orphism (see Kupka). Marcoussis became celebrated for his particularly lyrical and suave Cubist canvases.

ARIS MERTZANOFF (page 101). No biographical information available. His work, characterized by a highly decorative line, appears in only two issues near the end of the run of L'Assiette, No. 573 (Apr. 6, 1912) and No. 585 (June 30, 1912).

MICHAËL (pages 102 and 103). No biographical information. His work for L'Assiette begins with No. 2 (Apr. 11, 1901). Simplified, monumental forms emerge from a smudgy but purposeful application of crayon. In one issue it was stated that the artist worked in London and thus was presumably English—as Arthur Michaël (q.v.) might also very well have been—but their styles are not sufficiently similar to consider them with confidence as one and the same artist. If they were English, of course, their real names would lack the dieresis on the e.

ARTHUR MICHAËL (page 104). No background information. See discussion under Michaël, just above. "Arthur Michaël" is credited only with one (entire) issue of L'Assiette, No. 20 (Aug. 15, 1901). I have been unable to make a convincing connection (though the possibility exists) between this draftsman and the English painter A[rthur] C. Michael, who published An Artist in Spain about 1915.

HENRY MIRANDE (pages 105 and 106). Born in Nice, 1877; death not reported in a 1956 source. This etcher and painter did book illustrations and contributed cartoons to Le Rire and Fantasio as well as to L'Assiette, where he appears for the first time

in the omnibus issue on milk (No. 46 bis, of Feb. 1902) and for the last time in the omnibus issue on artists (No. 423, of May 8, 1909).

P.-L. (Paul-Louis?) MOREAU (page 107). No biographical information. He first appears in No. 8 of L'Assiette (May 23, 1901) and seldom afterwards.

BERNARD NAUDIN (pages 108–110). Born at Châteauroux, in central France, 1876; died in Paris, 1946. Although as a young man he worked for Le Cri de Paris and L'Assiette (from No. 192, of Dec. 2, 1904, to No. 423, of May 8, 1909), Naudin is best remembered for his later illustrations and particularly his work during World War I. Whether using brush, pen or the etching needle, he always had a predilection for military subjects, and this is already apparent in his strongly emotional and forthright drawings for L'Assiette.

OSTOYA: see d'Ostoya.

PAUL, HERMANN: see Hermann-Paul.

FRANCISQUE POULBOT (pages 111–119). Born in Saint-Denis, outside Paris, 1879; died in Paris, 1946. In his drawings, watercolors, book illustrations and posters, Poulbot celebrated the everyday pleasures and sorrows of the lower and bohemian classes of Paris, and especially the simple inhabitants of Montmartre. His subject matter, with its emphasis on shopgirls, prostitutes, barflies, tenement dwellers and street eccentrics, forms a striking parallel with the work that the German artist Heinrich Zille was doing in the Berlin slums in the same period. The similarity is particularly evident in their love for children; waifs and urchins of the kind immortalized by the French artist are still sometimes spoken of as les petits poulbots. Cartoons by Poulbot also appeared in Le Rire and Le Sourire. His credits in L'Assiette extend from No. 111 (May 16, 1903) to No. 483 (July 2, 1910).

MAURICE RADIGUET (pages 120–122). Born in Paris; reported as still living in Parc-Saint-Maur, near Paris, in a 1958 source (elsewhere, 1941 given for death). Known solely as a humorous draftsman, Radiguet appears in L'Assiette from No. 189 (Nov. 12, 1904) to No. 576 (Apr. 20 [actually 27?], 1912).

ALBERT ROBIDA (page 123). Born in Compiègne, 1848; died at Neuilly (Paris), 1926. In both age and experience, Robida was the dean of the artists associated with L'Assiette. A lithographer and etcher as well, he began drawing for magazines as early as 1866 (Le Journal amusant) and contributed to Paris-Caprice, La Vie élégante, Paris-Comique and La Vie parisienne during the last days of the Second Empire and the first days of the Third Republic. In 1873, after a few months in Vienna doing drawings for Der Floh, he founded the new La Caricature (the earlier one, of prestigious memory, had been founded in 1830 by Charles Philipon and had had Daumier as chief artist). Robida also wrote and illustrated a number of very successful books, both standard accounts of travel and topography and humorous prophecies of life and technology in the twentieth century; his "prophetic" volumes are still highly desirable collector's items. He is said to have produced some 60,000 drawings. Life at seaside resorts, the theme of his solitary issue of L'Assiette, No. 74 (Aug. 30, 1902), was a favorite subject of his for decades; the issue is drawn with exceptional care in the fussy, meticulous, scratchy style that prefigures Ronald Searle.

AUGUSTE JEAN-BAPTISTE ROUBILLE (*pages 124–127 and color page F*). Born in Paris, 1872; died 1955. Roubille was an engraver and a painter (he did café murals), a book illustrator and a designer of posters and dioramas. His work for humor magazines—*Le Courrier français, Le Rire, Le Sourire, Le Cri de Paris, Cocorico* and others—began in 1897. *L'Assiette* claimed his services for its very first issue (Apr. 4, 1901) and frequently in the years that followed. His style was eclectic, but almost always arresting, whether he used a simplified, flat-toned "Nabi" approach (as in pages 124 and F), a more traditional illustrator's style (as in page 125) or a pre-Expressionist manner bold in both composition and rendering (as in page 127). The drawing on page 126 is especially impressive for the way in which the information is imparted distributively and by synecdoche: the lonely dragoon far from home must be mentally reassembled by the viewer from one boot, one epaulet, his helmet on the whore's head and a portion of his own shaved head reflected in the mirror; the bistro locale is also established with the greatest economy, including a further mirror reflection; the whole scene prefigures some of Brassaï's ingenious photographs of the 1930s. The drawing on page 127, concerning atrocities committed during French colonization of Africa, is perfectly clear, but the caption may be confusing without a knowledge of the complete issue of *L'Assiette* from which it comes; the captions purport to be the thoughts and opinions of a typical selfishly reactionary bourgeois, while the pictures show the artist's version of the truth and invariably give the lie to the words; the drawing reproduced here forms a pendant to a view of an enraged worker fighting for his rights on a barricade; the reactionary opinion expressed in the paired captions is that the worker is intolerable when rebellious, but admirable when serving his country in a colonial regiment.

FRANCISCO SANCHA LENGO (*pages 128 and 129*). Born in Málaga, 1874. In Madrid Sancha painted figures and landscapes and did humorous drawings; he and Camara (q.v.) founded the magazine *Madrid cómico*. Parisian magazines such as *Le Rire* and *Le Cri de Paris* also published pieces by Sancha, whose work appears in *L'Assiette* sporadically, beginning with No. 5 (May 2, 1901). From 1901 to 1922 he was in London, where he decorated a Spanish clubhouse.

THÉOPHILE-ALEXANDRE STEINLEN (*pages 130–140*). Born in Lausanne, 1859; died in Paris, 1923. Although the reputation of a few young contributors to *L'Assiette,* such as Juan Gris, was eventually to become even more lofty than Steinlen's, there is no doubt that he was the magazine's most honored artist at the time of its creation and that his adherence helped to foster and sustain it. The very first page (cover) of No. 1 (Apr. 4, 1901) was by him, and his work appears frequently through No. 390 (Sept. 19, 1908). A Swiss of German descent, one of a family of artists, Steinlen came to Paris in 1882 and became a French citizen in 1901, the year in which *L'Assiette* saw the light. From the very outset of his French sojourn he became intimately associated with the special bohemian and politically liberal atmosphere of Montmartre. His first lithographs (illustrating songs by the famous cabaretier Aristide Bruant) date from 1884, his first posters (an art form in which he had particular success) from 1885, his first etchings from 1898. His drawings for over 30 magazines (some of which he founded) from 1882 to 1913, as listed in the catalogue raisonné of his works, occupy 35 large pages of small type. He also did murals and book illustrations. His style, though personal and distinctive, was influenced at various times by his illus-

trious contemporaries Degas, Vallotton, Toulouse-Lautrec, Rodin, Forain and Munch. His subject matter includes street life, political propaganda and studies of his beloved cats; the contributions to *L'Assiette* almost always reveal him as an *artiste engagé*, one committed to rooting out the inequities and complacencies of society.

MIKLÓS VADÁSZ (*pages 141 and 142*). Born in Budapest, 1884; died in Paris, 1927. This painter, pastel portraitist and draftsman, who contributed to various French, German and English magazines, moved to Paris in 1919. He appears in *L'Assiette* from No. 267 (May 12, 1906) to No. 423, the omnibus issue on artists (May 8, 1909).

FÉLIX-EDOUARD VALLOTTON (*pages 143 and 144*). Born in Lausanne, 1865; died in Paris, 1925. This Swiss artist came to Paris in 1882 (like his fellow townsman Steinlen) and studied at the Académie Julian for three years. Though he was already painting in the 1880s, the last decade of the century saw him concentrating on graphics for books and magazines. In this period, his most influential, while he was giving new vitality to the artistic woodcut, his drawings were internationally in demand, appearing in such important periodicals as *La Revue blanche* in France, *The Studio* in England, *Pan* and *Jugend* in Germany, and *The Chap-Book* in the United States. About 1900 he returned to painting and gained fame through his personal combination of Post-Impressionist techniques with a more somber "objectivity." His work for *L'Assiette* consists of one drawing in the adulterated-milk issue, No. 46 *bis* (Feb. 1902), and the entire No. 48 (Mar. 1, 1902): 23 true lithographs printed from stones on one side of the leaf only. This was the only issue of *L'Assiette* produced in this beautiful and costly manner.

KEES VAN DONGEN (*pages 145–147*). Born at Delfshaven, near Rotterdam, 1877; died in Monaco, 1968. This famous Dutch painter, who came to Paris in 1897, allied himself to the Montmartre group and worked his way successively through various Post-Impressionist movements culminating in Fauvism, of which he was one of the most brilliant representatives both in figure painting and landscape. From 1901 to 1903 he contributed drawings to such Parisian humor magazines as *Frou-Frou, L'Indiscret, Le Rire* and *Rab'lais. L'Assiette* was apparently his favorite—he appears from No. 12 (June 20, 1901) to No. 140 (Dec. 5, 1903) —and it rewarded him rather handsomely: he received 800 francs ($160), then a good sum for a young artist, for No. 30 (Oct. 26, 1901); this issue tells the generalized story of a harlot who rises from obscurity to moderate success (the item we reproduce, page 147, shows her squandering her first 20-franc fee in the big department stores), but ends in sickness and misery. Van Dongen was also employed by *L'Assiette* as an expert colorist of other men's drawings; thus, he is said to have colored Ibels' (q.v.) No. 273, on provincial cabarets (see page 87). After his Fauvist period, van Dongen's long career as a painter was one of enormous financial success, as he turned his hand to skillful and enjoyable but slick and unchallenging travel views and portraits of society ladies.

JEAN VEBER (*page 148 and color page G*). Born in Paris, 1864; died there, 1928. Though never completely successful (except for an occasional *succès de scandale*) with his enormous allegorical and fantastic paintings and tapestry designs, Veber was an important and respected draftsman, often illustrating satirical arti-

cles written by his brother Pierre. He worked for *Gil Blas illustré, Le Journal, L'Illustration* and *Le Rire;* for the last-named magazine, in 1898, he did a notorious issue lampooning the German Kaiser's ambitions in Palestine. He was represented in the first issue of *L'Assiette* (Apr. 4, 1901) and fairly often thereafter. His chief contribution is the haunting issue (No. 26, of Sept. 28, 1901) on the "reconcentration camps" in which the British were detaining Transvaal civilians in very desperate moments of the Boer War (during which most Continental European sympathies were with Kruger). The image reproduced on page 148 is even more jarring and dismaying for present-day viewers than it could have been when the British first invented the concentration camp. This issue of *L'Assiette* was temporarily banned by the French government, which was busily negotiating a defensive alliance with Britain, but eventually it ran into several editions. During the First World War, German planes dropped reprints of this issue over British trenches in France, as if to say "See what allies you have!" The British retorted with copies of Veber's 1898 anti-German issue of *Le Rire*.

JEAN VILLEMOT *(pages 149 and 150)*. Died 1958 according to one source. His work appears in *L'Assiette* from No. 230 (Aug. 26, 1905) to No. 423, the omnibus issue on artists (May 8, 1909).

JACQUES VILLON *(Gaston Duchamp; pages 151 and 152)*. Born at Damville, in eastern Normandy, 1875; died at Puteaux, near Paris, 1963; elder brother of the artists Marcel and Suzanne Duchamp and Raymond Duchamp-Villon. Gaston Duchamp abandoned the study of law for that of art (in Rouen, 1894; in Paris from 1895) and, as a young man, now calling himself Jacques Villon, contributed drawings to such magazines as *Le Chat noir, Gil Blas illustré, Le Rire* and *Le Courrier français*. His appearances in *L'Assiette* begin in the first issue (Apr. 4, 1901). Magazine work ended about 1910. As a painter, he went through periods of Fauvism and a special brand of Cubism (see Kupka and Marcoussis, above), ending up with important nonrepresentational canvases by the late 1910s. From 1919 to 1930 he had to support himself by printmaking, including reproductions of other artists' paintings. He lived in the United States from 1935 to 1940.

H. VOGEL *(pages 153 and 154)*. No clear biographical information. On the basis of the art work, this artist is almost surely not the Hermann Vogel who did humorous drawings for the publishers Braun & Schneider in Munich. Is he the book illustrator Hermann Vogel (assuming he is a different one) who was born in Flensburg (Schleswig-Holstein) in 1856, moved to Hamburg in 1864, studied art in Munich from 1872 to 1878 and later settled in Paris, where he died in 1918 as a naturalized Frenchman? At any rate, the H. Vogel of *L'Assiette* appears for the first time in No. 1 (Apr. 4, 1901) and for the last time in No. 169 (June 25, 1904), always represented by a striking *danse macabre* item executed in a richly hatched, academic pen technique.

LÉON-ADOLPHE WILLETTE *(pages 155–159)*. Born in Châlons-sur-Marne (in the Champagne region east of Paris), 1857; died in Paris, 1926. Like Steinlen (q.v.), Willette was a Montmartre bohemian and a hoary veteran of magazine illustration (he was associated with at least 20 periodicals, founding at least one). His reputation was a mighty asset by the time *L'Assiette* came into being. He wrote, lettered and illustrated the humorous "manifesto" on pages 2 and 3 of the first issue (Apr. 4, 1901; see Introduction) and contributed frequently through No. 423, the omnibus issue on artists (May 8, 1909). Other artistic activities included lithographs, posters, book illustrations, decorations in cabarets and other public and private buildings (oils on panels and paintings on glass), and political candidacy on an antisemitic ticket. His outspoken nationalism, rather on the reactionary and jingoist side, sometimes gave rise to a plethora of allegories in his art, but he also produced much in a light amorous vein consciously reminiscent of Watteau.

ZYG *(Zygismund Leopold Brunner; pages 160 and 161 and color page H)*. Born in Warsaw, probably in the late 1870s; died in Paris, 1961, according to one source. Brunner was a childhood friend of Marcoussis (q.v.), whom he followed to Paris, arriving by 1907 at the latest. He became associated with the artistic and literary group residing at the famous Bateau-Lavoir in Montmartre. His work occurs in *L'Assiette* with the credit "Z. Brunner" in No. 390 (Sept. 9, 1908), an issue about persecuted Slavic minorities in the Austro-Hungarian Empire, but a drawing signed "Zyg" had already appeared in No. 382 (July 25, 1908) and other "Zyg" items occur frequently through No. 579 (May 19, 1912).

APPRIVOISÉ!

TAMED! [No. 151, Feb. 20, 1904; issue on the Japanese attack on the Russian naval squadron at Port Arthur]

Adaramakaro 1

— *Madame ne préfère pas plutôt le petit salon rose?*
— *Oh! inutile, je suis avec mon mari.*

Paul Balluriau

"Wouldn't Madame rather be in the little pink room?" "What for? I'm with my husband." [No. 39, Dec. 28, 1901; Christmas issue]

Certains animaux ne virent pas d'étoile, mais,
à des signes certains « ils connurent que les temps étaient proches. »

Certain animals did not see a star, but from unmistakable signs "they knew the time was near." [No. 39, Dec. 28, 1901; Christmas issue]

Paul Balluriau 3

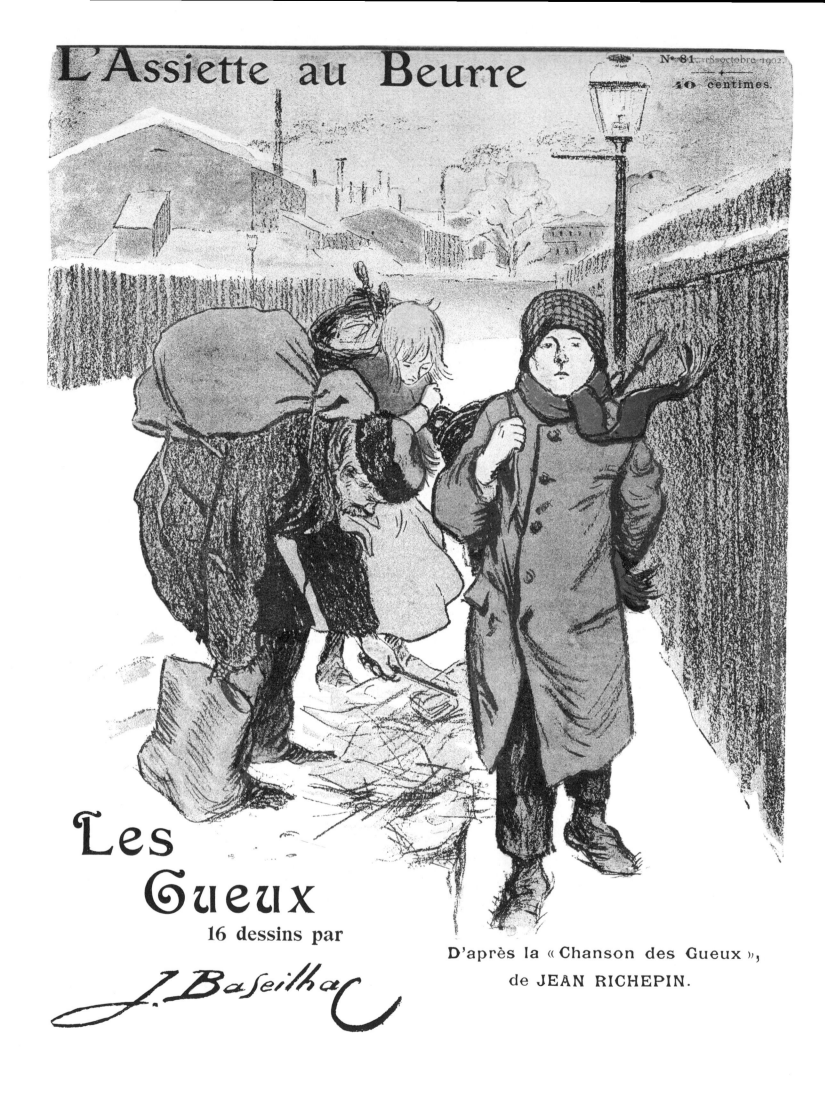

[Cover of No. 81, Oct. 18, 1902; issue on ragpickers and vagabonds, based on Jean Richepin's poem "Beggars' Song"]

LE PETIT TROU PAS CHER

— *Encore un train qui rentre à Paris, et nous on reste là à se barber, parce que tu as payé un mois d'avance à l'hôtel.*

THE LITTLE INEXPENSIVE NOOK. "Another train going back to Paris, and we're stuck here and bored because you paid for a whole month at the hotel." [No. 592, Sept. 15, 1912; issue on summer pleasures]

René Berger 5

— Va vite dire à Clara de me rejoindre, j'ai un poivrot à entôler...

"Fast, go tell Clara to join me. I've got a drunk to fleece." [No. 288, Oct. 6, 1906; issue on the evils of alcohol]

LES DEUX MONDES
— DÉCIDÉMENT, TU ME NÉGLIGES, ON DIRAIT QUE JE SUIS TA FEMME!

THE TWO WORLDS. "No two ways about it, you're neglecting me. People would think I was your wife!" [No. 2, Apr. 11, 1901]

Léopold Braun　　7

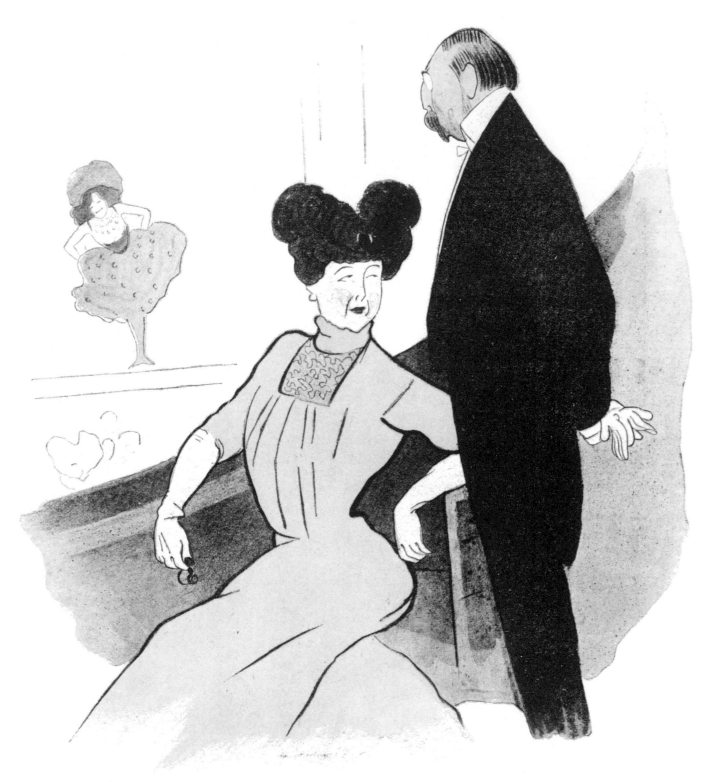

— Je veux bien que ce soit pour ton crédit.... mais si tu continues à lui prêter mes bijoux, on finira par croire que c'est moi qui l'entretiens.

"I agree, you should have the prestige [of keeping a mistress], but if you go on lending her my jewelry, people will end up thinking that *I'm* keeping her." [No. 84, Nov. 8, 1902; issue on high society]

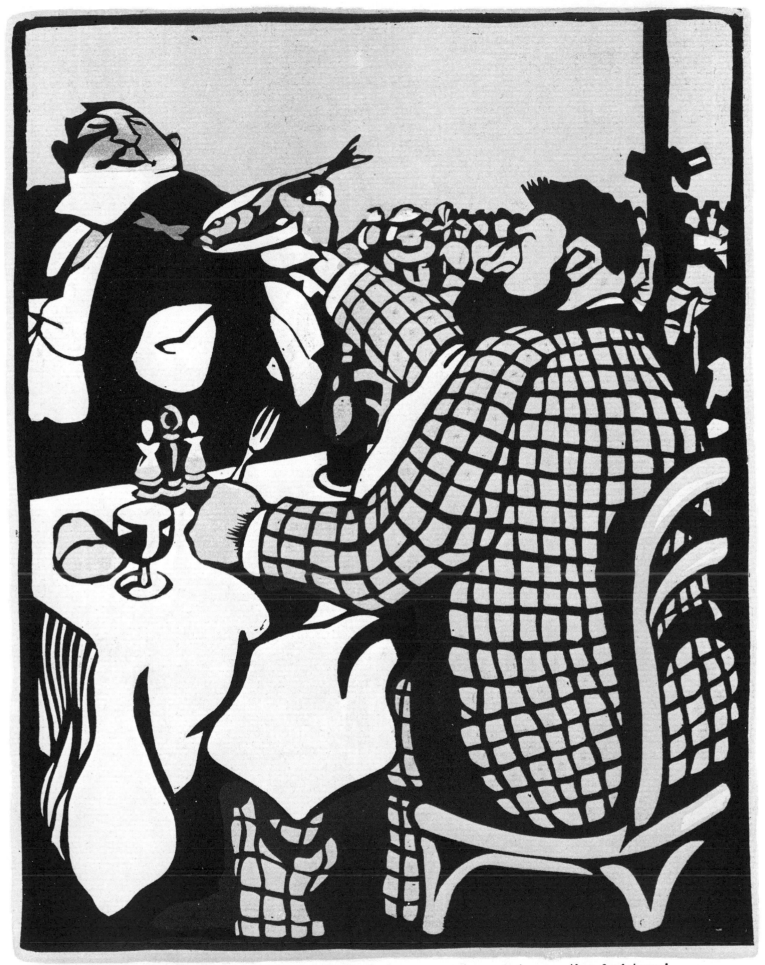

— Monsieur le Chevalier, jurez-moi sur votre croix que ce merlan est de première fraîcheur!

IN THE RESTAURANT WORLD. "Chevalier [of the Legion of Honor], swear to me on your official cross that this whiting is perfectly fresh!" [No. 40, Jan. 4, 1902; issue on the illicit traffic in government medals and decorations]

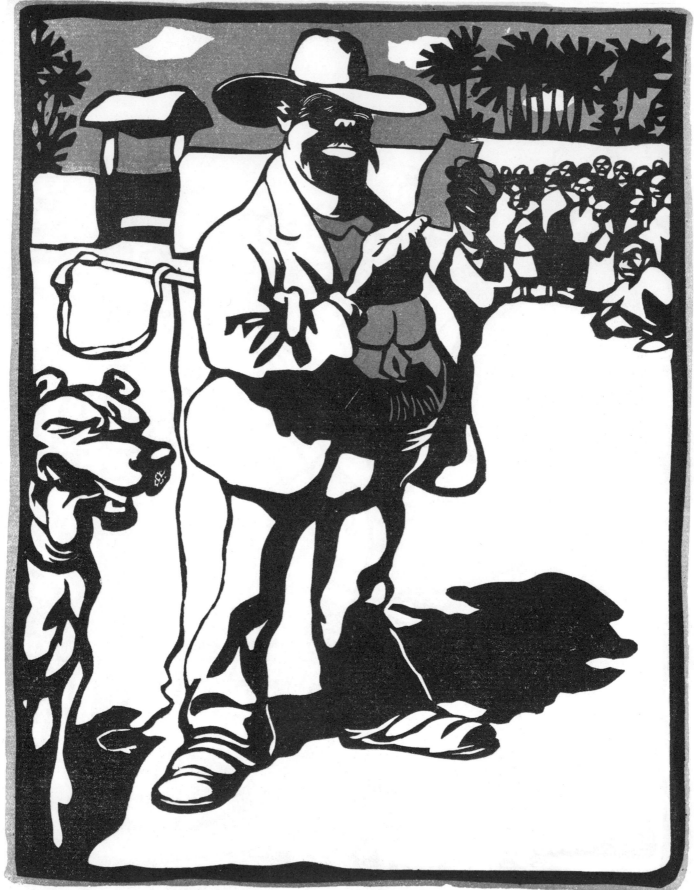

La lettre du Ministre.

« *Cher ami, ici l'on a raconté que vous vendiez des nègres, quelle infamie! Dans tous les cas, d'ici au 14 Juillet, ne faites que de simples échanges et ie vous garantis que vous le serez.* »

Agréez, etc. »

IN THE COLONIES. THE LETTER FROM THE CABINET MINISTER. "Dear friend, people here have reported that you were selling blacks—what a slander! In any case, between now and July 14 [the national holiday], just barter them and I guarantee you [your decoration]. Best wishes, etc." [No. 40, Jan. 4, 1902; issue on the traffic in medals]

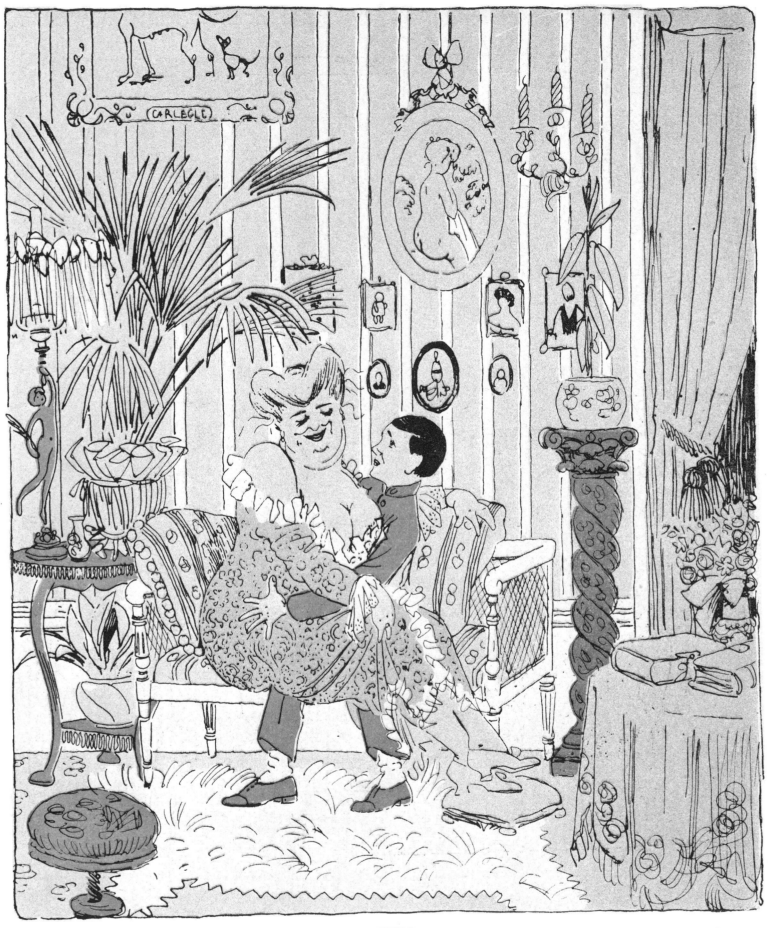

L'AMATRICE ET LE LYCÉEN

LUI. — Jure-moi que je suis le premier !...

THE NONPROFESSIONAL AND THE HIGH-SCHOOL BOY. HE: "Swear that I'm
your first!" [No. 269, May 26, 1906; issue on lovemaking]

Charles-Emile Carlègle 11

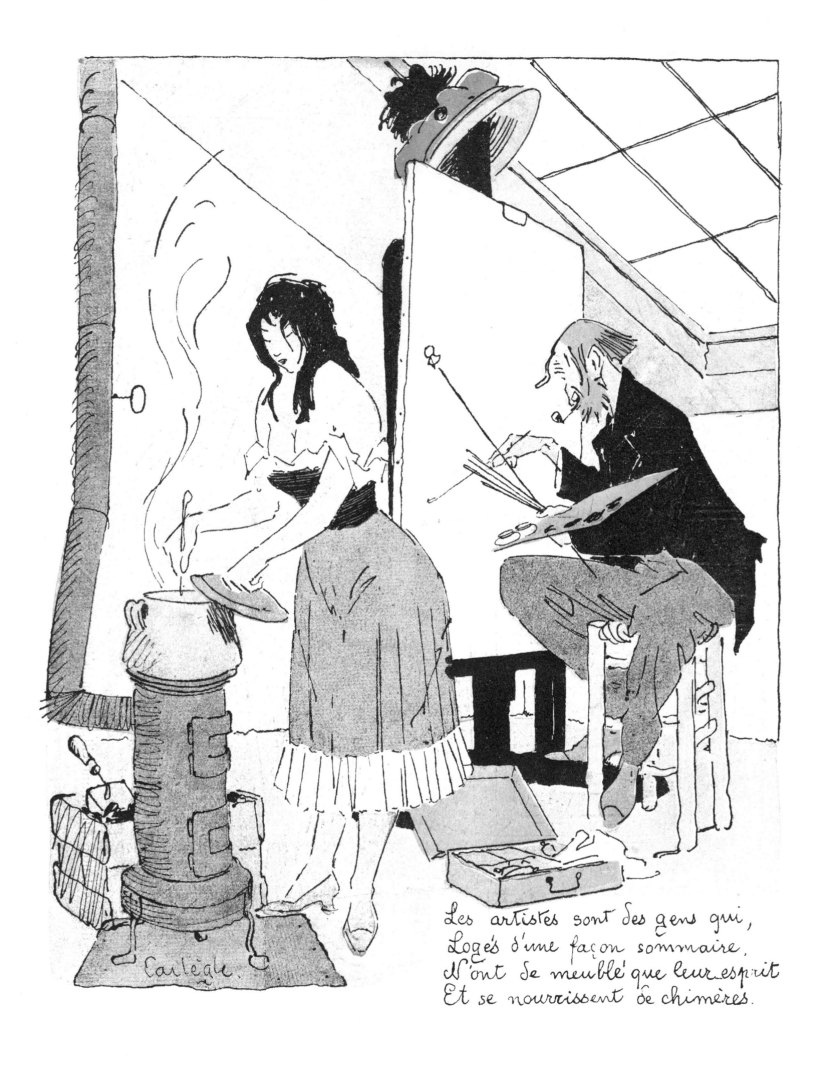

Les artistes sont des gens qui,
Logés d'une façon sommaire,
N'ont de meublé que leur esprit
Et se nourrissent de chimères.

Artists are people who don't have fancy residences. Only their minds are well furnished, and they feed on fantasies. [No. 423, May 8, 1909; issue on artists for the benefit of the imprisoned artist Delannoy]

Charles-Emile Carlègle

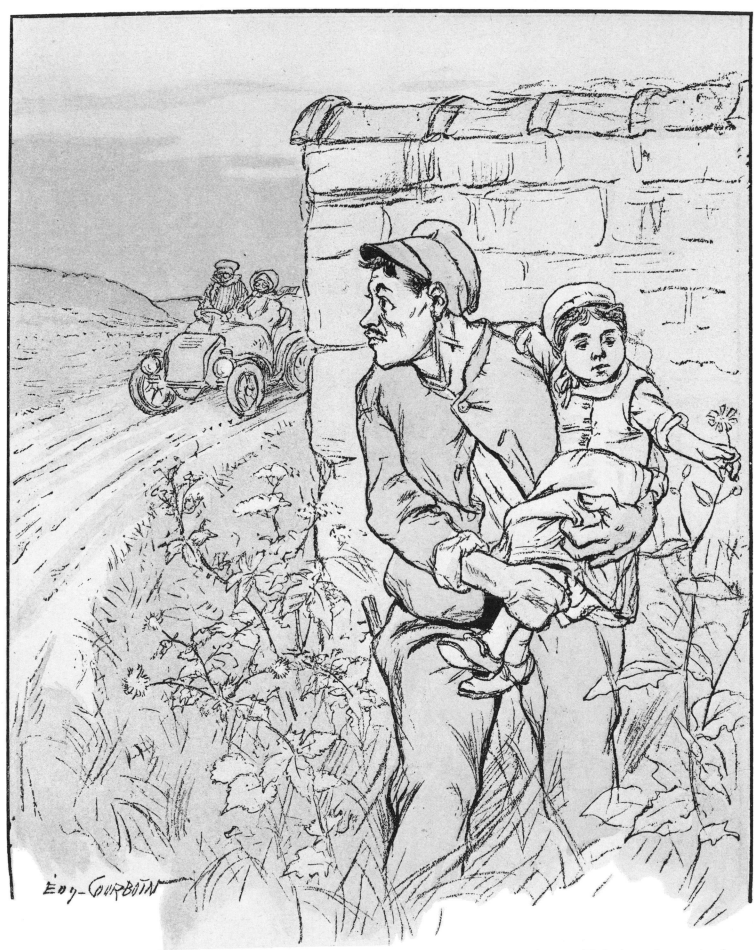

— *Jean-Louis a eu 10.000 francs du chauffeur qui a écrasé son gosse... faut qu'j'aie la même veine !...*

"Jean-Louis got 10,000 francs from the driver who ran over his kid. I hope I have the same luck." [No. 128, Sept. 12, 1903; issue on "rural scenes"]

Eugène Courboin 13

— Le régiment vous change un homme ; depuis mon retour du service, il n'y a plus que les combats de coqs qui m'intéressent !

Aristide Delannoy

"Army service really changes a man; since I'm back, the only thing I care about is cockfights!" [No. 134, Oct. 24, 1903; issue on small-town life]

A L'ORPHELINAT DE LA PROVIDENCE. — LA RECRÉATION

LES RETARDATAIRES. — La cloche sonne !... Faut encore se retenir pendant trois heures !

AT THE PROVIDENCE ORPHANAGE; RECESS. THE LATECOMERS: "The bell is
ringing! We've got to hold ourselves in for another three hours!" [No. 190, Nov. 19,
1904; issue on "rescuing children"]

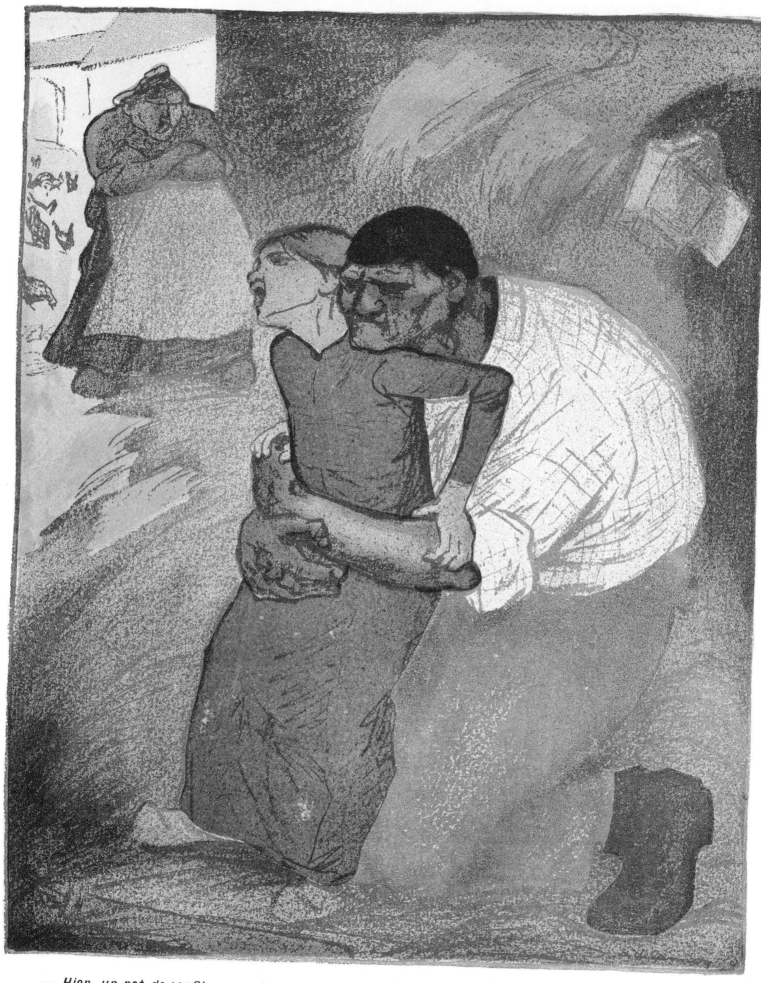

— *Hier, un pot de confiture ; aujourd'hui, mon homme !*

Aristide Delannoy

[THE FARMER'S WIFE:] "Yesterday it was a pot of jam [that you stole], today it's my husband!" [No. 306, Feb. 9, 1907; issue on the exploitation of children]

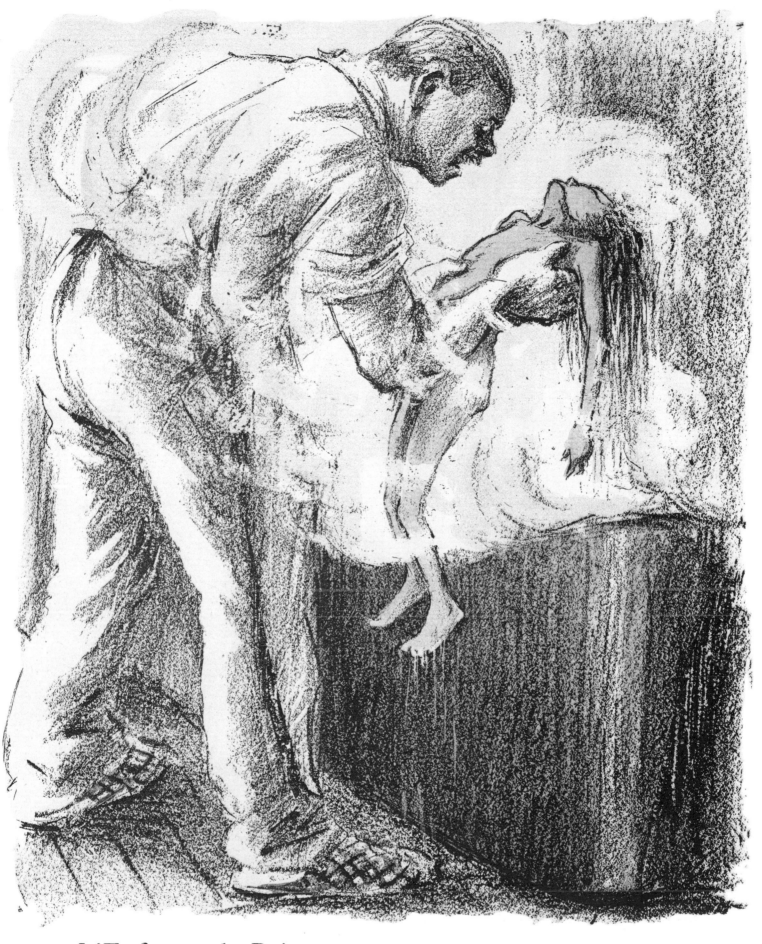

L'Enfant et le Bain.

— N... de D...! il est cuit!...

THE CHILD AND THE BATH. "My God! He's been boiled!" [No. 32, Nov. 9, 1901; issue on government-run orphanages and other welfare institutions]

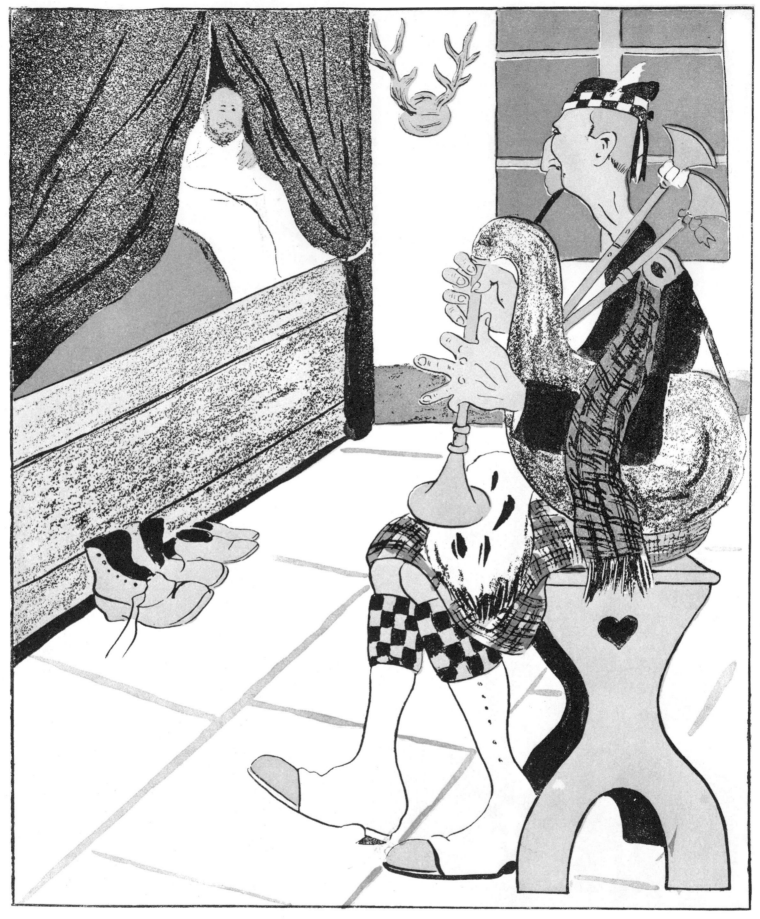

HOSPITALITÉ ÉCOSSAISE

— *Vous êtes vraiment trop aimable... mais dans ces cas là, la musique me produit un effet déplorable.*

d'Ostoya

SCOTTISH HOSPITALITY. "You are really most kind, but in these circumstances music has a terrible effect on me." [No. 194, Dec. 17, 1904; issue on "why they travel"]

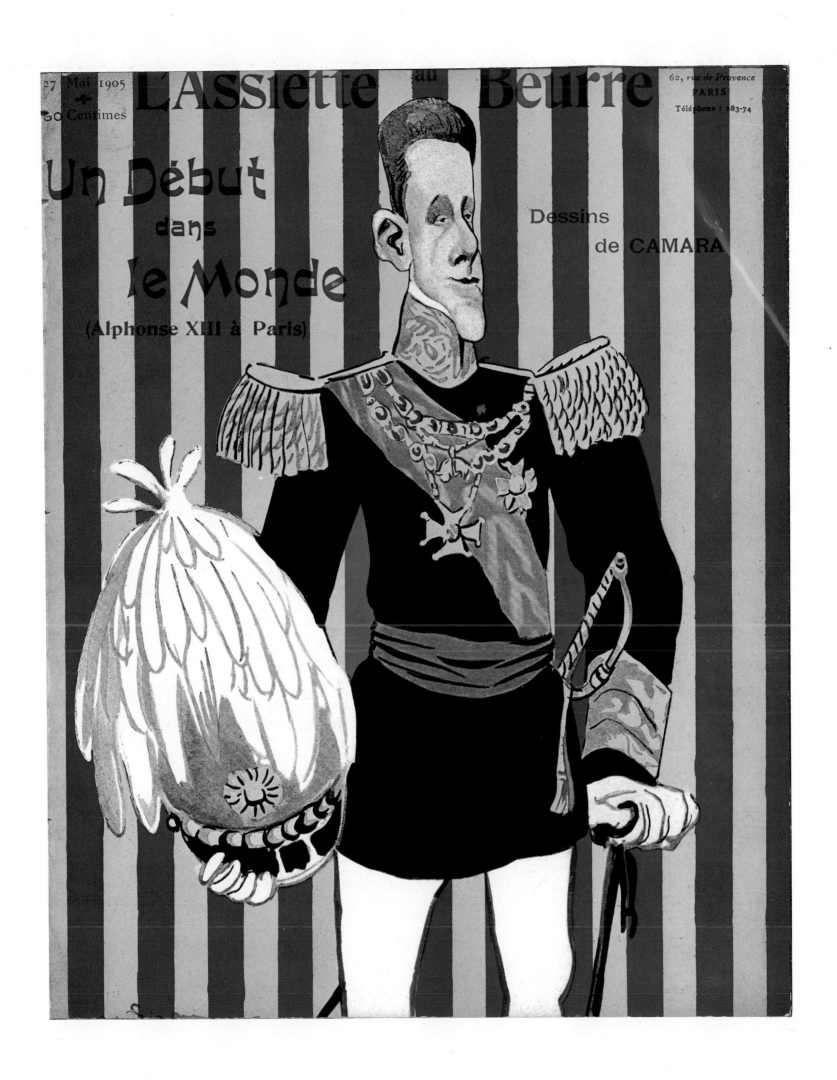

[Cover of No. 217, May 27, 1905; issue on the first visit to Paris by the young King Alfonso XIII of Spain]

Thomaz Leal da Camara [A]

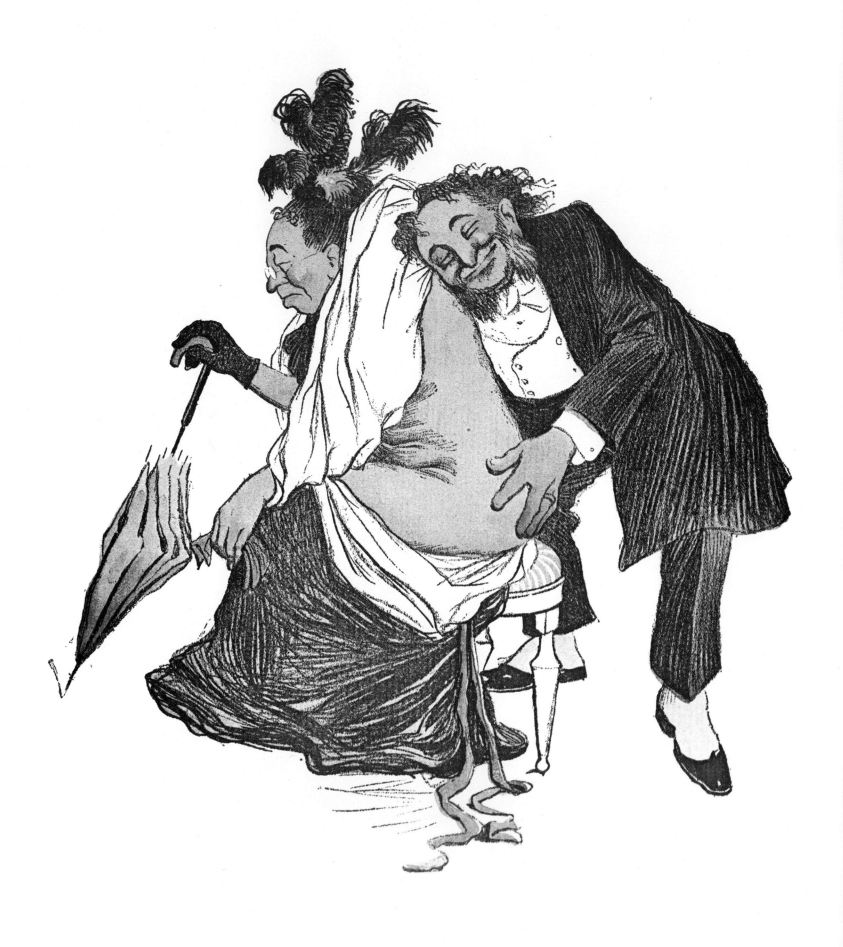

[B] *Abel Faivre* [From cover of No. 51, Mar. 22, 1902; issue on doctors]

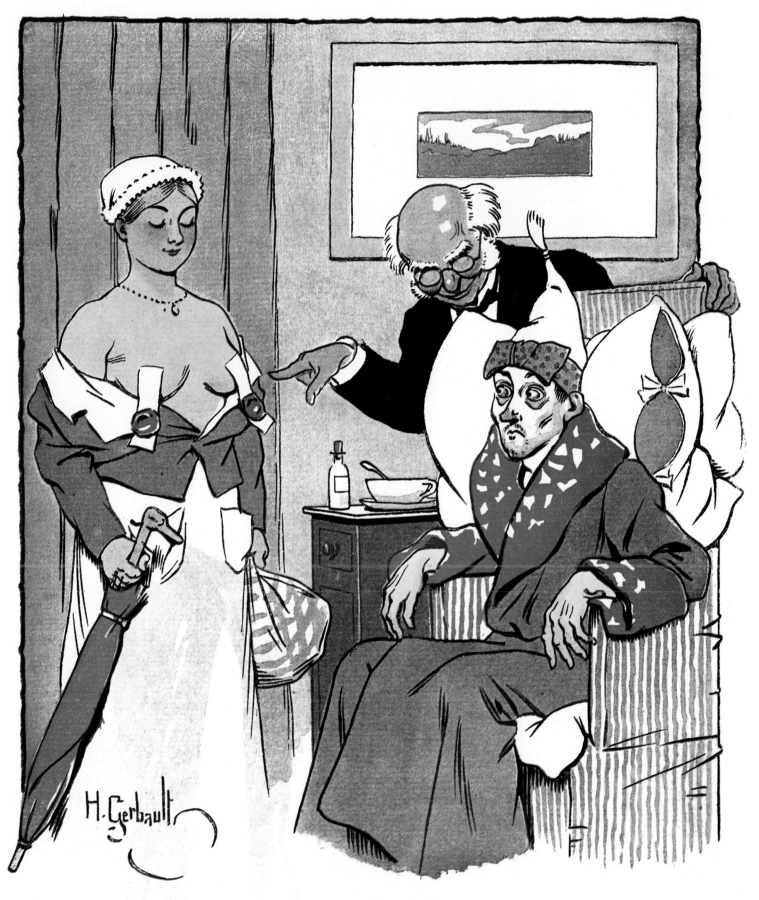

RÉGIME LACTÉ

— *Vous pouvez en prendre en toute sécurité, c'est du lait cacheté.*

MILK DIET. "You can drink it without any qualms, it's farm-sealed." [No. 46 *bis*, Feb. 1902; issue on an adulterated-milk scandal]

Henry Gerbault [C]

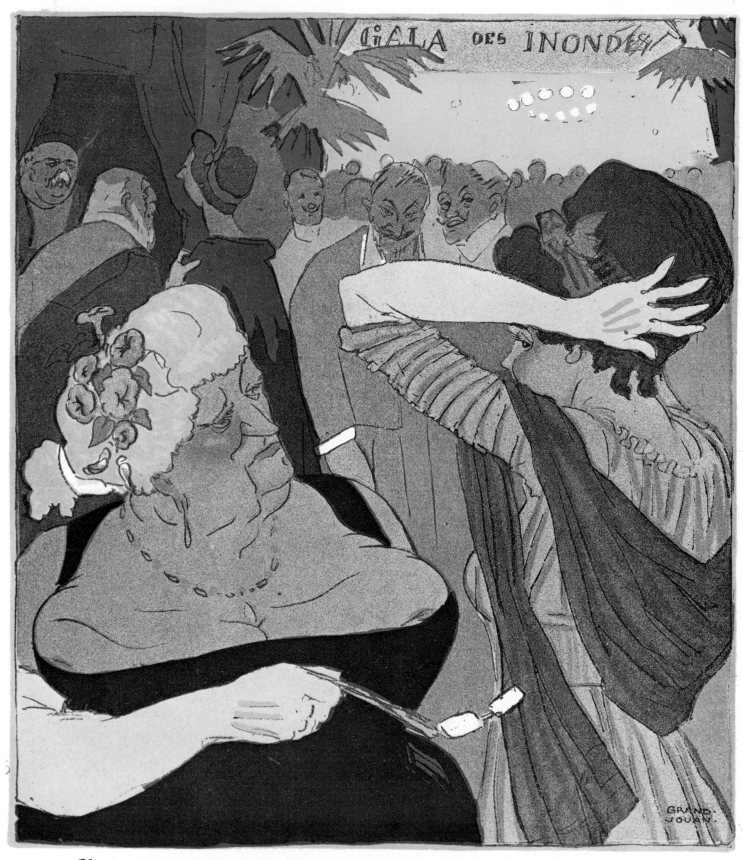

— *Maman, je t'avais bien dit de fermer ton décolleté !... Il y a un monsieur qui vient de dire :*
« *Jusqu'à la mère qui a eu un débordement !* »

[D] *Jules-Félix Grandjouan*

FLOOD-RELIEF GALA. "Mother, I told you to cover up your bosom! One man just said: 'Even her mother has overflowed her banks!'" [Cover of No. 465, Feb. 26, 1910; issue on charity balls]

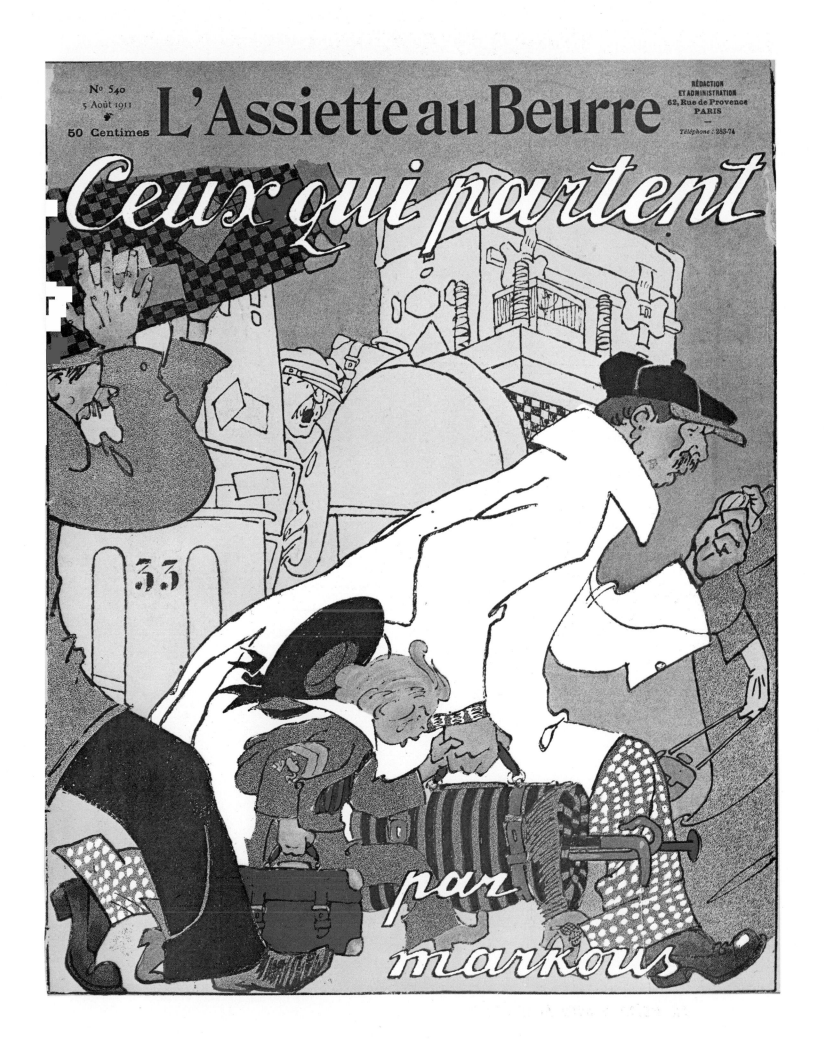

[Cover of No. 540, Aug. 5, 1911; issue on departures; "Markous"=Marcoussis] *Louis Marcoussis* *[E]*

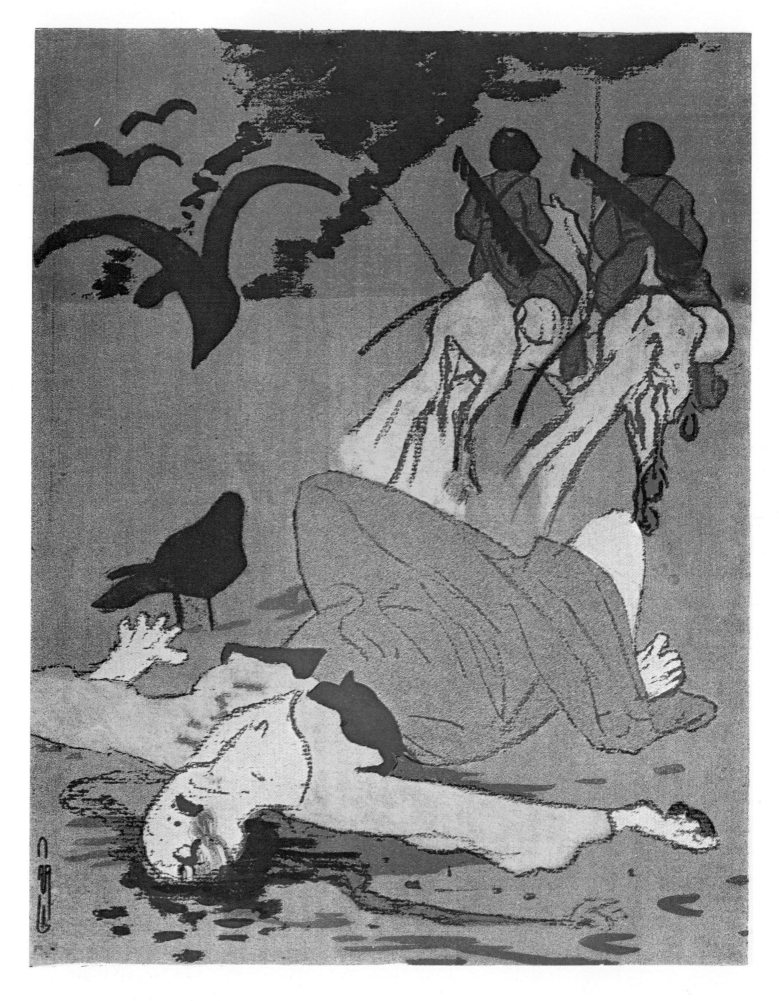

La Pologne sera heureuse.

Poland will be happy. [No. 251, Jan. 20, 1906; issue on ironic predictions for the year 1906]

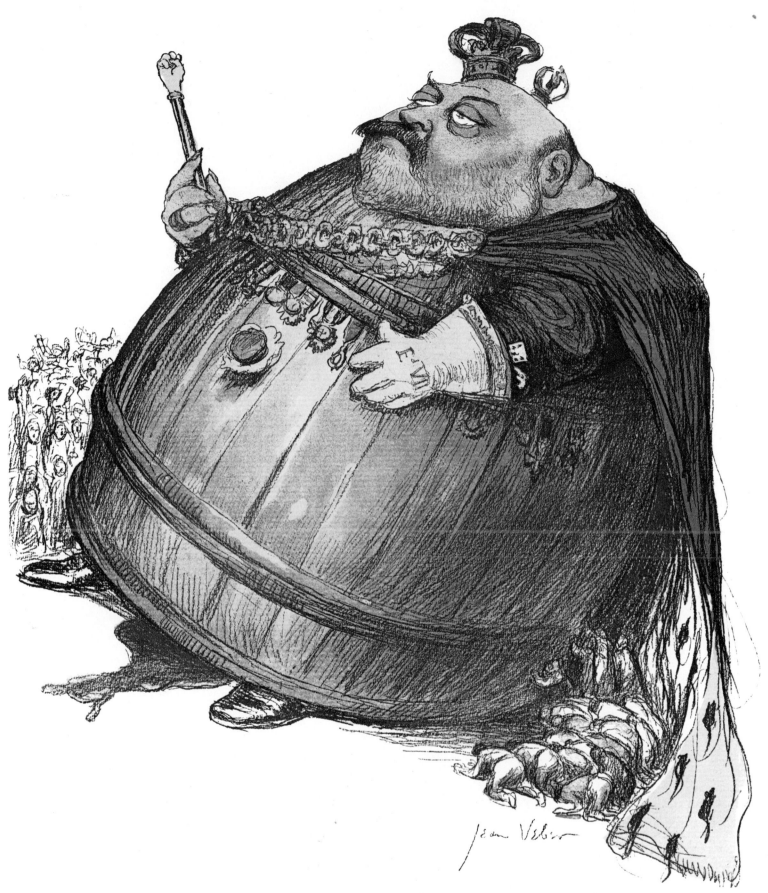

Le Foudre de Guerre

His Majesty Edward VII, King of England, Emperor of India; the Thunderbolt of War.
[No. 26, Sept. 28, 1901; issue on the Boer War concentration camps]

Jean Veber [G]

— On me demande un nouveau roman. Prenez mon premier livre, « La Bien-Aimée », appelez-le « Haine à mort », changez les dix premières et les dix dernières pages et envoyez-le-moi ce soir même.

"I've been asked for a new novel. Take my first book, *The Beloved Woman*, call it *Deadly Hatred*, change the first ten and the last ten pages, and send it to me not later than tonight." [No. 547, Sept. 23, 1911; issue on hack writers]

[H] Zyg (Brunner)

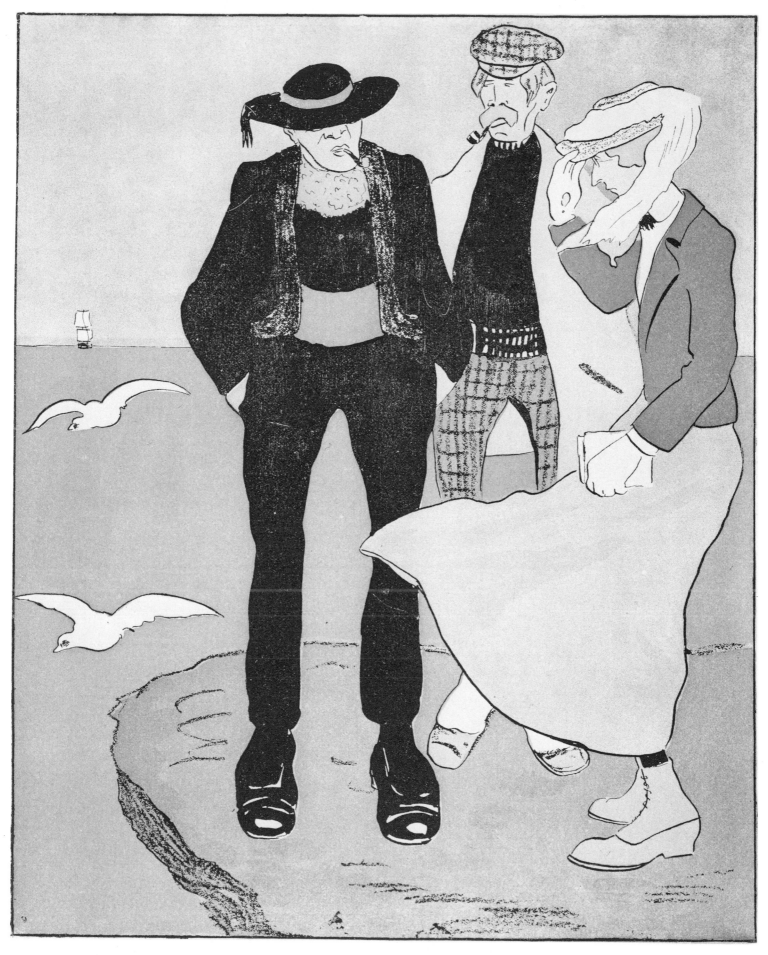

— *Un homme, en tombant de cette falaise, est allé s'aplatir contre les rochers.*
— *Aoh ! very well ! Combien demandez-vous pour faire le même chose devant nous ?...*

[BRETON:] "A man fell off this cliff and was crushed on the rocks below." [ENGLISH
TOURIST:] "Oh, very well! How much do you want to do the same thing in front of us?"
[No. 194, Dec. 17, 1904; issue on "why they travel"]

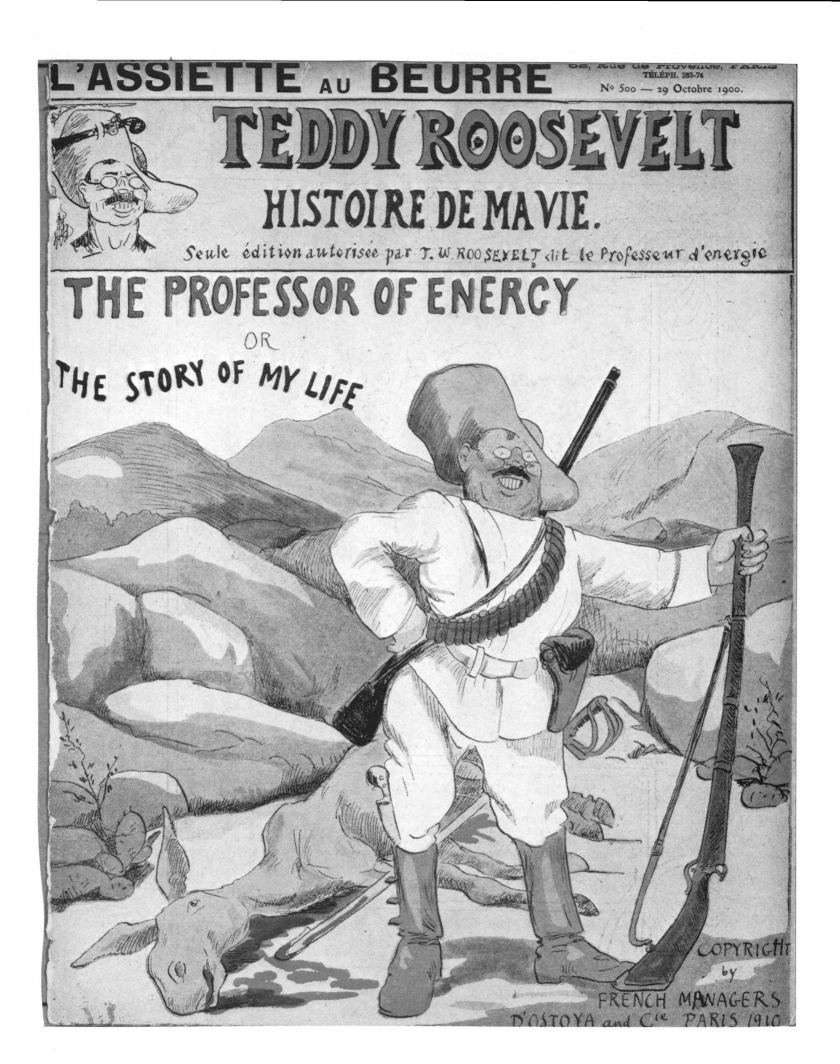

[Cover of No. 500, Oct. 29, 1910–not 1900 as printed; issue on mock autobiography of Theodore Roosevelt]

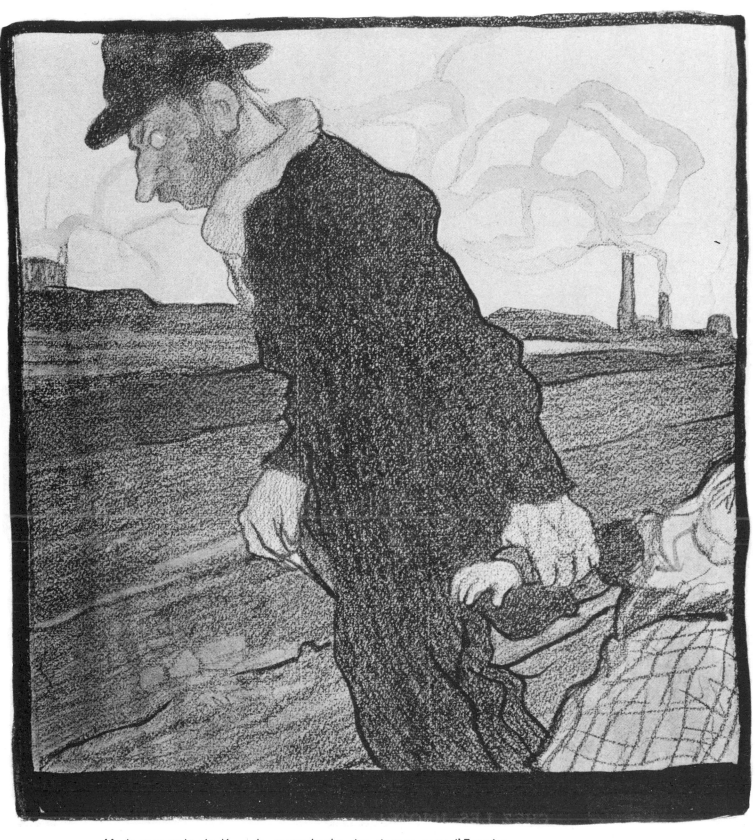

M· le marquis de X···, la coqueluche des dames sous l'Empire·

The Marquis X., darling of the ladies during the Empire [1852–1870; in his old age, he
has become a monster preying on children on the outskirts of town; No. 146, Jan. 16,
1904; issue titled "No Women Allowed Here"]

AU SEMINAIRE

— *Monsieur, on a trouvé une jarretière dans votre malle.*

IN THE SEMINARY. "Sir, a lady's garter has been found in your trunk." [No. 146, Jan. 16, 1904; issue titled "No Women Allowed Here"]

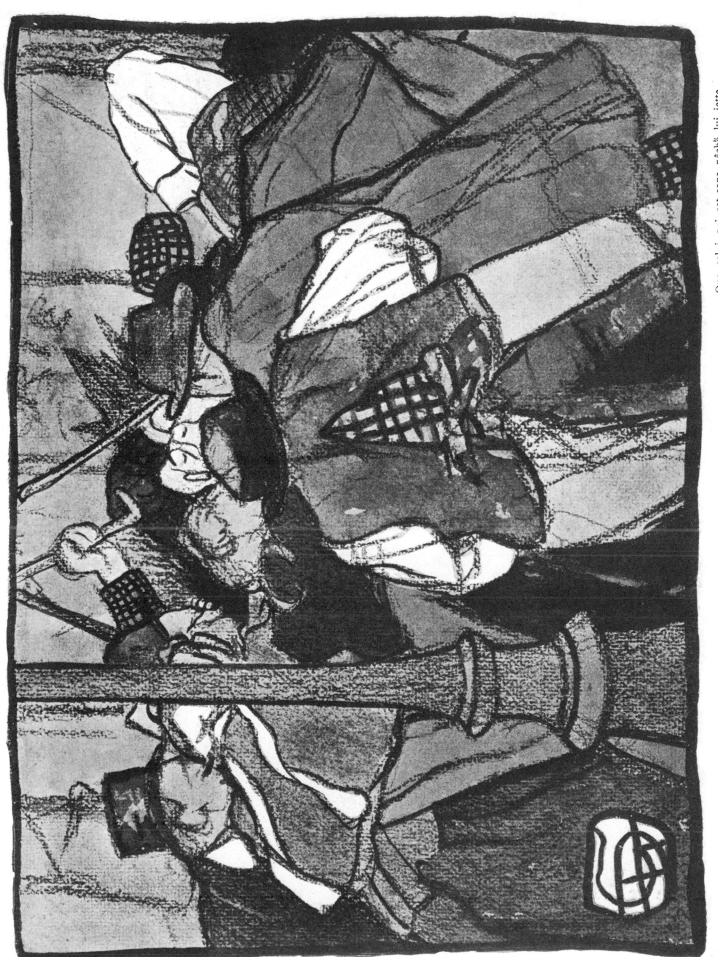

LE VOLEUR

« Que celui qui est sans péché lui jette la première pierre.» *Jésus.*

THE THIEF. "Let him amongst you that is without sin cast the first stone": Jesus. [No. 153, Mar. 5, 1904; issue on crowds]

Georges Dupuis 23

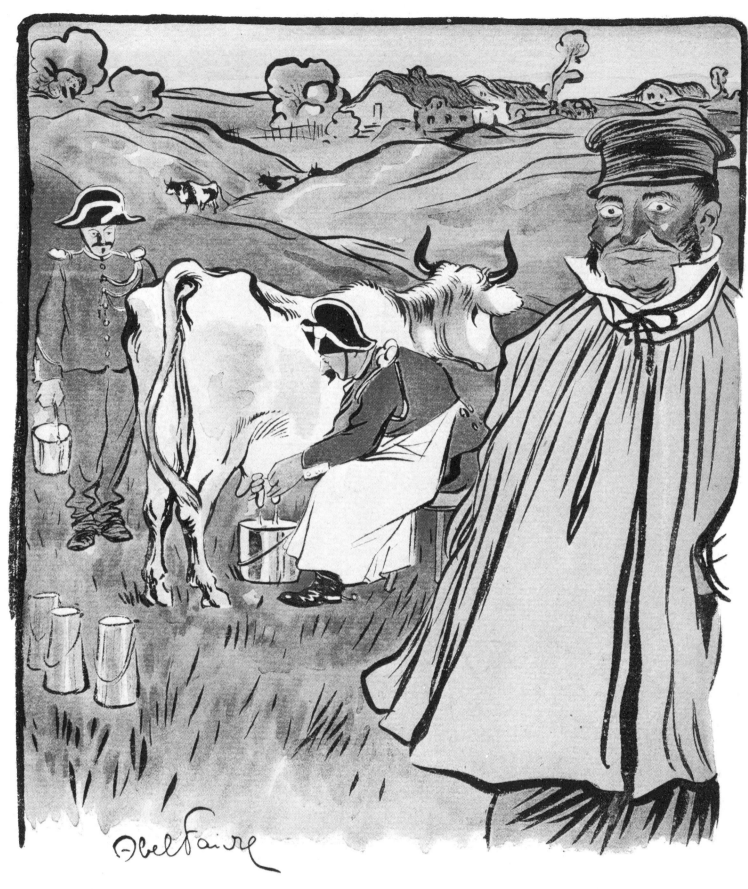

— Il ne nous reste plus qu'à falsifier les vaches!

[THE FARMER:] "All we can do now is adulterate the cows!" [since the rural constabulary is doing the milking and protecting the purity of the product; No. 46 *bis*, Feb. 1902; issue on an adulterated-milk scandal]

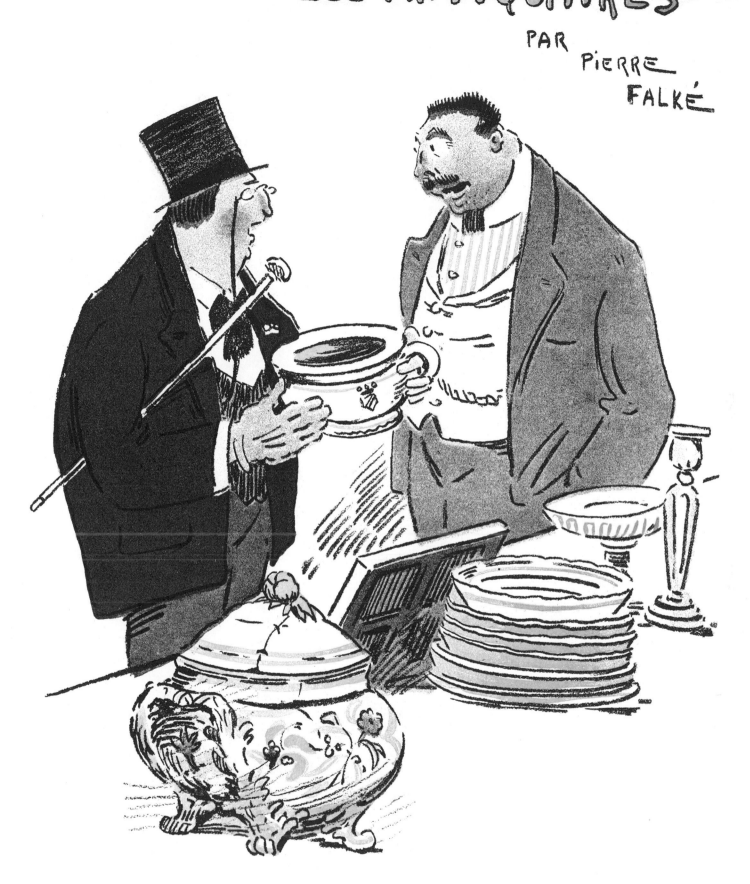

LES ANTIQUAIRES
PAR Pierre FALKÉ

— *Je ne vous l'avais pas garanti ancien, je vous ai simplement dit qu'il avait appartenu à Marie-Antoinette.*

"I didn't guarantee it was an antique; I merely said it belonged to Marie Antoinette."
[Cover of No. 543, Aug. 26, 1911; issue on antique dealers]

Pierre Falké 25

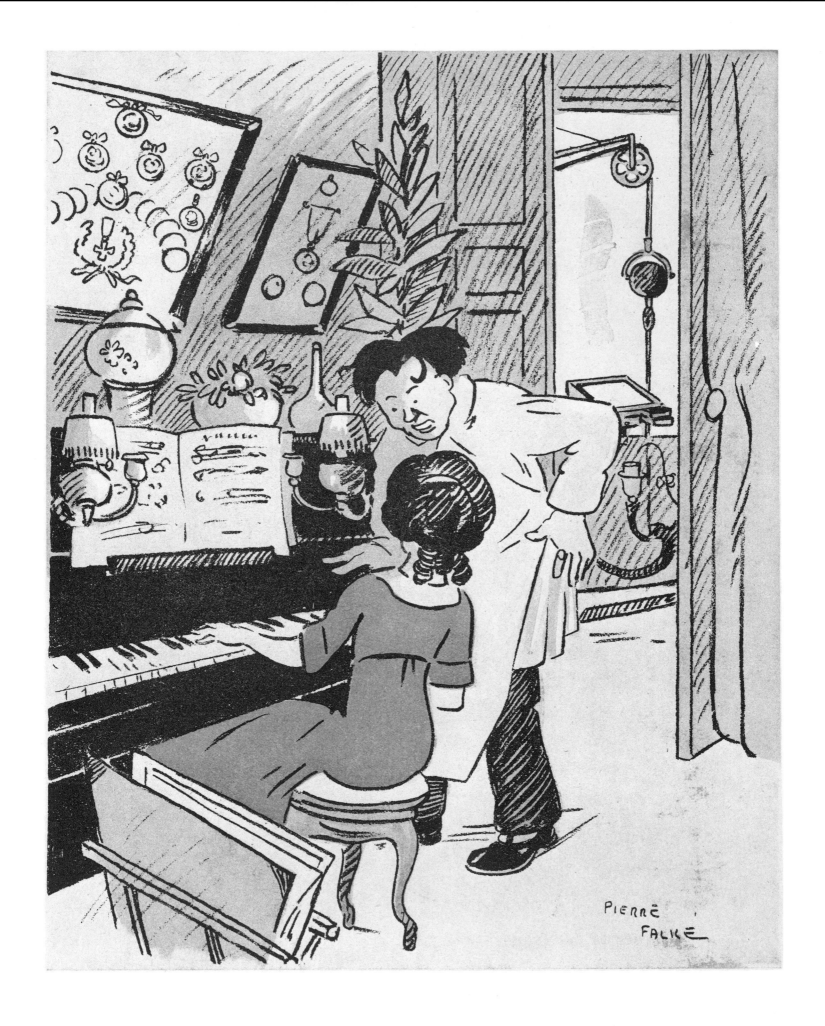

— *Dès qu'un client gueule, vous attaquez du Wagner pour que les autres ne l'entendent pas !*

"As soon as a patient begins to scream, start playing Wagner so the others don't hear!"
[No. 567, Feb. 24, 1912; issue on dentists]

LE PROFESSEUR DE MUSIQUE.
Professeur d'accompagnement et maître de doigté. La leçon de chant finit d'habitude par un cours de chantage.

THE MUSIC TEACHER. Teaches accompaniment; a master of fingering. The singing *[chant]* lesson usually ends with a course on blackmail *[chantage]*. [No. 122, Aug. 1, 1903; issue on monsters and satyrs]

LES LARBINS DE TROIS ANS

La colonelle déménage.

THE THREE-YEARS' SERVANTS [conscripted soldiers used for private purposes].
The colonel's wife is moving. [No. 165, May 28, 1904; issue on domestic servants]

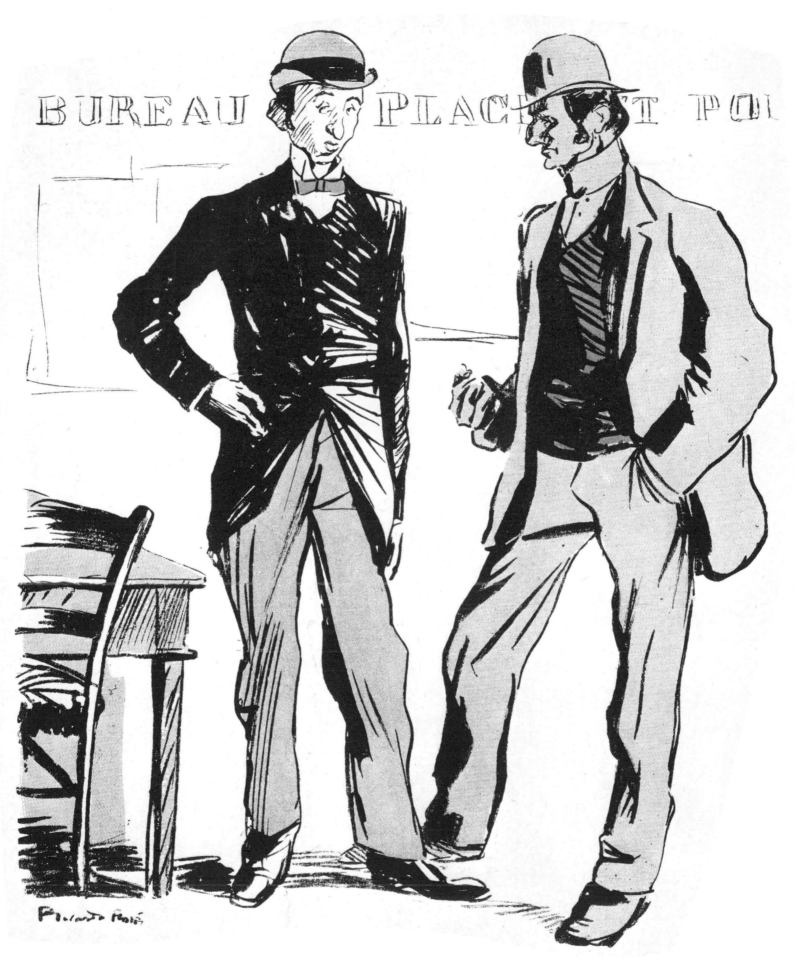

— La place était trop éreintante … La baronne était folle de moi.

[THE SERVANT, IN AN EMPLOYMENT OFFICE:] "The job was too exhausting. The Baroness was mad about me." [No. 165, May 28, 1904; issue on domestic servants]

Ricardo Florès 29

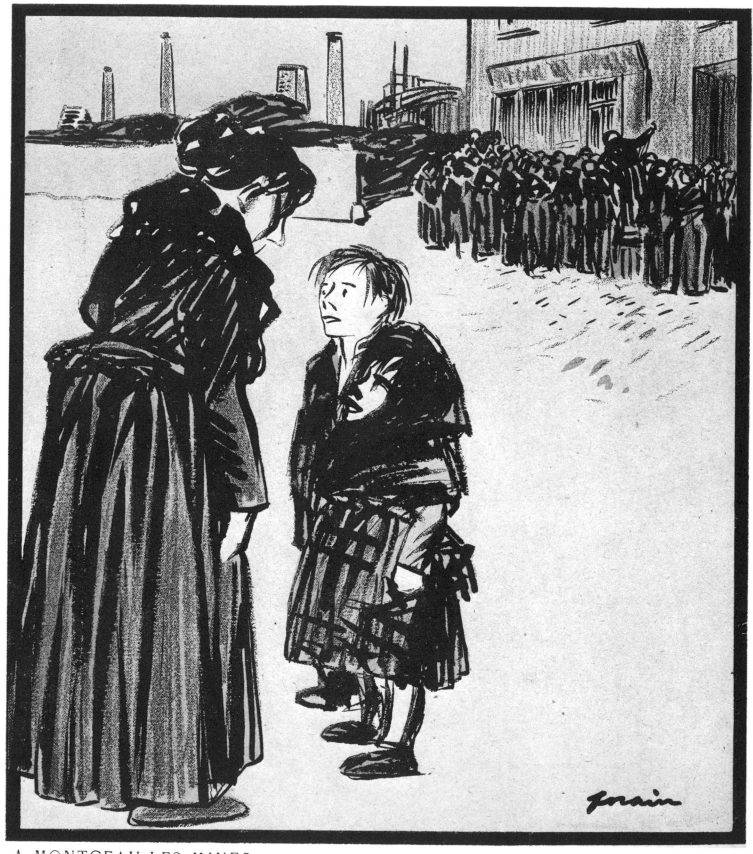

A MONTCEAU-LES-MINES
— VOILÀ DEUX HEURES QUE J'VOUS APPELLE !
— MAMAN, NOUS ÉTIONS EN FACE... ON R'GARDAIT MANGER L'DÉPUTÉ.

AT MONTCEAU-LES-MINES [in a depressed mining region]. "I've been calling you for two hours!" "Mama, we were across the way—we were watching the Deputy eat." [Cover of No. 2, Apr. 11, 1901]

MODESTIE

...ET PUIS ELLE NE VOUS DIT PAS TOUT... C'EST ELLE QUI A FERMÉ LES YEUX A MON ONCLE.

MODESTY. "And she's still not telling you everything . . . It was she who closed my uncle's eyes when he died." [No. 3, Apr. 18, 1901]

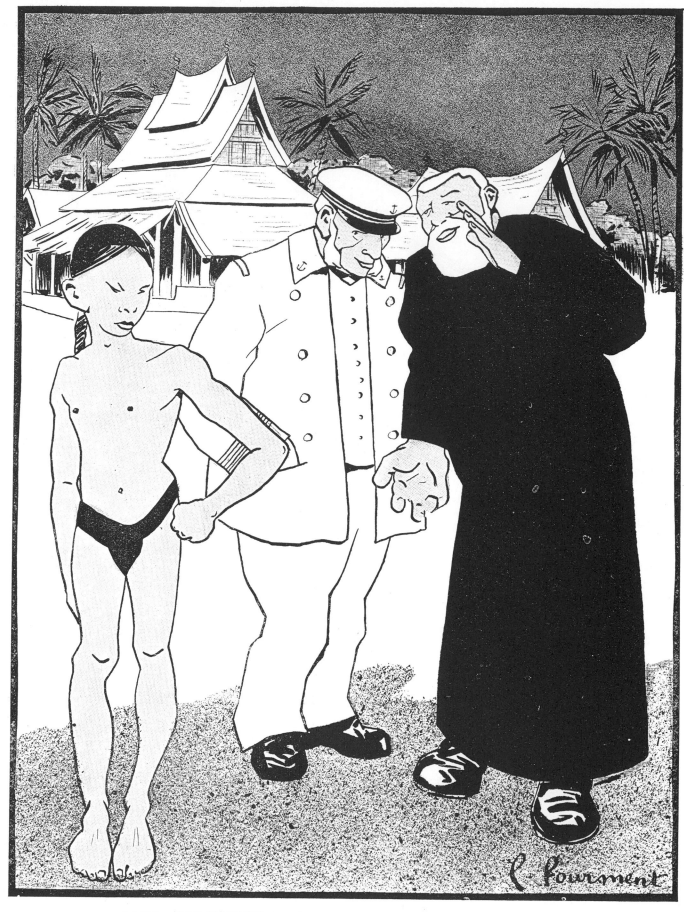

AUX COLONIES

LE BON PÈRE. — Celui-là... cinquante francs... mais, vous savez, on en fait tout ce qu'on veut... c'est moi qui l'ai dressé.

IN THE COLONIES. THE GOOD FATHER: "That one . . . fifty francs . . . but you know, you can do whatever you want with him . . . I trained him myself." [No. 237, Oct. 14, 1905; issue on the navy]

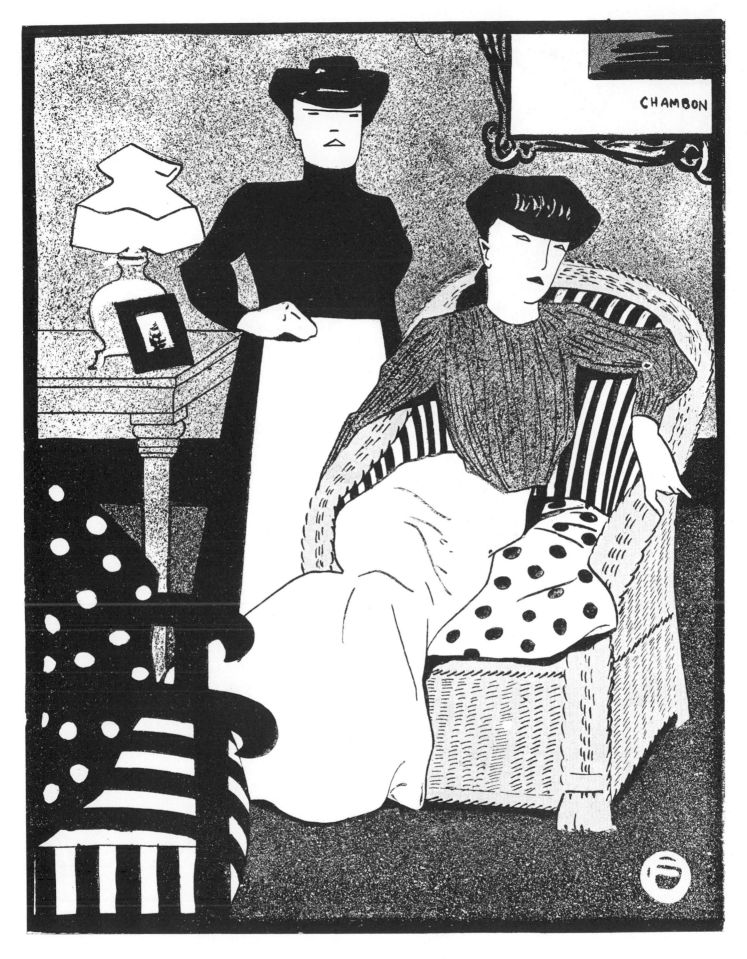

LES GENS DE MAISON

— Mademoiselle s'ennuie ?... Qu'elle fasse comme Madame : qu'elle prenne un amant !

THE HOUSEHOLD STAFF. "Bored, Miss? Why not do what your mother does: take a lover!" [No. 253, Feb. 3, 1906; issue on "the great educators"]

Léon Fourment 33

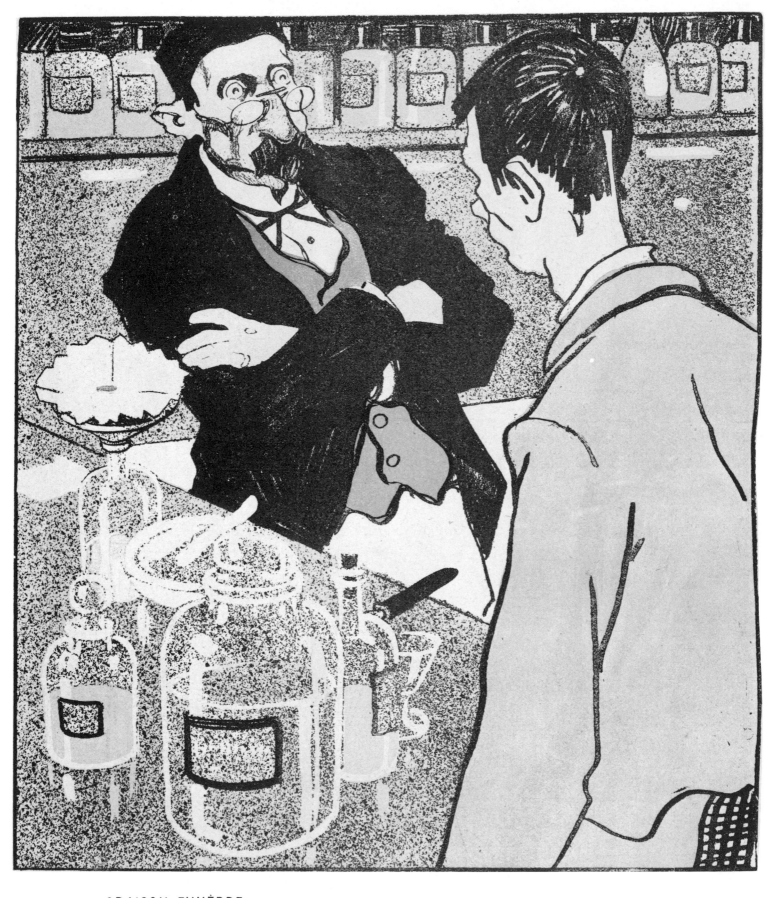

ORAISON FUNÈBRE.

— *Ne pouvait-il pas mourir une heure plus tard!.. Il me laisse une ordonnance de 32 francs 80 sur les bras!*

FUNERAL ORATION. "Why couldn't he die one hour later? Now he's left me with a prescription on my hands worth 32 francs and 80 centimes!" [No. 107, Apr. 18, 1903; issue on pharmacists]

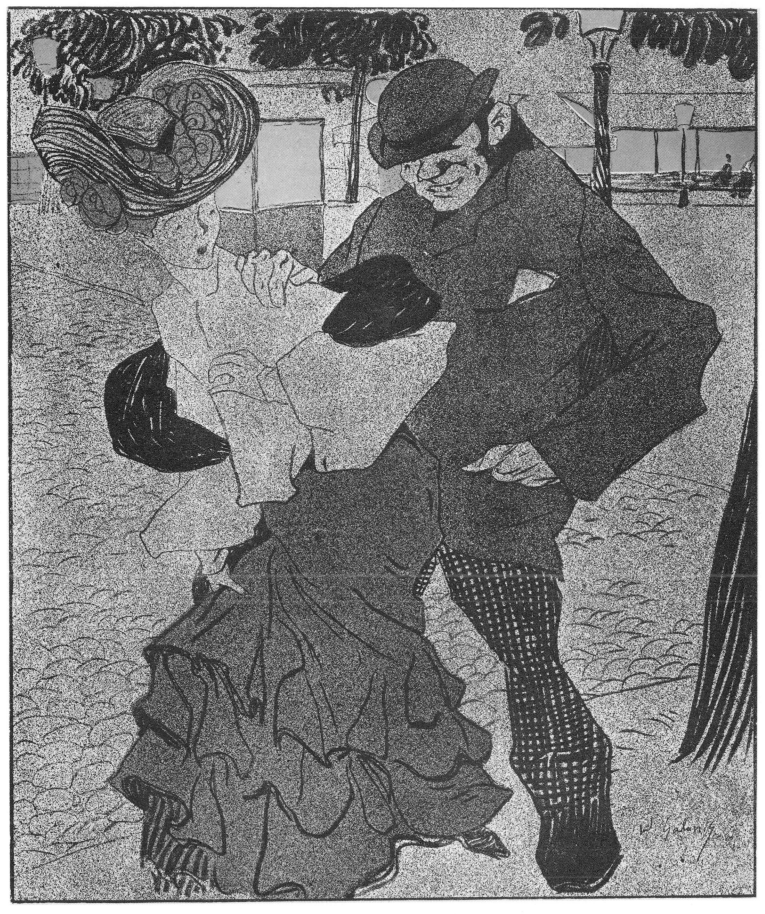

— Mais, monsieur, je suis une honnête femme !...
— C'est ce que nous verrons à la visite !

"But, sir, I'm an honest woman!" "That's what we'll see at the medical examination!"
[No. 113, May 30, 1903; issue on the abuses of the vice-squad plainclothesmen; apparently the sister or fiancée of a Parisian journalist had just been mistakenly apprehended]

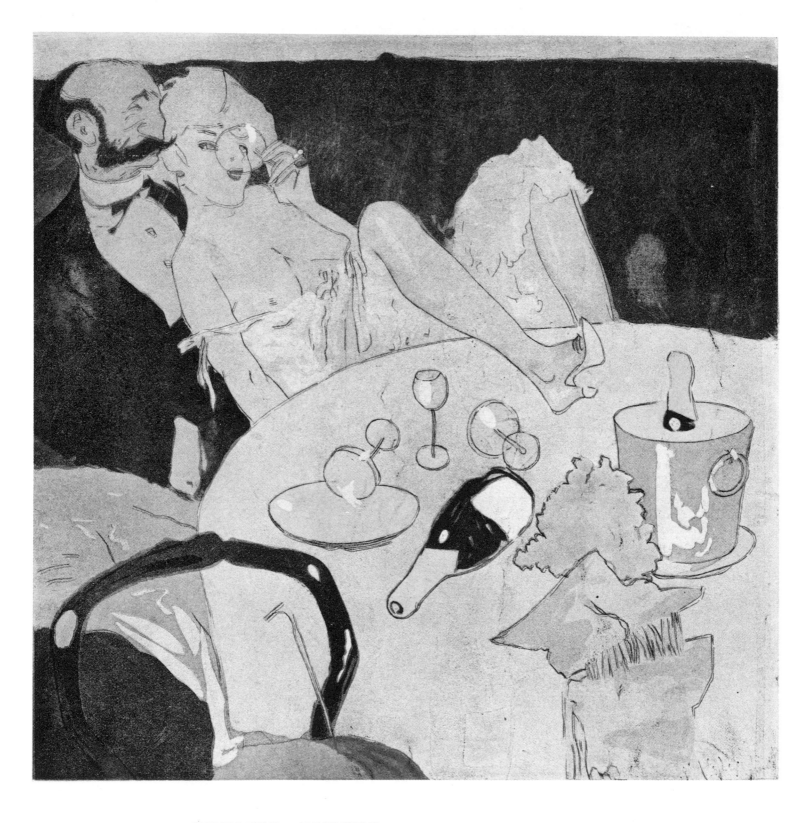

PRINCES RUSSES

— *Donc déjà, petit bébé, la bombe, ça nous connaît!*

Dimitrios Galanis

RUSSIAN PRINCES. "Listen, baby, my kind is well acquainted with *la bombe* [means 'spree' and 'bomb']!" [No. 220, June 17, 1905; issue on night life]

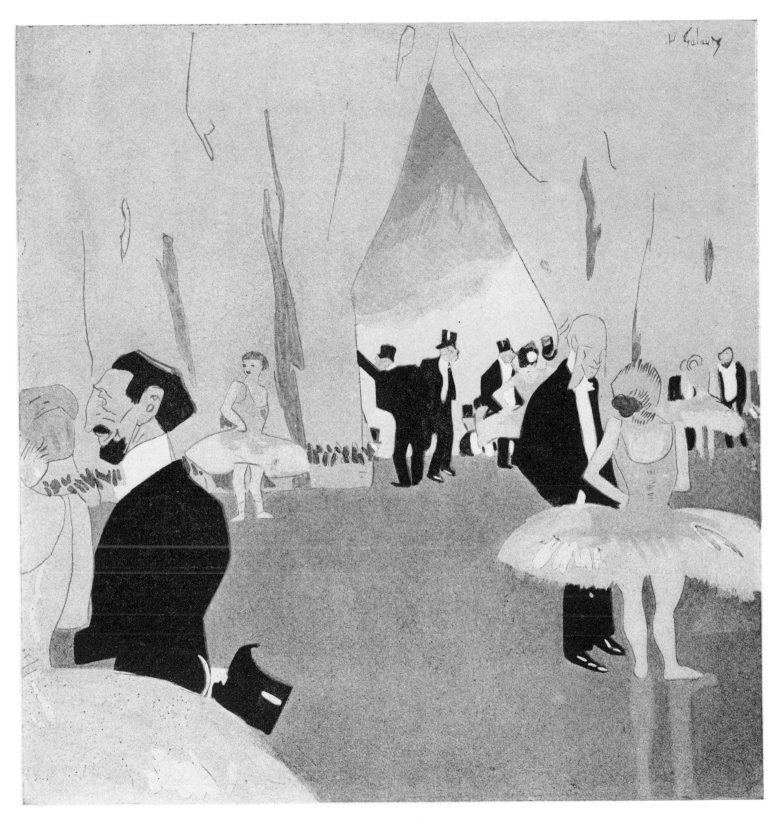

AU FOYER DE LA DANSE

— *On ne vous as pas vu, la semaine dernière...*
— *Pas pu venir... Très pris... Beaucoup de dîners de famille : j'ai enterré ma femme.*

IN THE BALLET GREENROOM. "We didn't see you last week." "Couldn't make it
. . . Tied up . . . Lot of family dinners: I buried my wife." [No. 220, June 17, 1905;
issue on night life]

Dimitrios Galanis 37

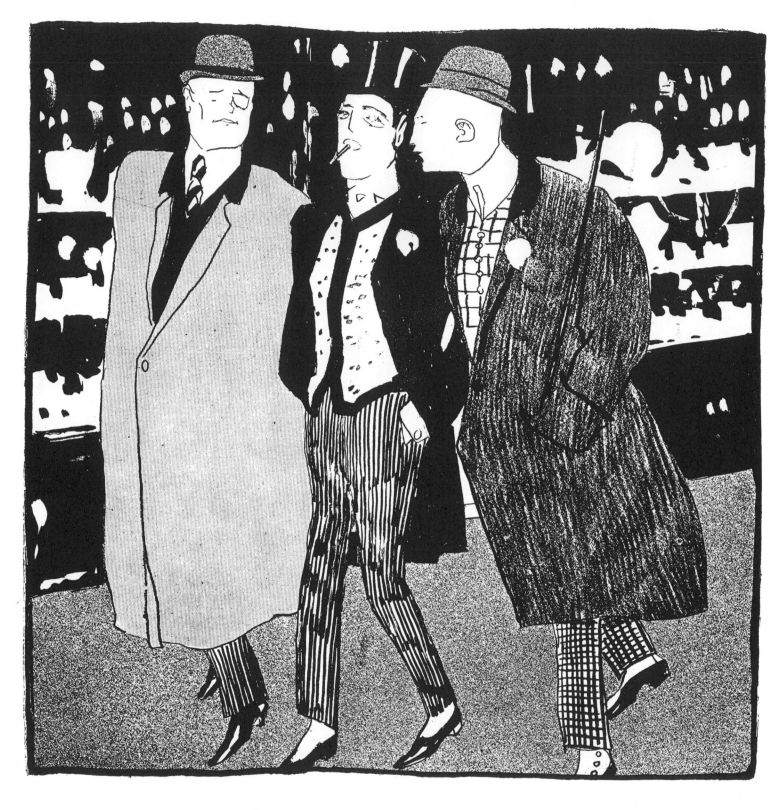

GRAND CHIC (Côté des hommes)

— ... *et puis, un homme qui achète ses cravates au Louvre ne peut être qu'un voyou !*

HIGH FASHION: FOR MEN. "... And then, a man who buys his neckties in a department store can't be anything but a hooligan!" [No. 285, Sept. 15, 1906; issue on the Rue de la Paix]

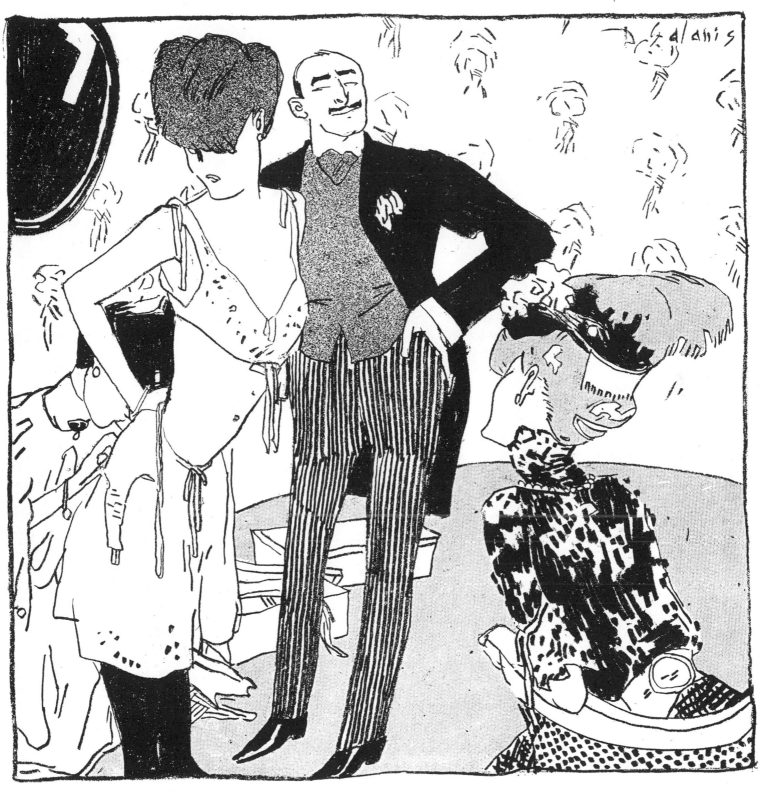

GRAND CHIC (Côté des dames)

— *600 francs, c'est peut-être un peu cher, pour un corset... Mais songez qu'il vient de la rue de la Paix!...*

HIGH FASHION: FOR WOMEN. "600 francs may be a little high for a corset—but keep in mind that it comes from the Rue de la Paix!" [No. 285, Sept. 15, 1906; issue on the Rue de la Paix]

Dimitrios Galanis 39

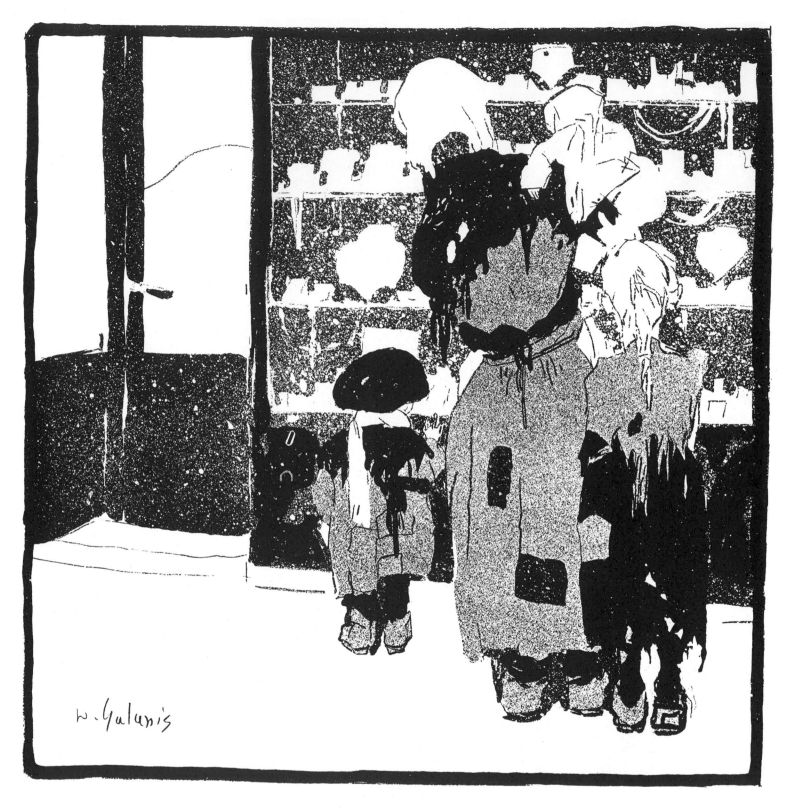

LES ÉTALAGES

— *Dire qu'avec une de ces bagues-là, on pourrait se payer du pain pour le restant de ses jours !*

THE WINDOW DISPLAYS. "Just imagine, with one of those rings you could buy bread for the rest of your life!" [No. 285, Sept. 15, 1906; issue on the Rue de la Paix]

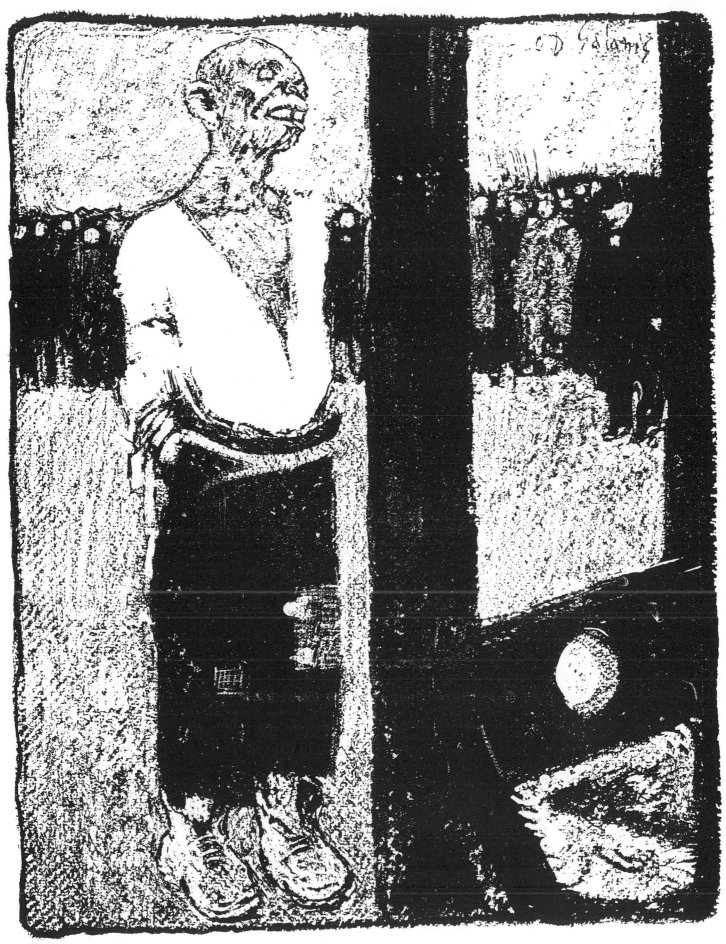

IL FAUT GUILLOTINER, PARCE QUE...

la Société doit être vengée... par la mort d'une brute, d'un fou ou d'un idiot...

WE MUST GO ON GUILLOTINING BECAUSE . . . Society must be avenged—by the death of a dumb brute, a madman or an idiot . . . [No. 310, Mar. 9, 1907; issue on capital punishment]

Dimitrios Galanis 41

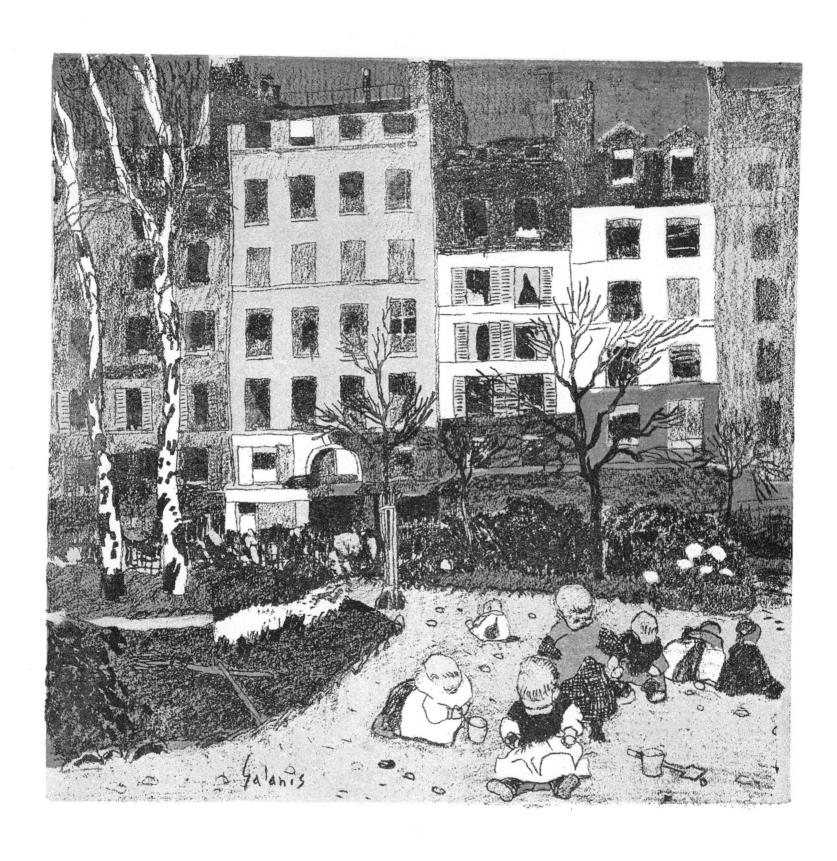

[No. 299, Dec. 22, 1906; issue titled "The Son of Man"; the life of a poor Frenchman is narrated in such a way as to parallel the life of Christ; here, he is a child growing up in a slum neighborhood]

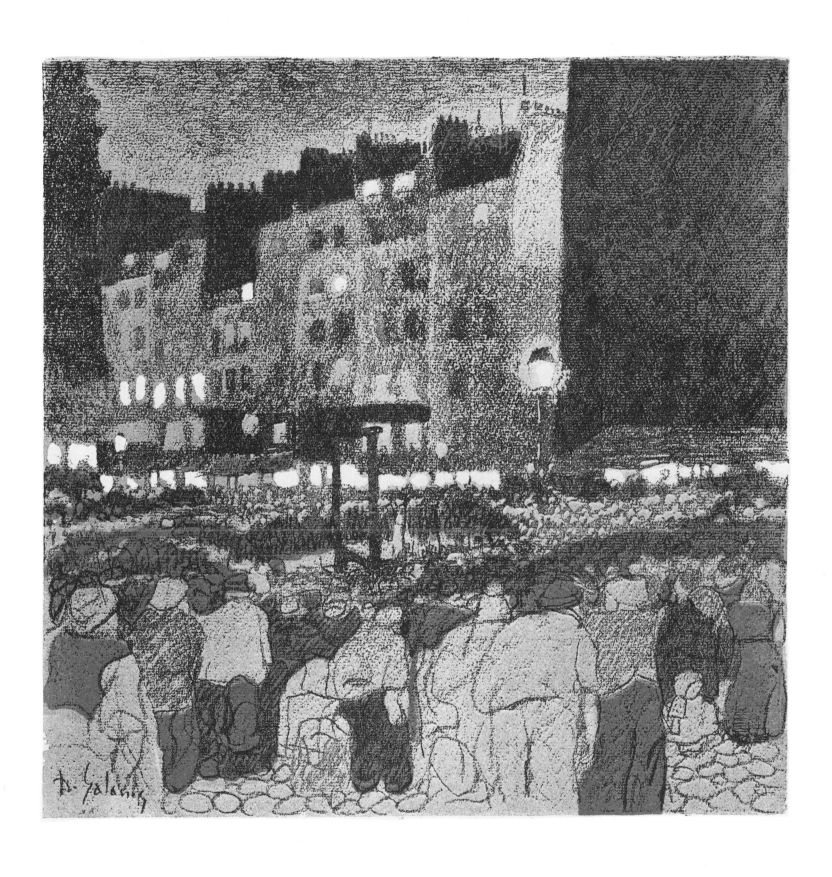

[No. 299, Dec. 22, 1906; "The Son of Man"; here, after his unbending spirit has led him into revolutionary agitation, he is guillotined]

Dimitrios Galanis 43

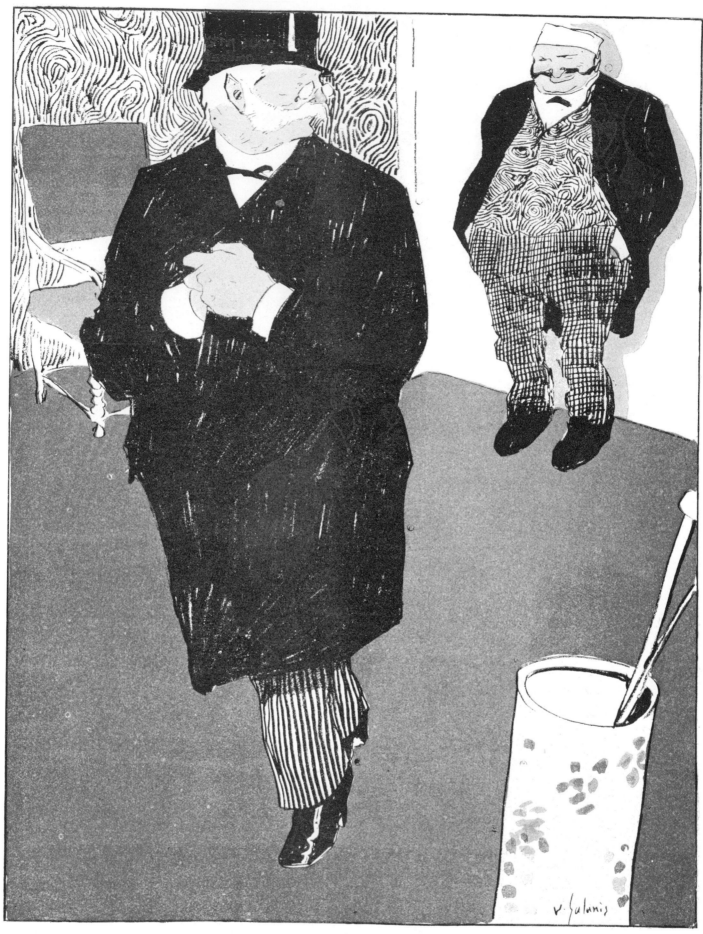

LE DOCTEUR. — Et surtout pas de soucis, pas d'imprudences, pas d'opérations à la Bourse!
LE BANQUIER. — Compris, docteur!... Vous me conseillez de ménager ma bourse pour vos opérations.

Dimitrios Galanis

THE DOCTOR: "And above all, no worries, no rash moves, no Stock Exchange [*Bourse*] operations!" THE BANKER: "I understand, Doctor! You advise me to save my purse [*bourse*] for *your* operations." [No. 187, Oct. 29, 1904; issue on extortioners]

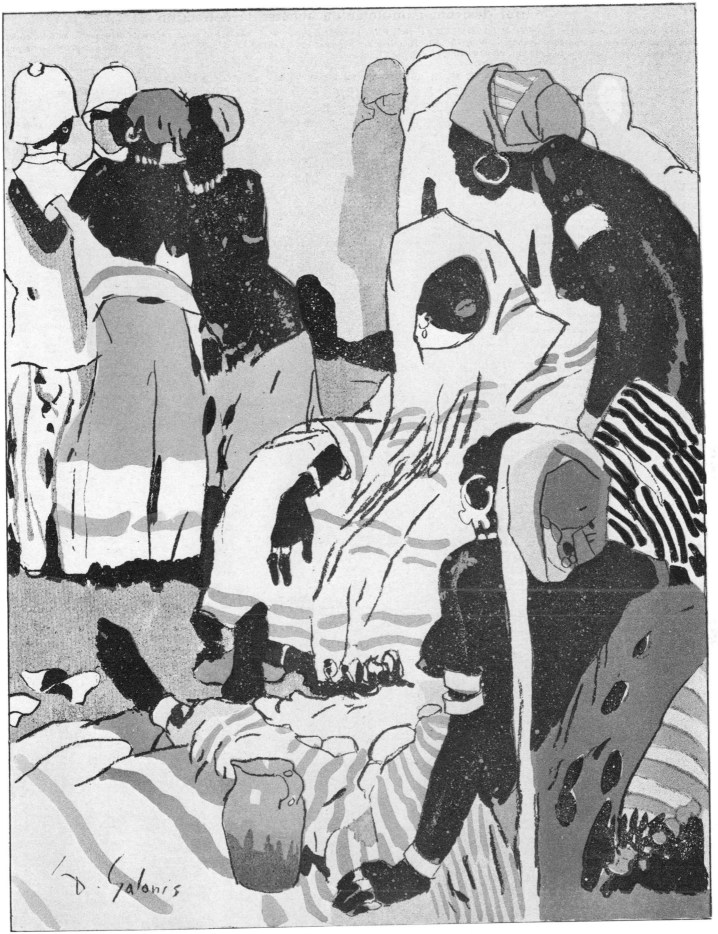

POUR PROTÉGER LA MORALE

Sur les instances de Monsieur Bérenger, des maisons closes seront créées, où l'on observera stricte-ment le principe de la Pénétration Pacifique et de la Porte ouverte.

TO PROTECT PUBLIC MORALS. On the insistence of Senator Bérenger [the self-appointed censor of the era], brothels will be established, where the principles of Peaceful Penetration and the Open Door [diplomatic slogans of the day] will be strictly observed. [No. 335, Aug. 31, 1907; issue titled "Let's Civilize Morocco"]

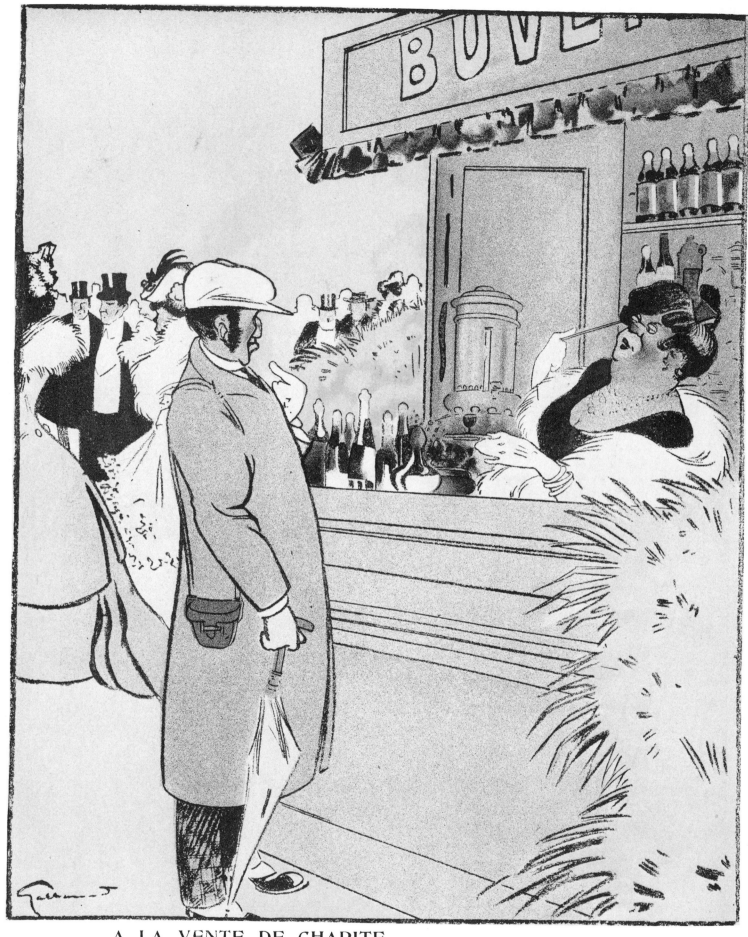

A LA VENTE DE CHARITE

LA BARONNE. — *Ça coûte cent francs, parce que j'y ai goûté.*

L'ANGLAIS. — *Je paierai cent cinquante, mais je voulais un verre propre !*

AT THE CHARITY BAZAAR. THE BARONESS: "That will be a hundred francs because I have tasted it." THE ENGLISHMAN: "I'll give you a hundred fifty, but I want a clean glass!" [No. 280, Aug. 11, 1906; issue on "humanitarians"]

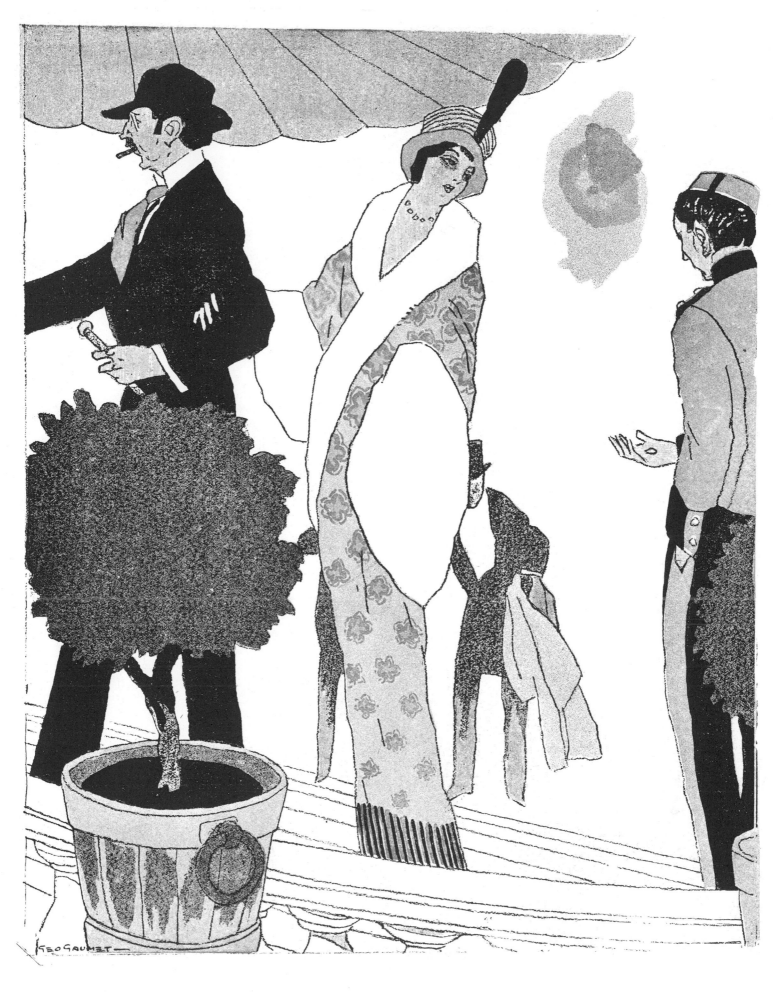

— Gare au lapin ! Y m'a refilé juste dix ronds.

"Don't let that character bilk you! He slipped me only a dime." [No. 589, Aug. 4, 1912; issue on bellhops]

— J'vous dis qu'il ne viendra pas... c'est un lapin... j'm'y connais... c'est moi le chasseur!

"I tell you he won't come . . . he's stood you up . . . I know all about such things . . . I'm the bellhop!" [No. 589, Aug. 4, 1912; issue on bellhops]

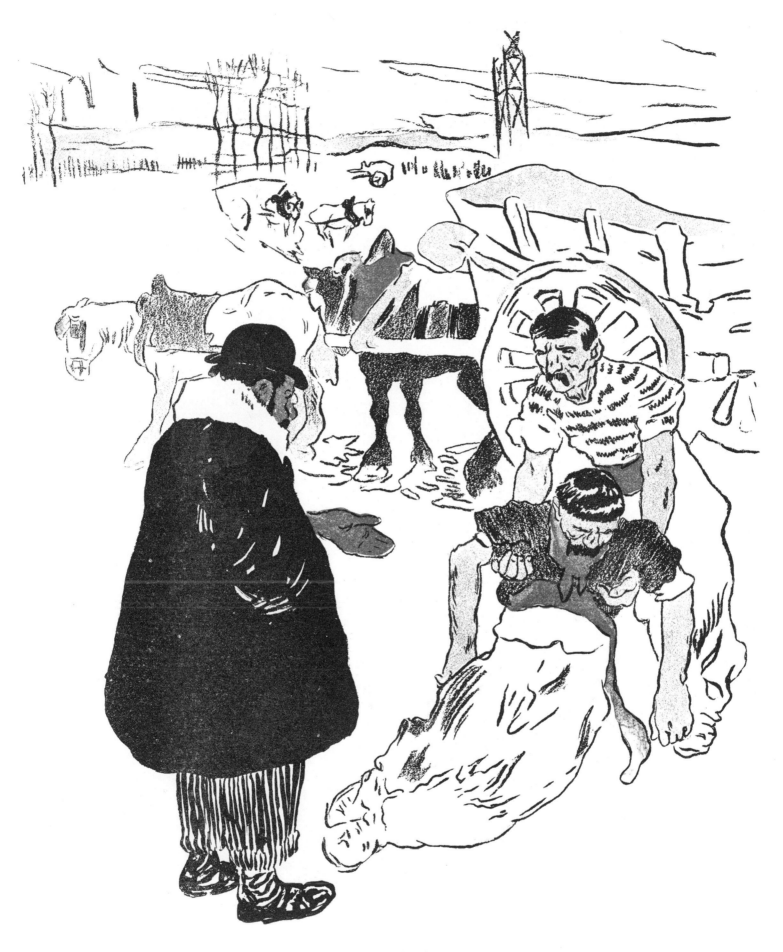

— Ça tombe de faiblesse et ça veut travailler !

"He's too weak to stand up and he wants to work!" [No. 159, Apr. 16, 1904; issue on contractors]

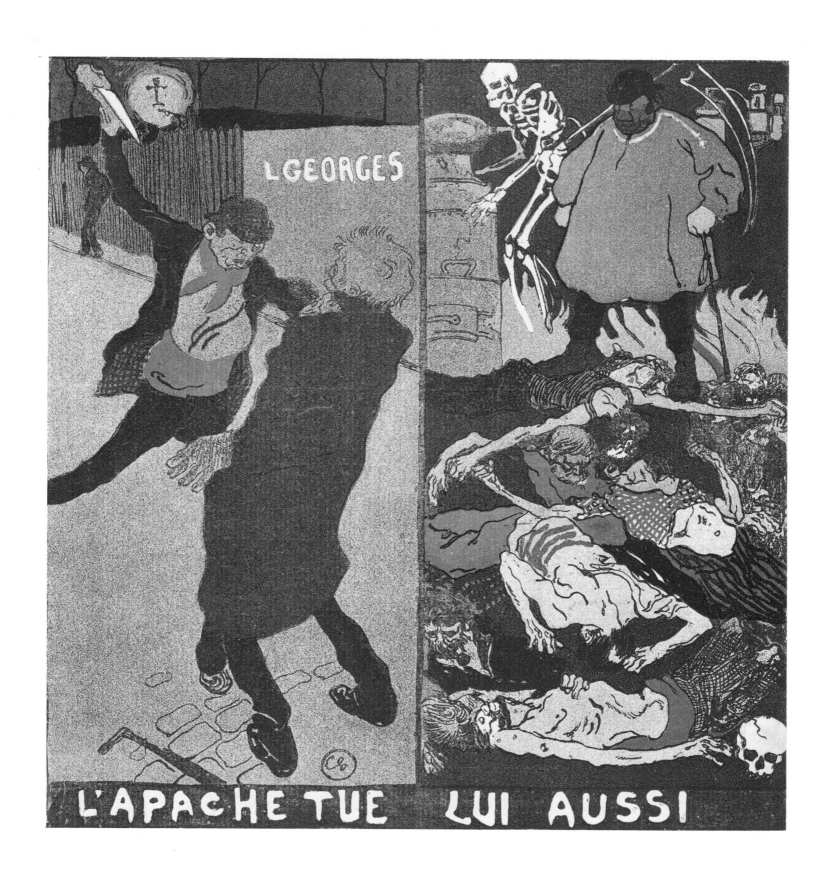

L.GEORGES

L'APACHE TUE LUI AUSSI

The apache [Parisian thug] kills. So does he. [Cover of No. 98, Feb. 14, 1903; issue on moonshiners]

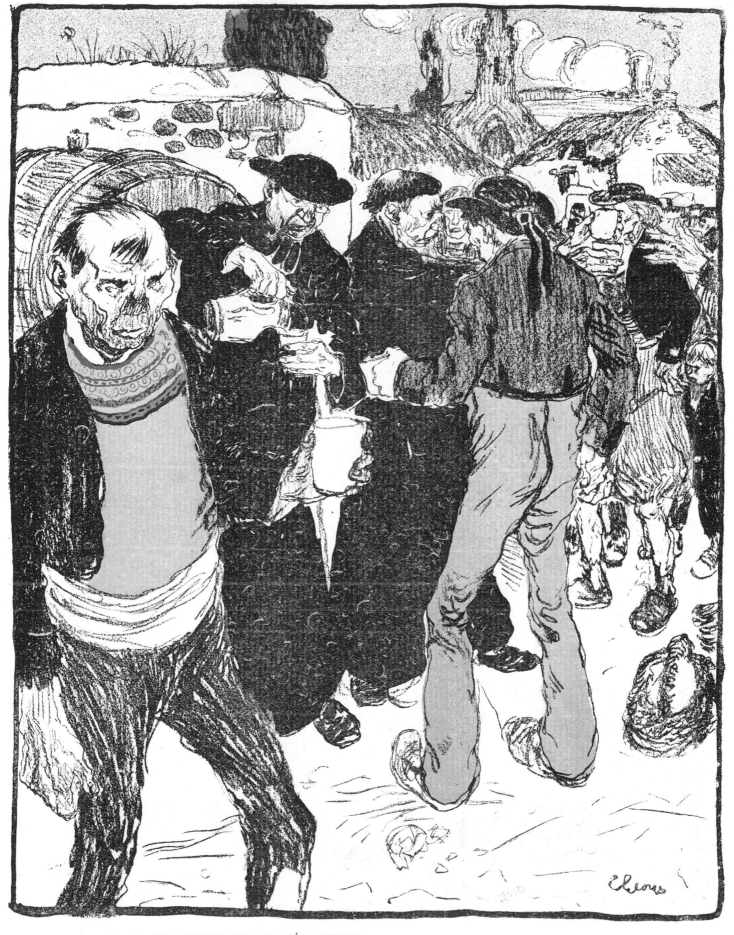

A M. DE CUVERVILLE, SÉNATEUR

« *L'alcool est la base de la grandeur de la foi religieuse en Bretagne* ».

(Renseignement fourni par la Régie, *séance du Sénat, 30 octobre 1902.*)

TO SENATOR DE CUVERVILLE. "Alcohol is the basis of the strength of religious faith in Brittany" (information supplied by the Excise Department in the Senate session of Oct. 30, 1902). [No. 98, Feb. 14, 1903; issue on moonshiners]

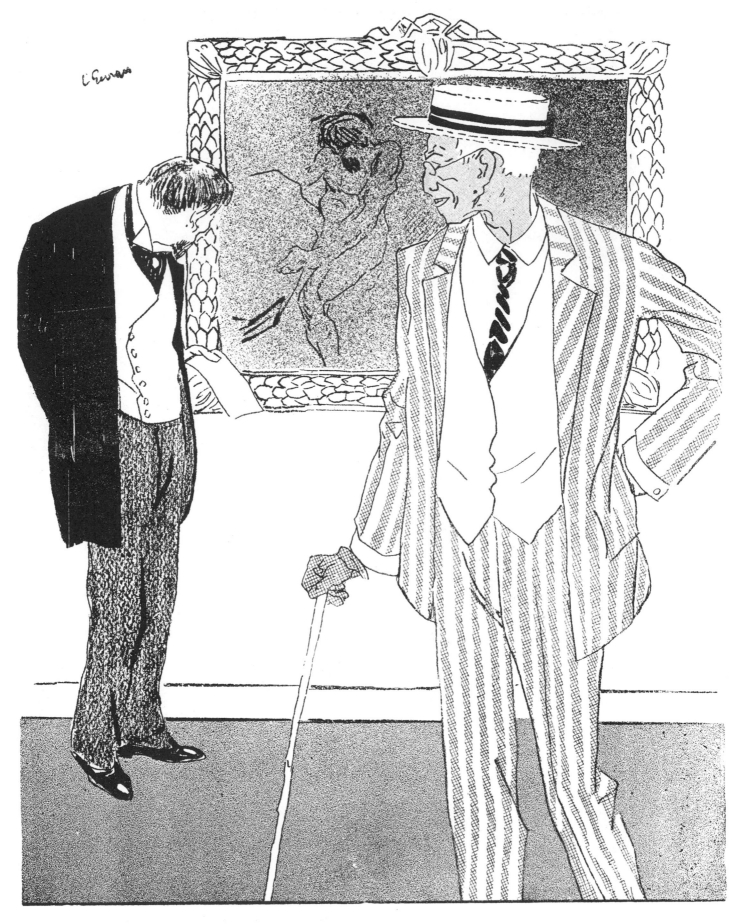

LE YANKEE.

— Vous me gratterez le bras gauche. J'éviterai ainsi les frais de douane, et Taupin's and Son, de Chicago, me retouchera cela très bien.

THE YANKEE. "Scrape the left arm for me. That way I'll avoid customs duties, and Taupin and Son in Chicago will do a very nice retouching job for me." [No. 388, Sept. 5, 1908; issue on patrons of the arts]

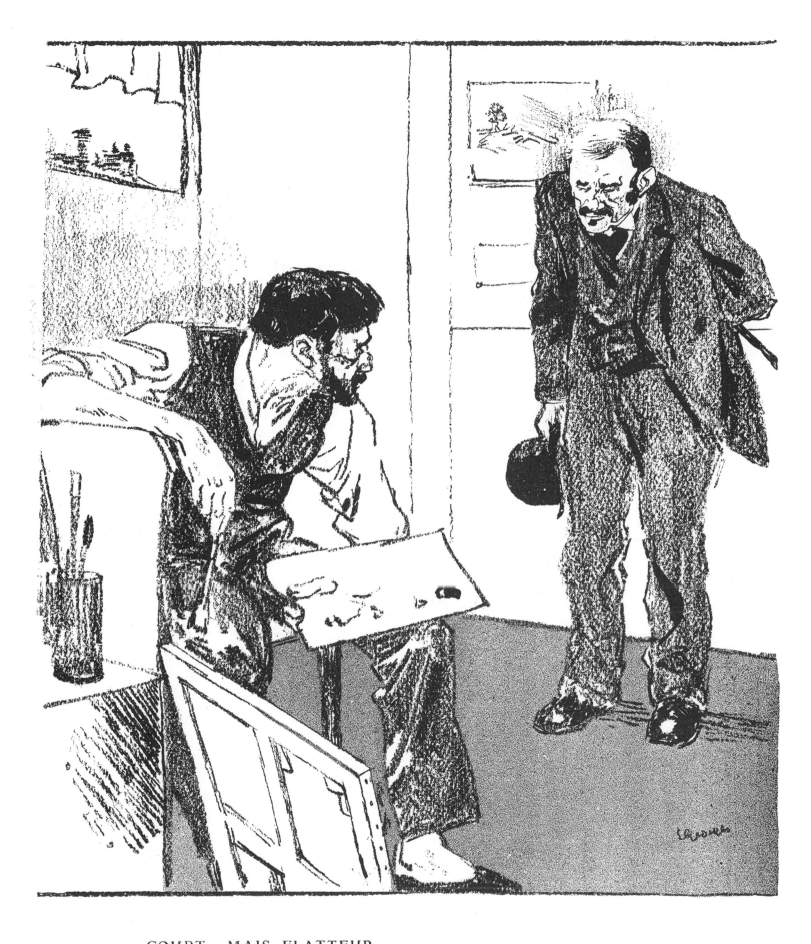

COURT, MAIS FLATTEUR.

— Donnez-moi donc quelque chose de vous... Un rien... Une petite cochonnerie...

SHORT BUT FLATTERING. "Please let me have something of yours . . . a trifle . . . any piece of trash." [No. 388, Sept. 5, 1908; issue on patrons of the arts]

Léon Georges 53

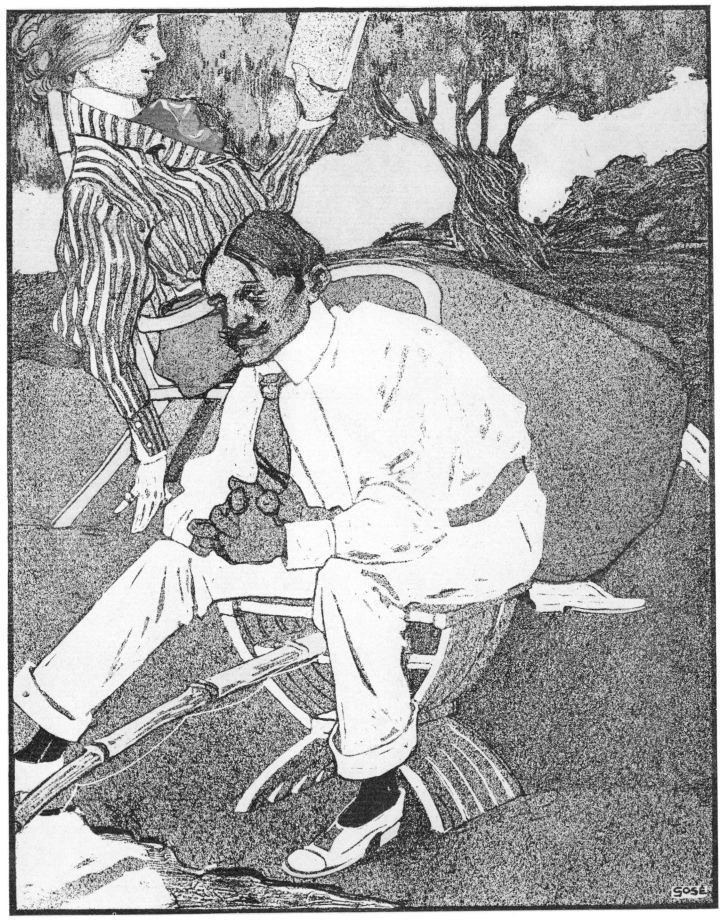

PECHE A LA LIGNE

Il pêche! Elle a vingt ans!... Il pêche, l'imbécile.
La Peste soit du pauvre troubadour,
Qui sacrifie à ce jeu tranquille
Le plus charmant des sports : « L'amour! »

ANGLING. He is fishing! She is twenty! He is fishing, the fool. The devil take the poor troubadour who prefers that quiet pastime to the most charming of sports—love! [No. 44, Feb. 1, 1902; issue on sports]

54 *Francisco Javier Gosé*

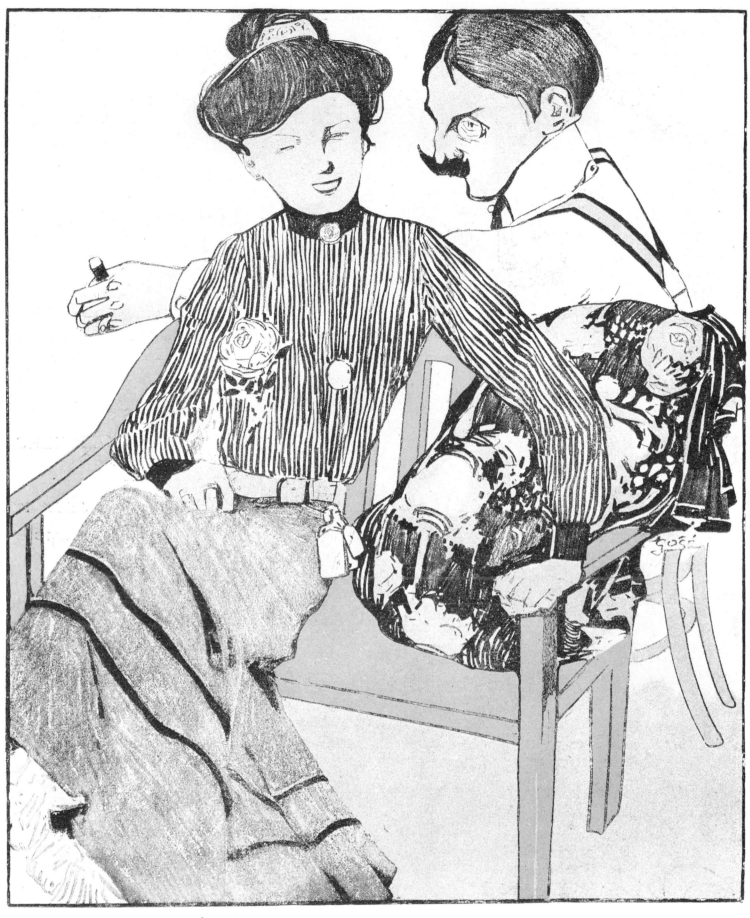

ALTESSE PÉRUVIENNE

— *Il n'y a pas dé quoi riré!... Après tout, cé vieux, il n'est pas si dégoutant!... Èt avec lé doú millé pésétas qu'il té doúnerait, yé pourrais au moinsse payer ma detté d'honnour!*

HIS HIGHNESS FROM PERU. "There's nothing to laugh about! . . . After all, that old man isn't so disgusting! . . . And with the two thousand pesetas he'd give you, I would at least be able to pay my debt of honor!" [No. 118, July 4, 1903; issue on flashy adventurers, with captions by the playwright Henry Kistemaeckers]

Francisco Javier Gosé 55

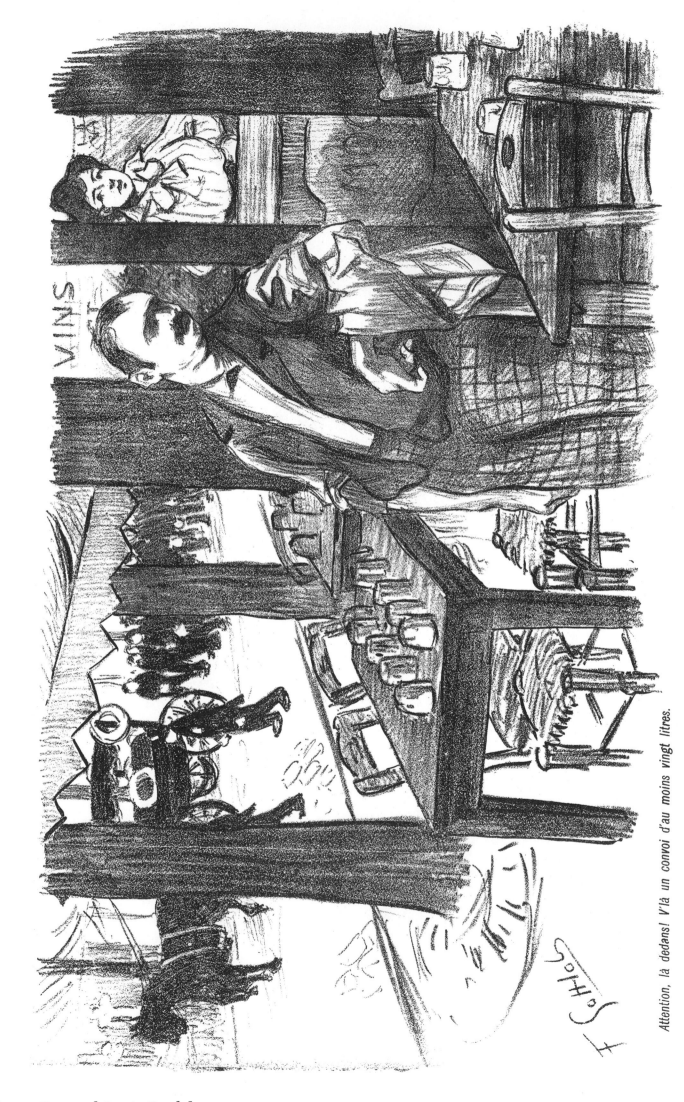

Attention, la dedans! V'là un convoi d'au moins vingt litres.

"Look alive inside there! Here comes a procession that's good for at least twenty liters."
[No. 31, Nov. 2, 1901; issue on funerals]

« La retraite des ouvriers n'est pas assurée et dépend du bon vouloir de la Compagnie. »

— C'est malheureux d'être comme l'oiseau sur la branche et pas sûr, en tombant, de ramasser sa retraite.

"There is no fixed pension plan; it depends on the good will of the Company." "It's a rotten life to be perched like a bird on a branch, and never sure of getting a pension if I should fall." [No. 87, Nov. 29, 1902; issue on the gas monopoly, which was to be up for renewal in three years' time]

Jules-Félix Grandjouan 57

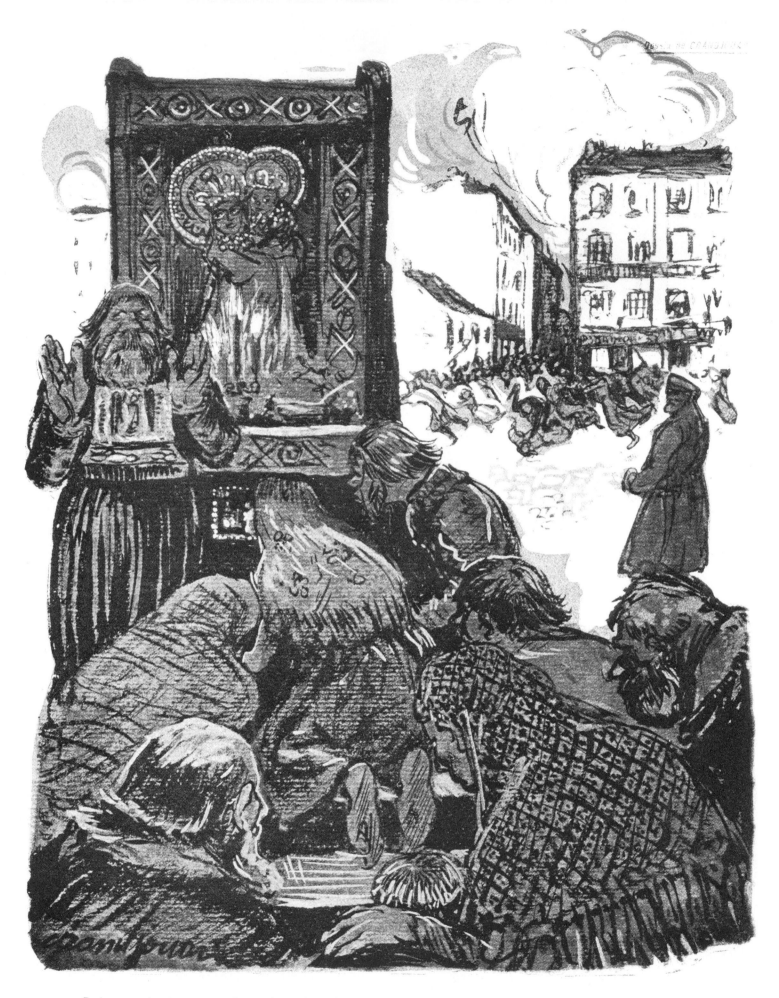

Paix sur la terre et dans les cieux!

Jules-Félix Grandjouan

"Peace on earth and in heaven!" [No. 114, June 6, 1903; issue on the notorious Easter 1903 pogrom in Kishinev, Bessarabia, represented as a "crime of Tsarism"]

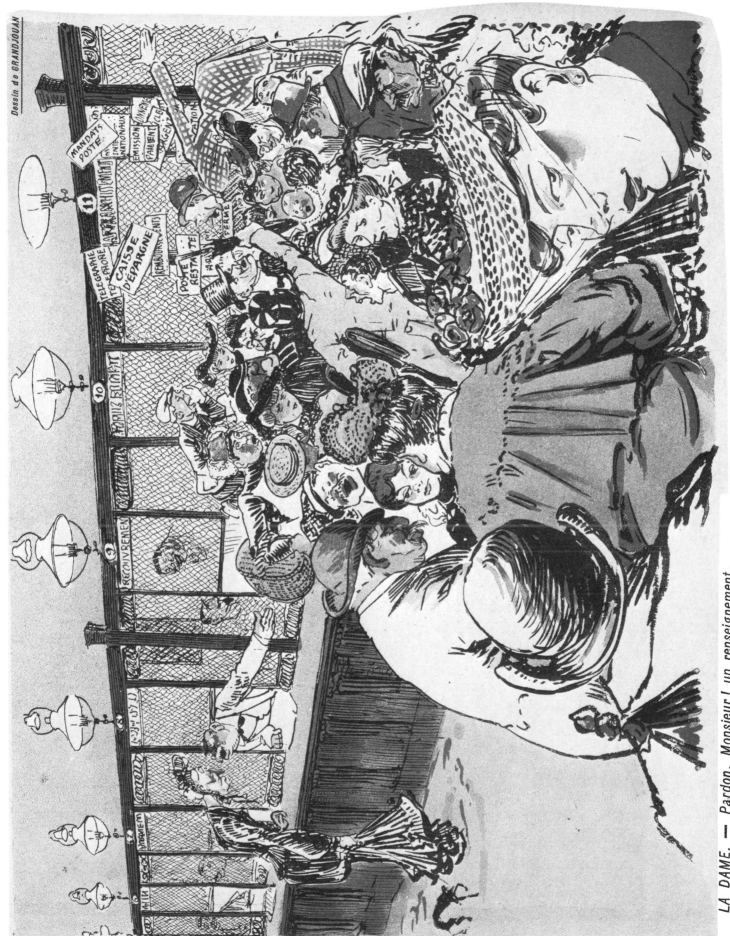

LA DAME. — *Pardon, Monsieur! un renseignement...*
L'EMPLOYÉ, *hurlant.* — *Adressez-vous au guichet 11.*

THE LADY: "Excuse me, can you tell me—" THE CLERK (roaring): "Ask at window 11."
[No. 164, May 21, 1904; issue on the postal service]

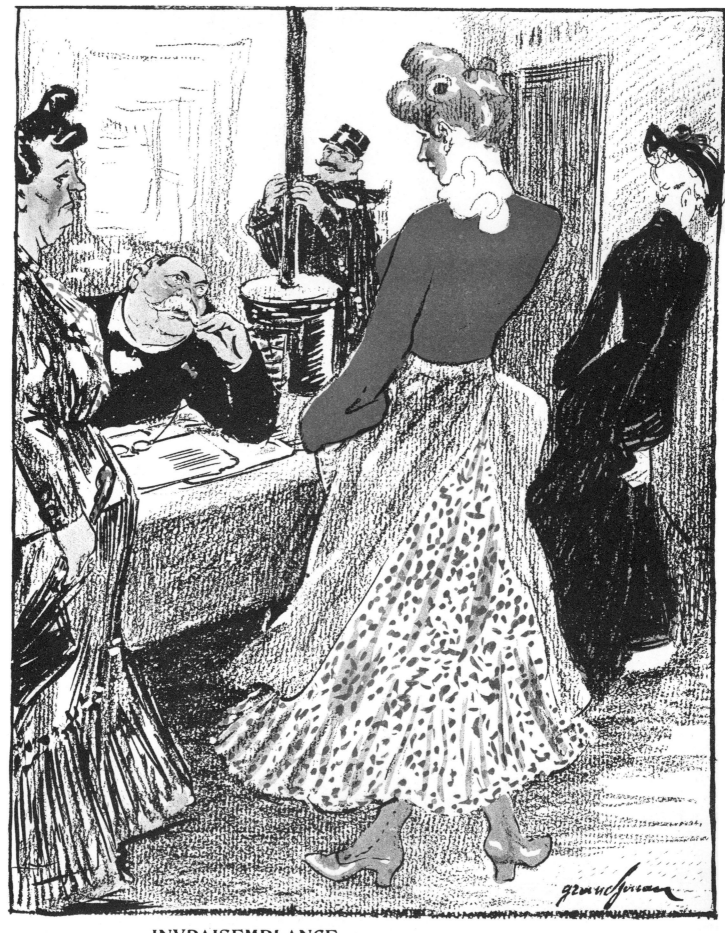

INVRAISEMBLANCE

— A qui ferez-vous croire, fille Untel, qu'un agent ait accepté vos faveurs et sollicité de vous de l'argent?

Jules-Félix Grandjouan

IMPROBABILITY. "Who do you think, my little streetwalker, is going to believe that a policeman accepted your favors and then demanded money from you?" [No. 188, Nov. 5, 1904; issue on the vice squad]

— *Ah ça! monsieur le commissaire, vous savez bien que vous n'avez pas le droit d'entrer dans les maisons à plus de quarante francs.*

"What's this, Commissioner? You know very well you have no right to come into the houses that charge more than forty francs." [No. 188, Nov. 5, 1904; issue on the vice squad]

Jules-Félix Grandjouan 61

PETIT JOUR

LE CONCIERGE. — *Madame aura le plaisir de trouver là-haut Monsieur qui est rentré de voyage cette nuit.*

DAYBREAK. THE HOUSE PORTER (CONCIERGE): "There's a pleasant surprise for you upstairs, Ma'am. Your husband got back from his trip last night." [No. 200, Jan. 28, 1905; issue on concierges]

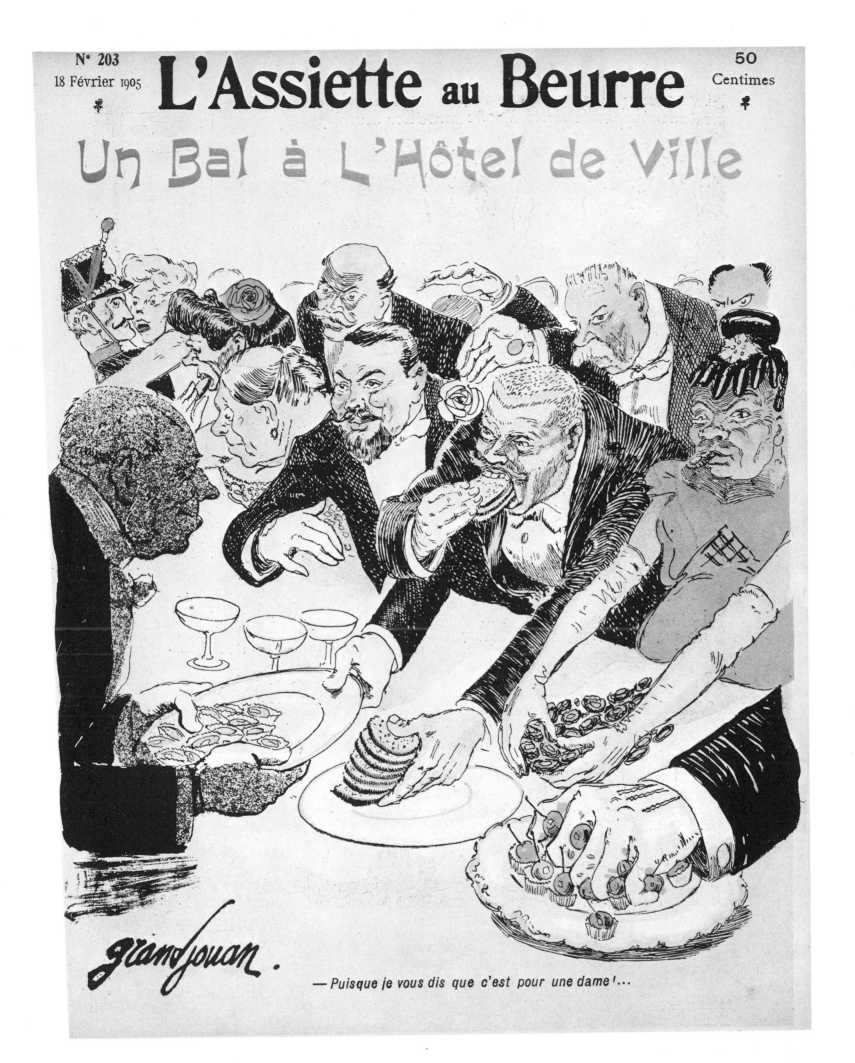

"But I tell you—it's for a lady!" [Cover of No. 203, Feb. 18, 1905; issue on public receptions at the Paris city hall]

Jules-Félix Grandjouan 63

COURRIÈRES

64 *Jules-Félix Grandjouan*

[Cover of No. 260, Mar. 24, 1906; issue on the coal-mine explosion at Courrières in northern France, which was due to the company's unsafe practices and negligence; there were over a thousand victims]

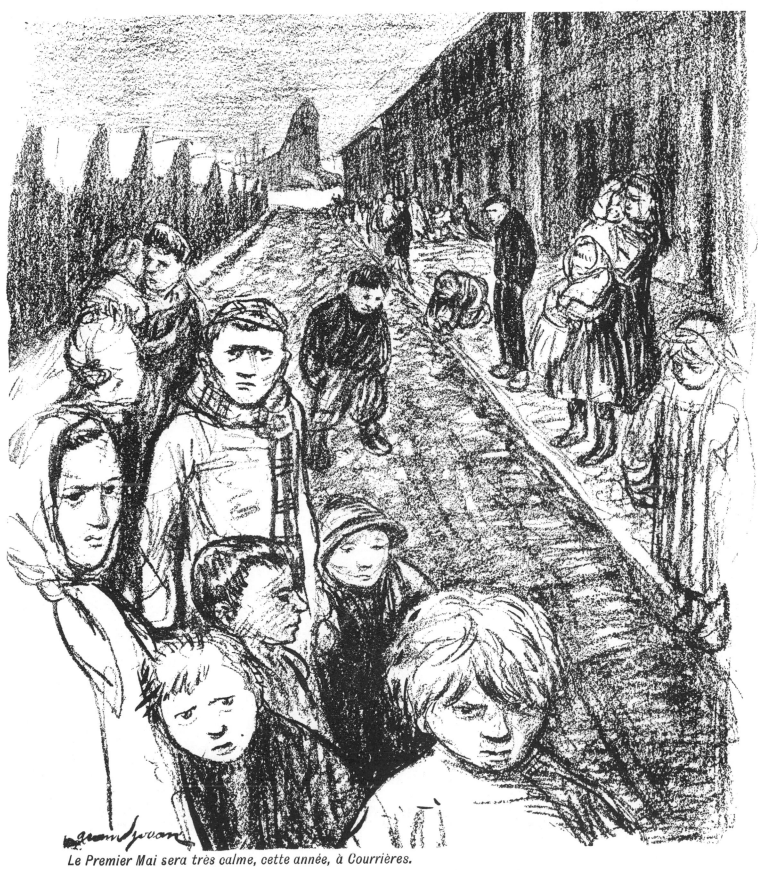

Le Premier Mai sera très calme, cette année, à Courrières.

The First of May [European labor day] will be very quiet this year in Courrières."
[No. 260, Mar. 24, 1906; issue on the Courrières disaster]

Jules-Félix Grandjouan 65

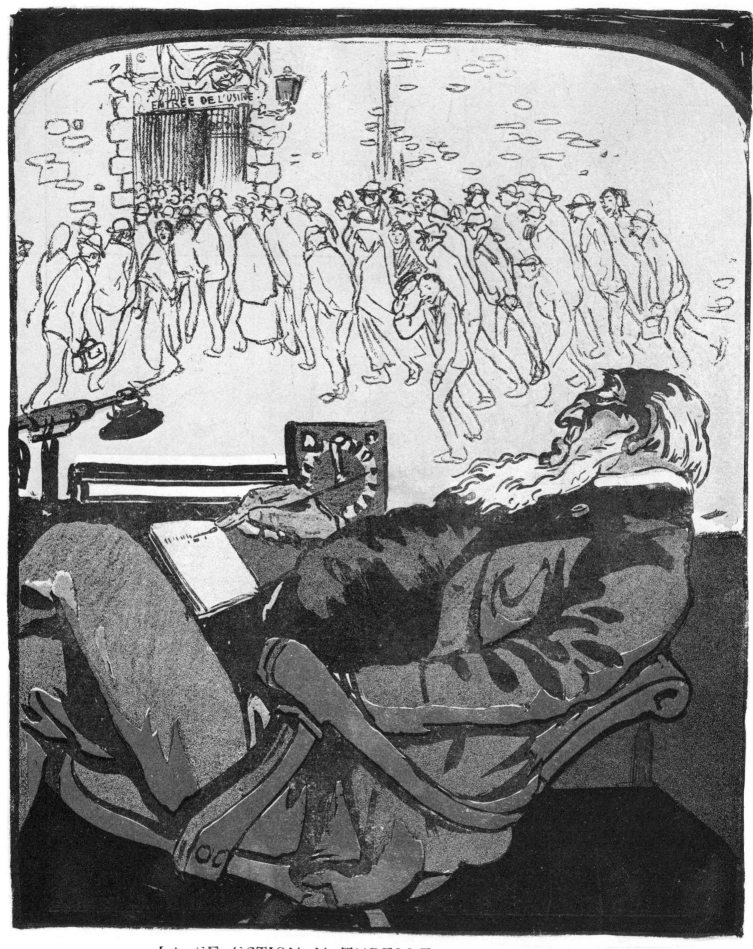

LA SELECTION NATURELLE

— *Il fallait en renvoyer quelques-uns : les balles ont fait le choix.*

66 *Jules-Félix Grandjouan*

NATURAL SELECTION. "Some of them had to be let go: the bullets decided which ones." [No. 214, May 6, 1905; issue on strikes]

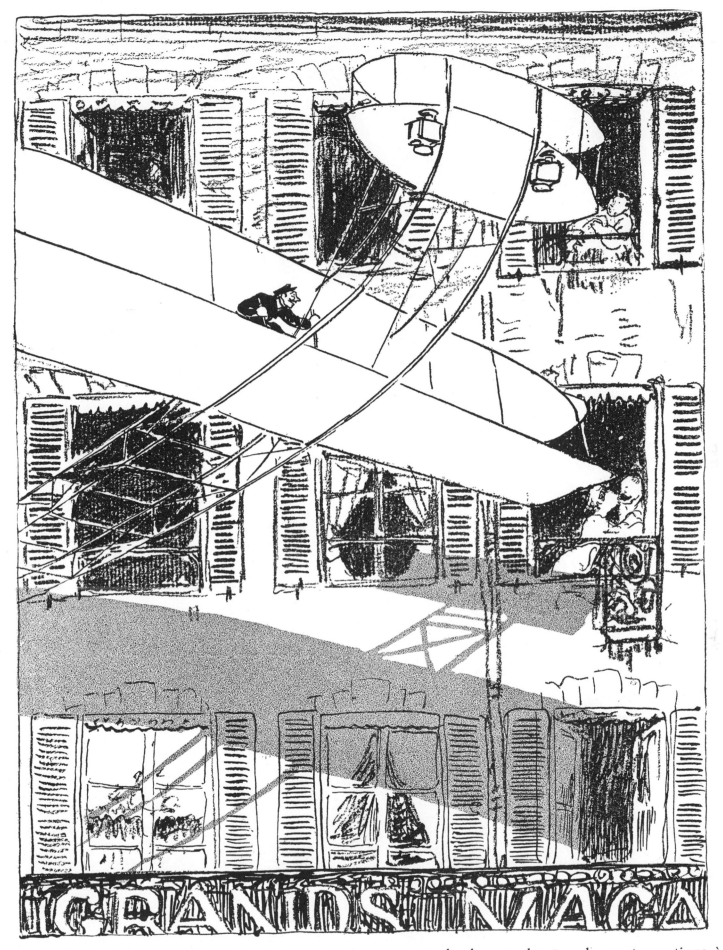

L'Agent-voyeur. — Chouette instrument qui me permet de dresser des tas de contraventions à l'article 33o puisqu'à présent tous les *gestes aimables,* même faits à domicile, deviennent des outrages publics à la pudeur.

THE VOYEURISTIC POLICEMAN: "Dandy machine! It allows me to write up loads of violations of Article 330, because now all 'loving gestures,' even at home, become immoral acts committed in public." [No. 398, Nov. 14, 1908; issue on airplanes]

Jules-Félix Grandjouan 67

Jules-Félix Grandjouan

"Hey! What are *you* doing at the meeting of the Chiefs of Staff?" "I'm the spy on duty." [Cover of No. 444, Oct. 2, 1909; issue on spies]

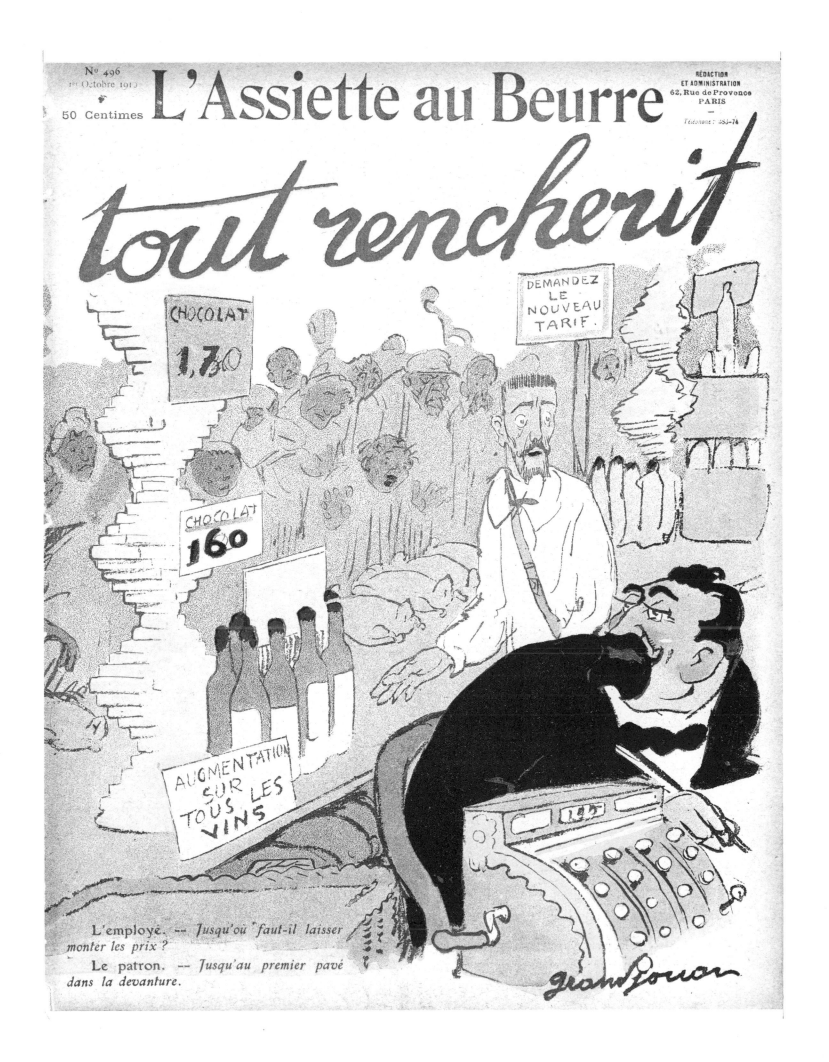

THE CLERK: "How long should we let the prices go up?" THE OWNER: "Till the first brick comes through the window." [Cover of No. 496, Oct. 1, 1910; issue titled "Everything's Getting Dearer"; the signs read: "Ask for the new price list" and "Price rise on all wines"]

Jules-Félix Grandjouan 69

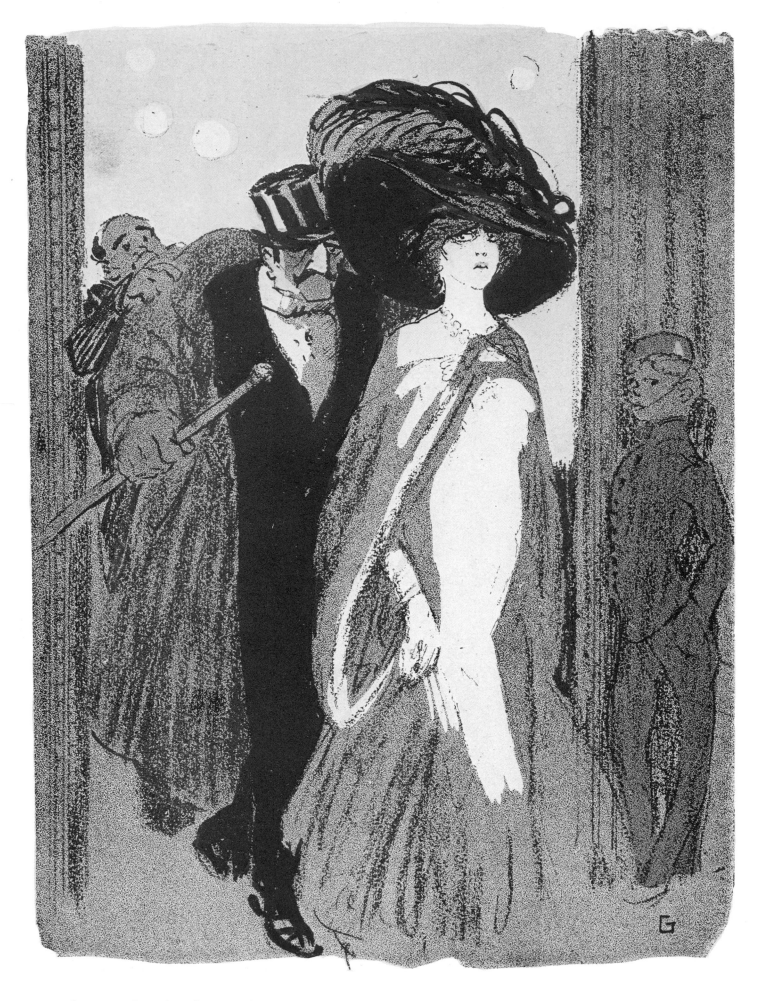

— Avec ce client-là, c'est pas le réveillon qui m'inquiète : c'est le réveil !

70 *Jules-Félix Grandjouan*

"With this customer, it isn't the night out *(réveillon)* that upsets me, it's waking up *(réveil)* the next morning!" [No. 508, Dec. 24, 1910; issue on Christmas and New Year's celebrations]

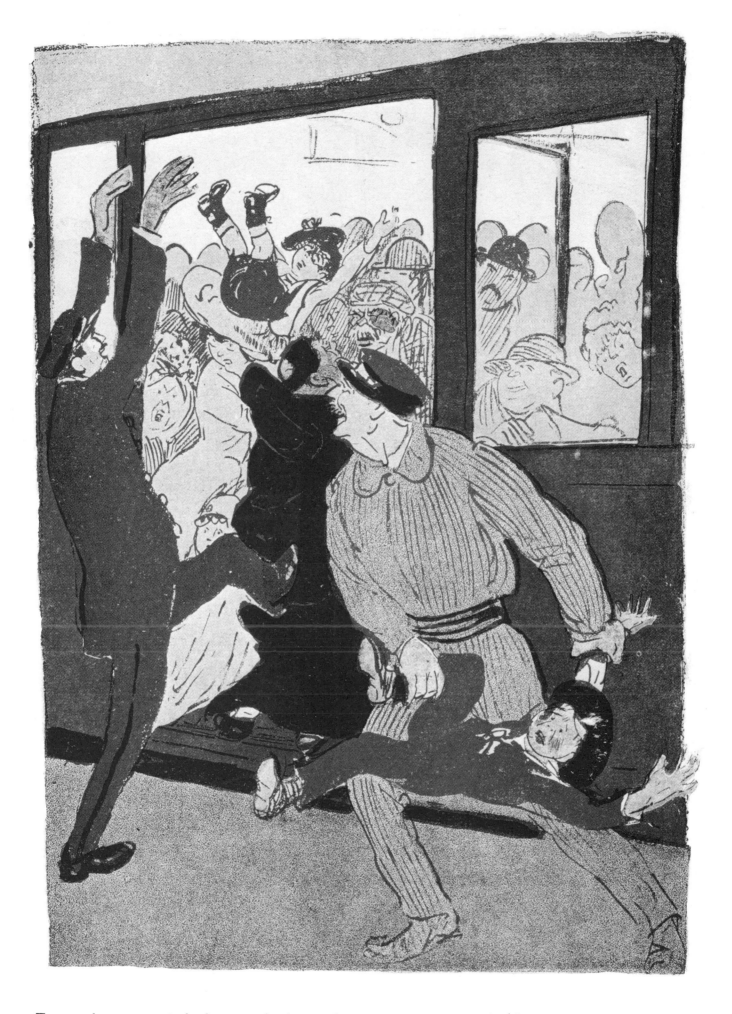

Encore deux ou trois lardons sur le dessus des petits pois, ça va très bien avec.

Another two or three *lardons* [means "pieces of larding bacon" and "kids"] on top of the "green peas" [here, equivalent to our "sardines"]—they go very well together. [No. 518, Mar. 4, 1911; issue on subway crowding]

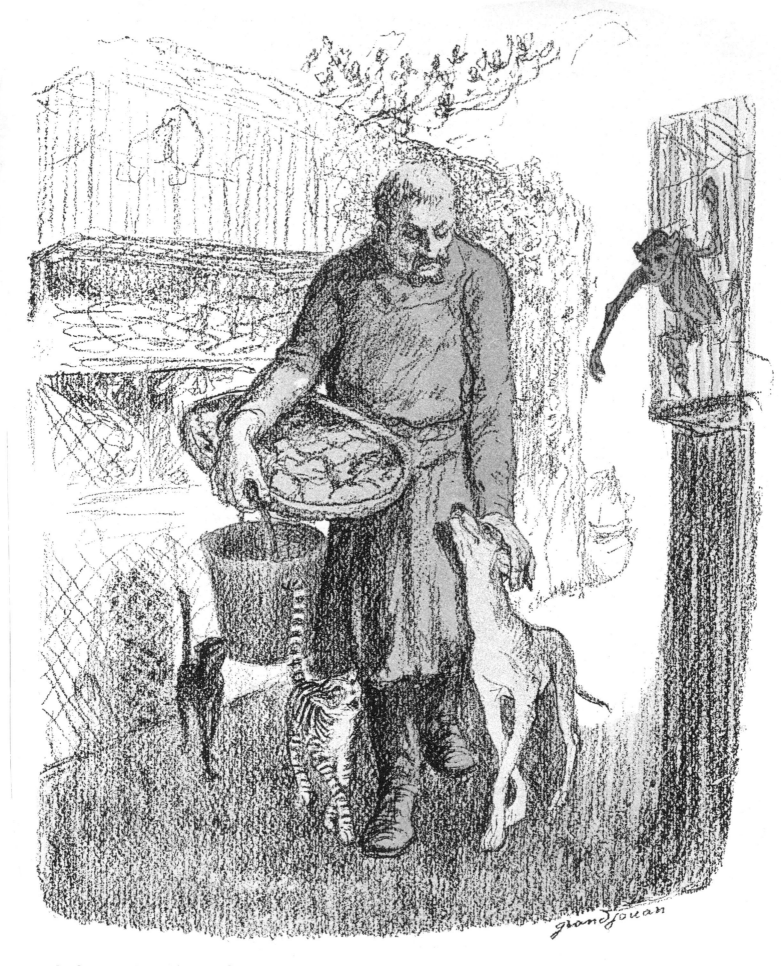

LE GARÇON DE LABORATOIRE. — On ne devrait pas s'attacher aux bêtes, ici. Pour ce qu'elles durent !

THE LABORATORY SERVANT. — We ought not to become attached to animals here. So quickly they disappear !

Jules-Félix Grandjouan

THE LAB ASSISTANT: "We shouldn't become attached to the animals here. They come and go so fast!" [No. 535, July 1, 1911; issue on vivisection]

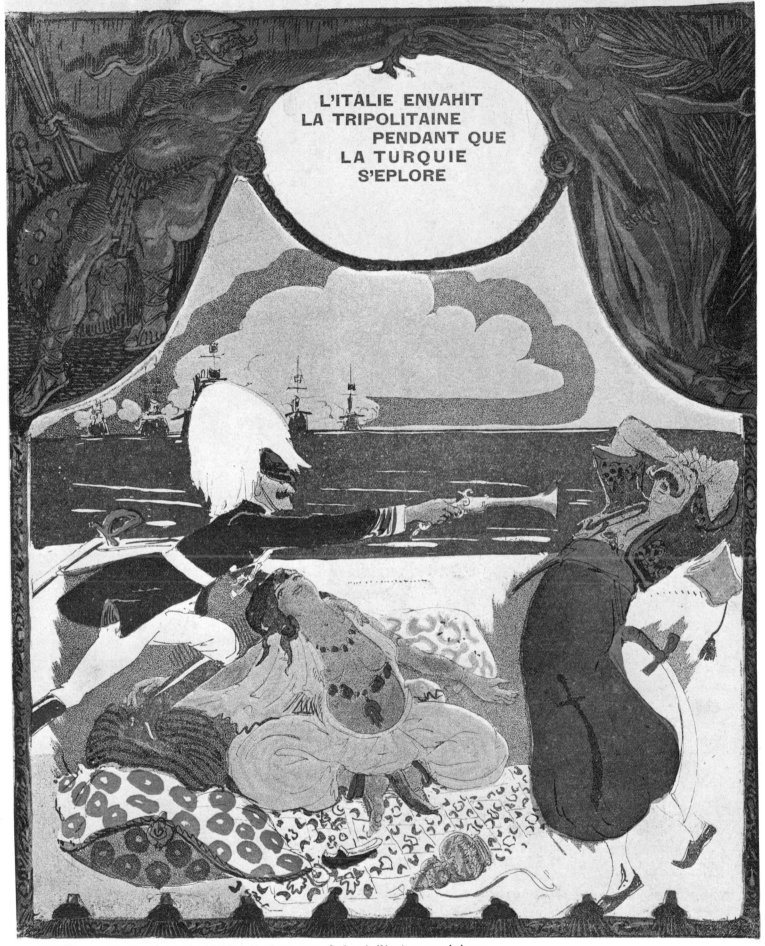

L'ITALIE ENVAHIT
LA TRIPOLITAINE
PENDANT QUE
LA TURQUIE
S'EPLORE

L'Italie. — Ne prenez pas ça mal! C'est au nom de la civilisation supérieure...

ITALY INVADES TRIPOLITANIA WHILE TURKEY LAMENTS. ITALY: "Don't take it badly! It's for the cause of higher civilization . . ." [Cover of No. 550, Oct. 21, 1911, issue titled "The Oppressors Oppressed"]

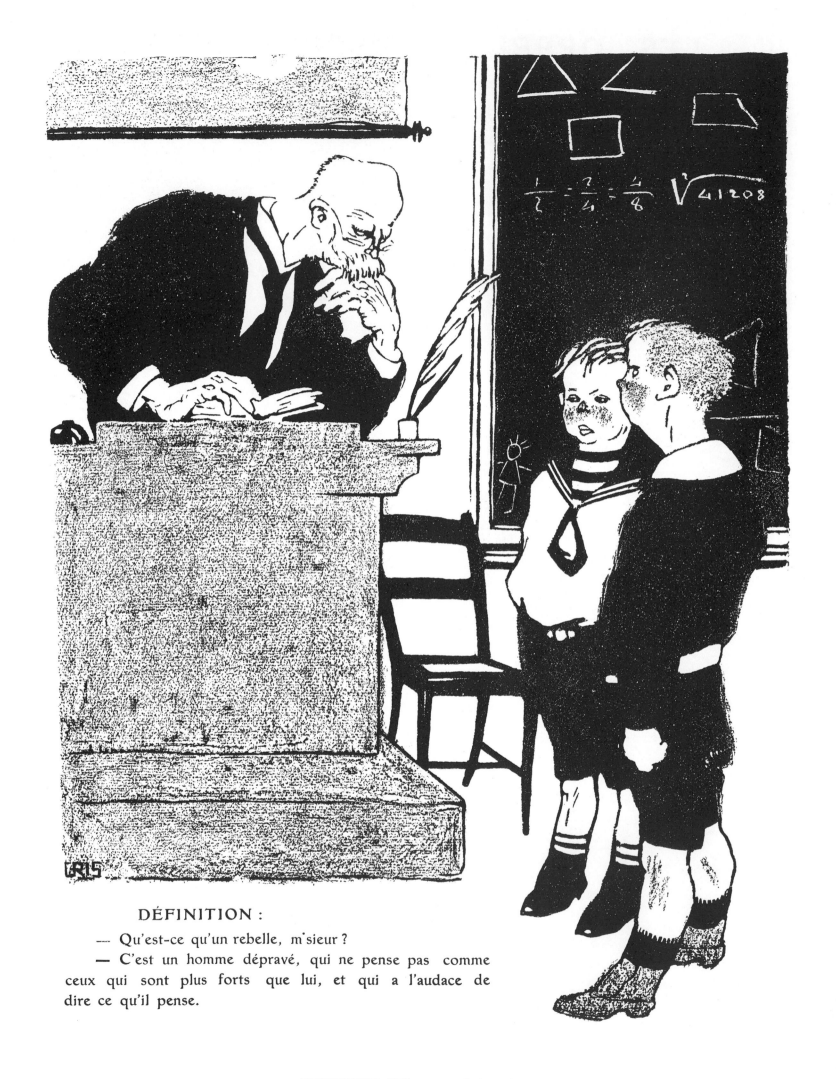

DÉFINITION :

— Qu'est-ce qu'un rebelle, m'sieur ?

— C'est un homme dépravé, qui ne pense pas comme ceux qui sont plus forts que lui, et qui a l'audace de dire ce qu'il pense.

DEFINITION. "What is a rebel, sir?" "A depraved man who thinks differently from those who are stronger than he is, and has the gall to say what he thinks." [No. 386, Aug. 22, 1908; issue on rebels]

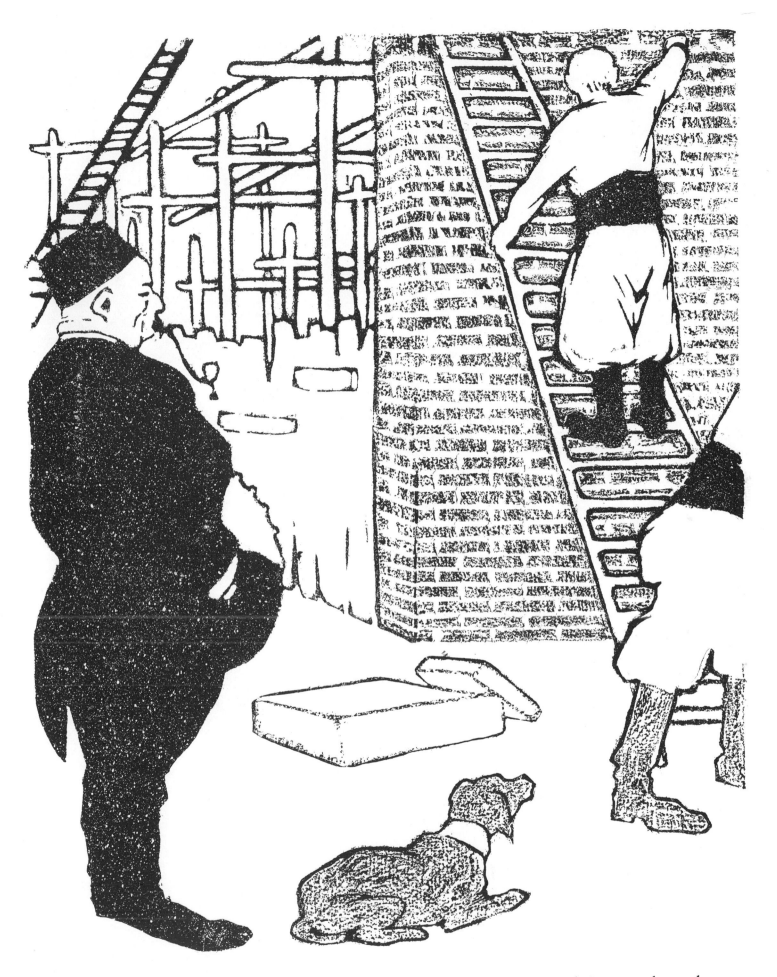

Ainsi que chaque pays qui se respecte, la Turquie divisera ses populations en deux classes : 1° ceux qui travaillent, et 2° ceux qui regardent travailler.

Like every self-respecting country, Turkey will divide her people into two classes: those who work and and those who watch others work. [No. 387, Aug. 29, 1908; issue titled "Turkey Regenerated"— the bloodless revolution of July 1908 led to a restoration of the suspended constitution]

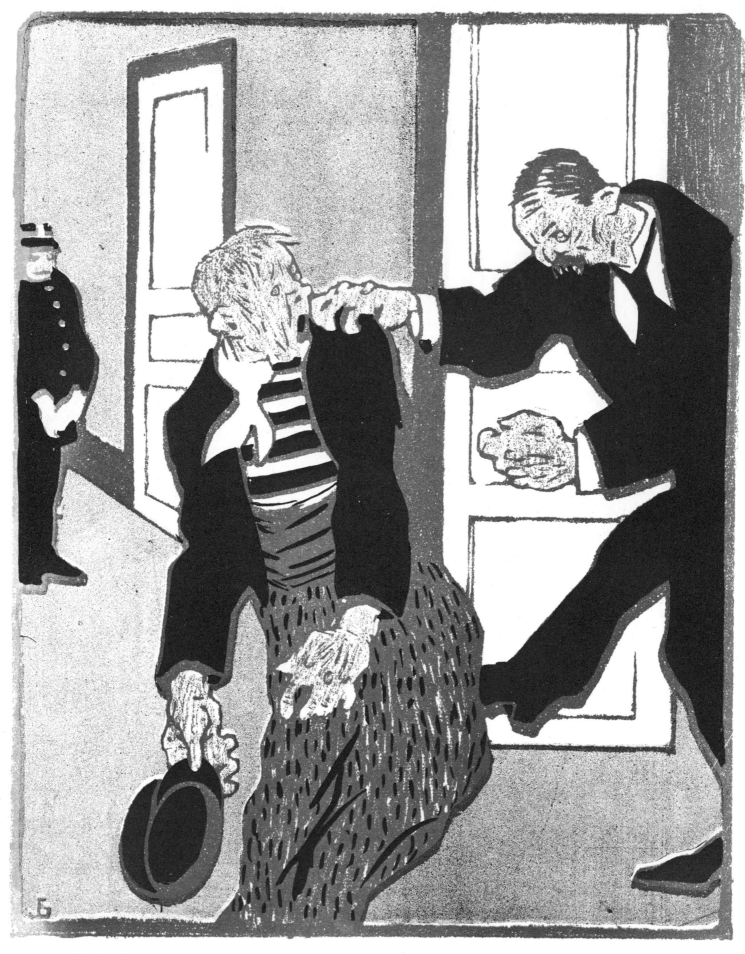

— Ah ! ah !... vous vous permettez d'établir votre innocence après quinze mois d'instruction !...
Allez, mais qu'on ne vous y reprenne plus !

"So! You have the nerve to prove your innocence after fifteen months of preliminary examinations! You can leave, but don't let me catch you at it again!" [No. 391, Sept. 26, 1908; issue on judicial inquiries]

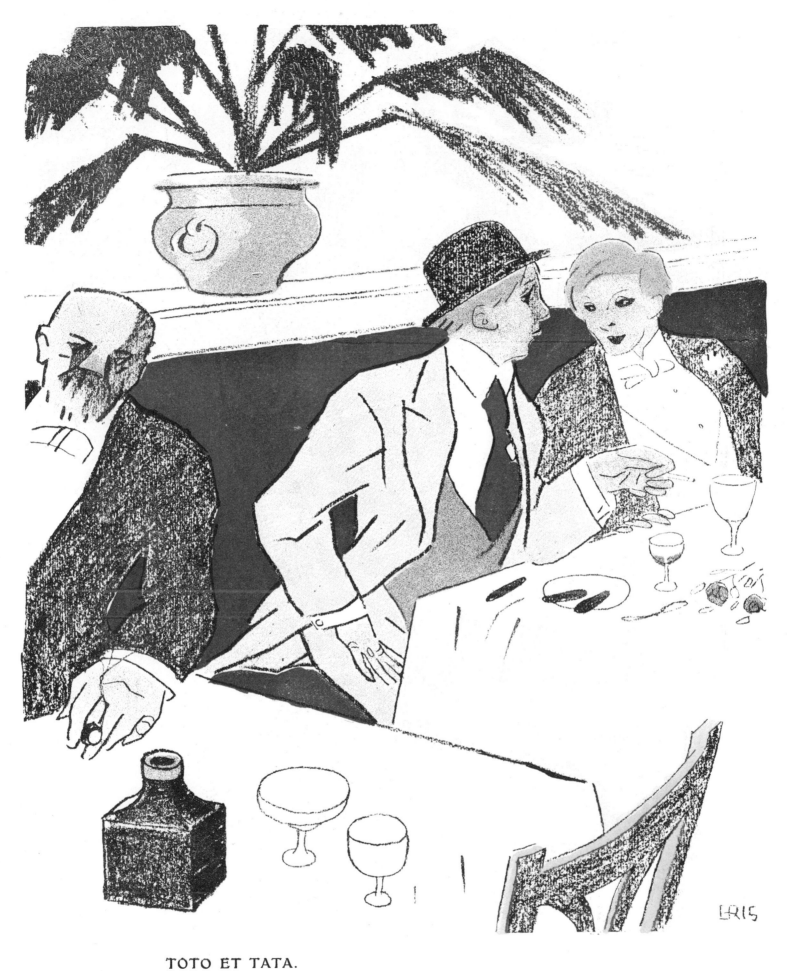

TOTO ET TATA.

— Cette loi va faire augmenter sensiblement notre clientèle, car avec nous.... pas de risques !

THE GAYS. "This law will bring us a lot of new customers, because with us—there's no risk!" [No. 484, July 9, 1910; issue on a strict new paternity law]

Juan Gris 77

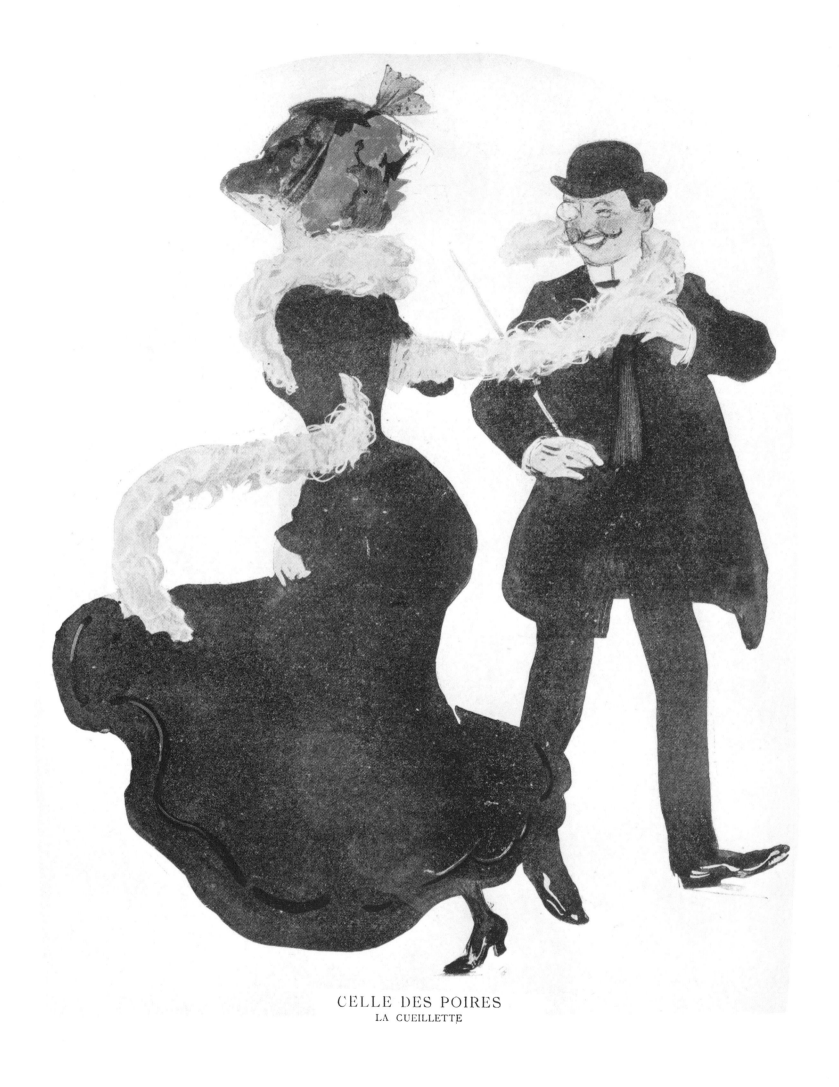

CELLE DES POIRES
LA CUEILLETTE

Jules-Alexandre Grün THE SAP'S MUG. Picking up trade. [No. 104, Mar. 28, 1903; issue titled "Their Ugly Mugs"]

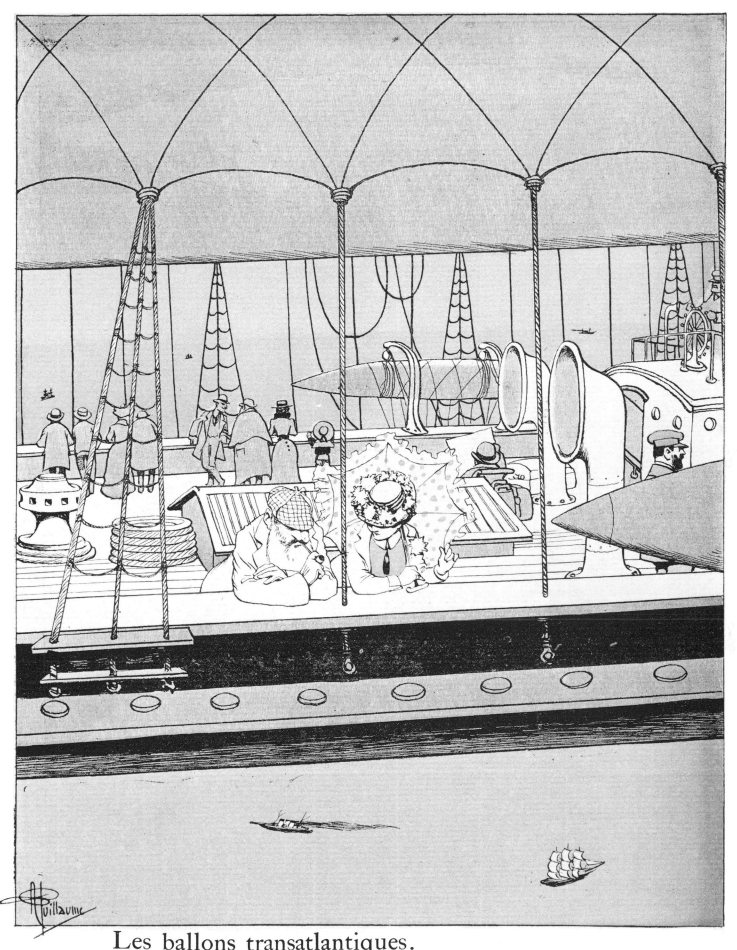

Les ballons transatlantiques.

— *Ces ballons anglais ont toujours du retard... c'est absurde... Nous allons encore mettre près de quatre heures pour aller du Havre à New-York!...*

TRANSATLANTIC BALLOONS. "These English balloons are always late . . . how silly . . . it'll still take us nearly four hours to get from Le Havre to New York!" [No. 37, Dec. 14, 1901; issue on air travel]

Albert Guillaume 79

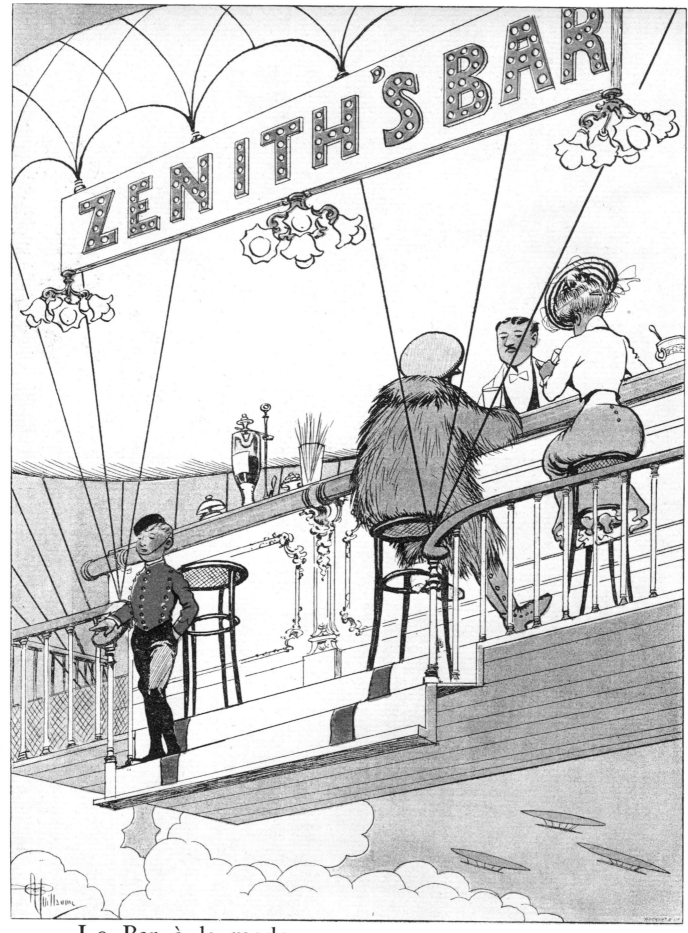

Le Bar à la mode.

Tous nos élégants et nos élégantes se donnent rendez-vous vers 5 heures au Zenith's-Bar.

THE FASHIONABLE BAR. All our chic ladies and gentlemen meet at the Zenith Bar around five o'clock. [No. 37, Dec. 14, 1901, issue on air travel]

LÁ VIE PRATIQUE
— FAUT PAS AVOIR PEUR, MONSIEUR LE COMTE, ILS NE SONT PAS MÉCHANTS...

PRACTICAL LIFE. "Don't be afraid, Count, they won't hurt you." [No. 1, Apr. 4, 1901]

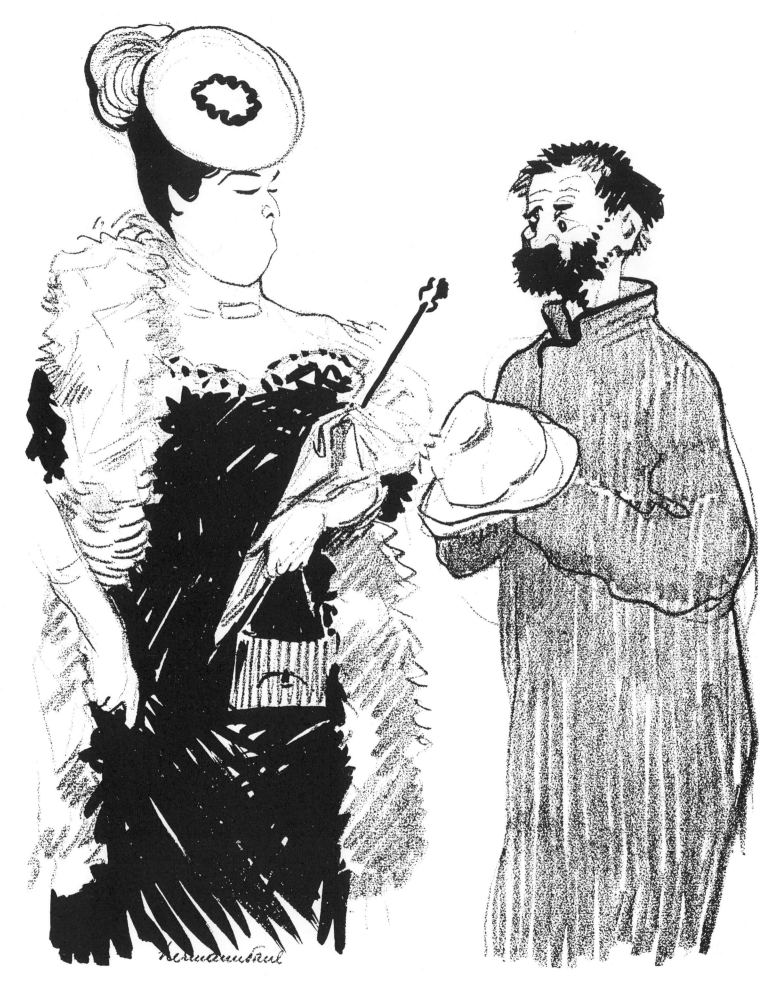

LA DAME BIENFAISANTE

THE CHARITABLE LADY. [No. 231, Sept. 2, 1905; issue on "the joys of the street"]

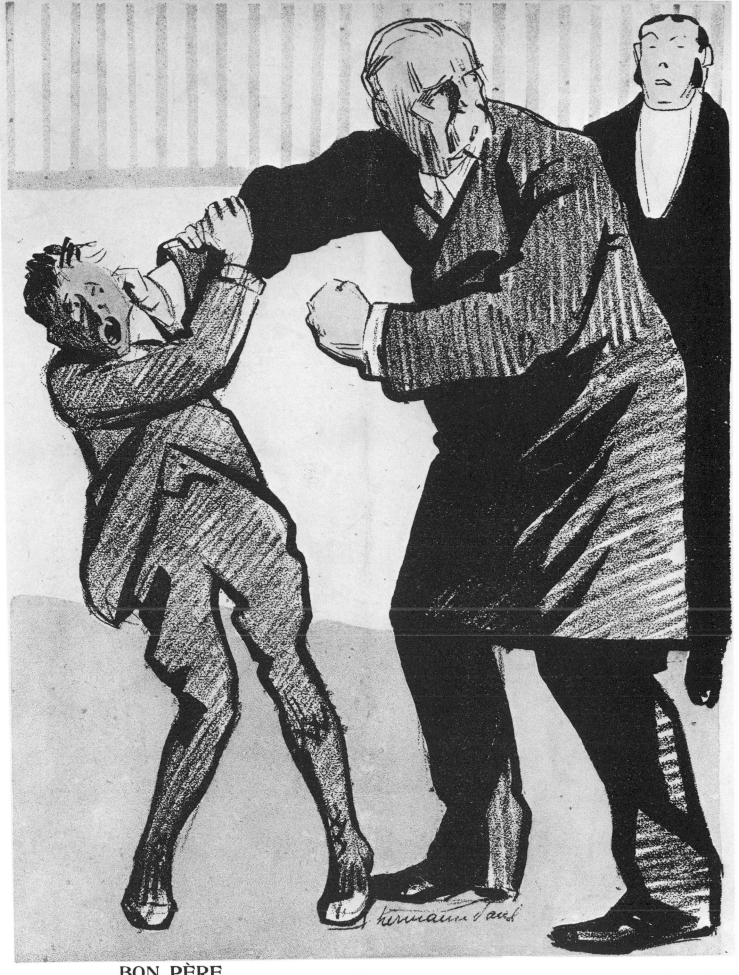

BON PÈRE

— *Monsieur, ce sont ces Messieurs du Comité pour la libération des peuples esclaves...*
— *Priez-les d'attendre un instant.*

A GOOD FATHER. "Sir, the gentlemen have arrived from the Committee for the Liberation of Enslaved Peoples." "Ask them to wait a minute." [No. 236, Oct. 6, 1905; issue titled "Mister Morality, Cuckold and Socialist"]

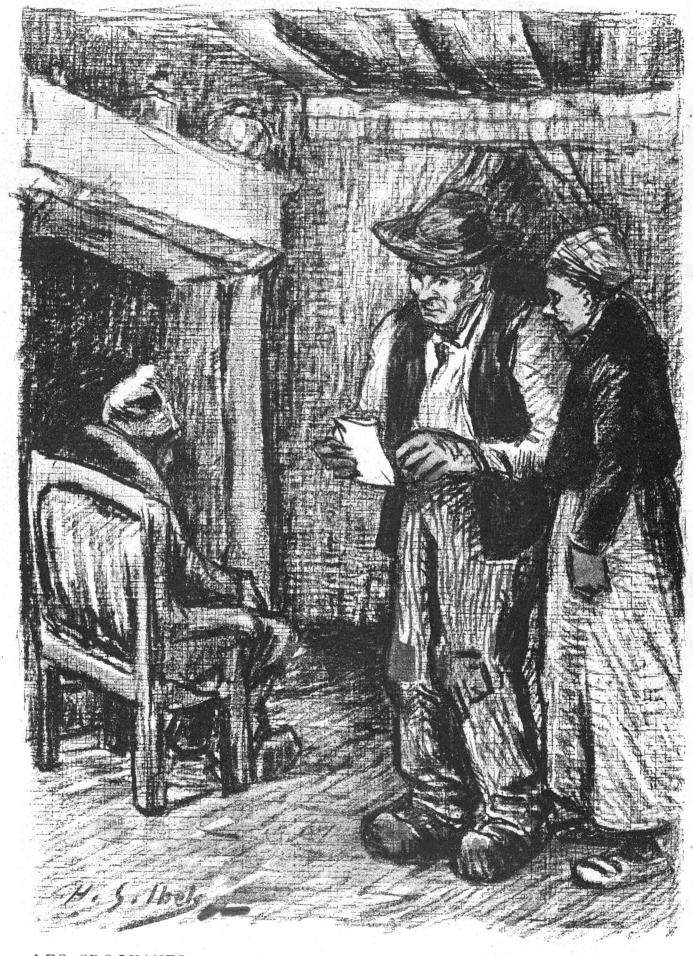

LES CROQUANTS

— SOIXANTE FRANCS!
— POUR SUR QUE L'DOCTEUR DOIT MARQUER SES VISITES AVEC UNE FOURCHETTE!...

THE CLODHOPPERS. "Sixty francs!" "The doctor is surely billing us for more visits than he's made!" [No. 1, Apr. 4, 1901; the implication is that the unfeeling peasants begrudge the money spent on their sick old parent]

84 *Henri-Gabriel Ibels*

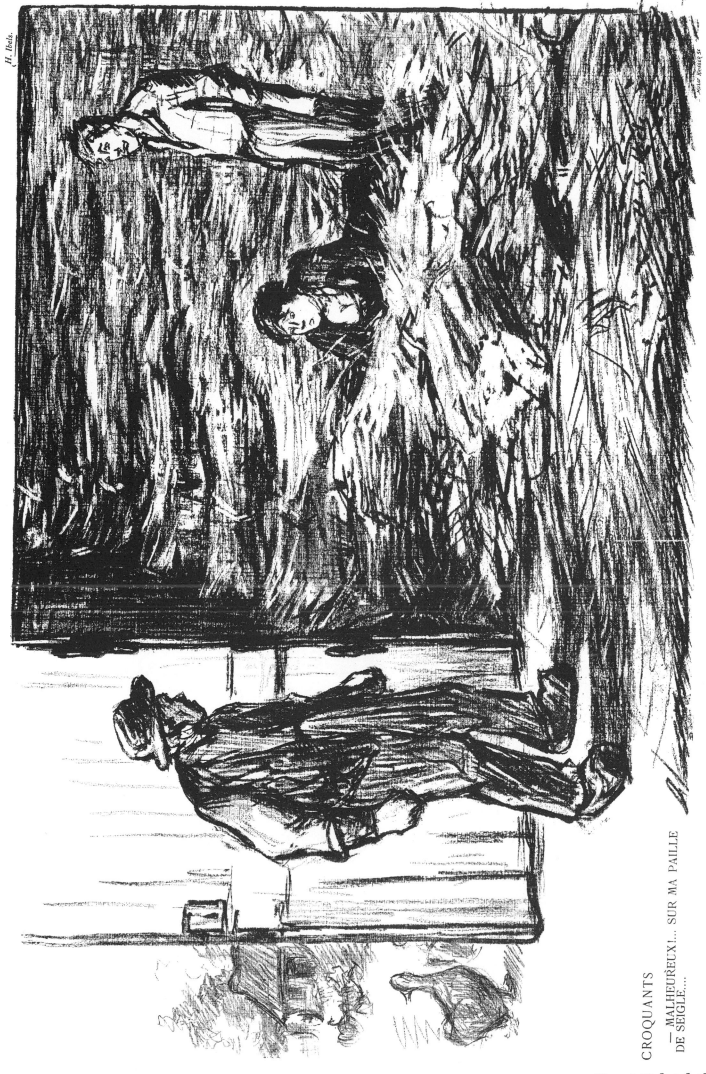

H. Ibels.

CROQUANTS
— MALHEUREUX!... SUR MA PAILLE
DE SEIGLE.....

CLODHOPPERS. "Good-for-nothings! On my rye straw!" [No. 4, Apr. 25, 1901]

Henri-Gabriel Ibels 85

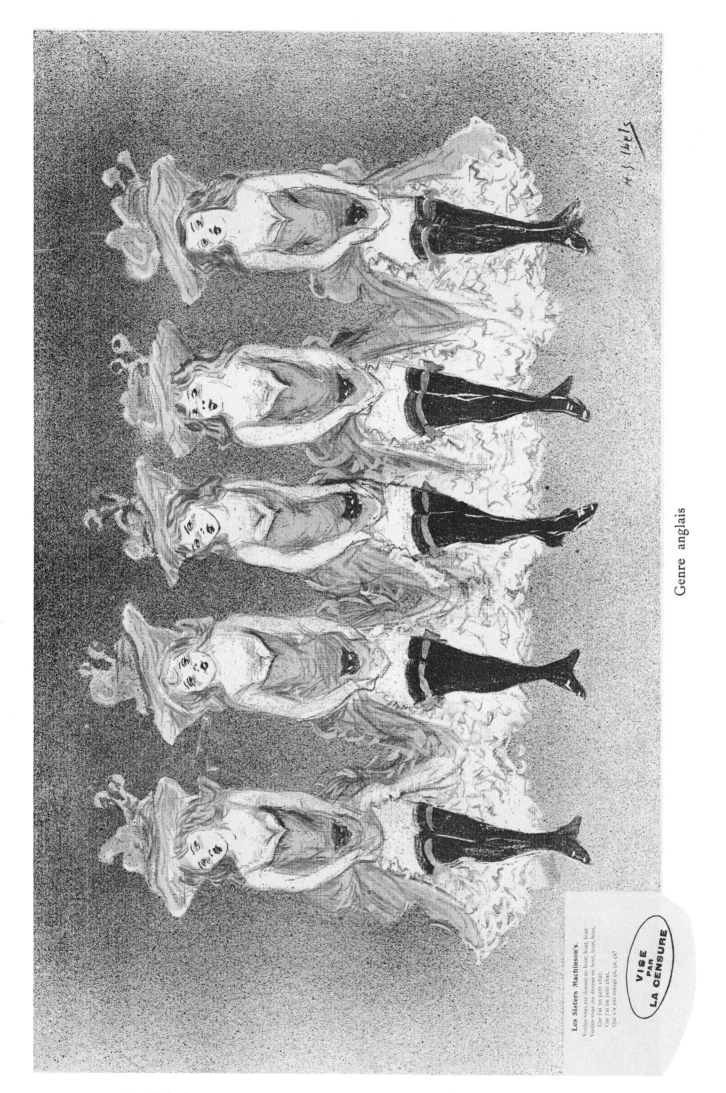

Genre anglais

ENGLISH STYLE. THE WHAT'S-THEIR-NAME-SISTERS. "Wanna gimme a piece, piece, piece?/ Wanna gimme a piece, piece, piece?/ 'Cause I've got a little cat/ 'Cause I've got a little cat/ Who hasn't eaten that, that, that!" [No. 36, Dec. 7, 1901; issue on censorship in the music halls; the seal, which indicates that government censors found no fault with the material, was part of the joke and appeared on every item in the issue]

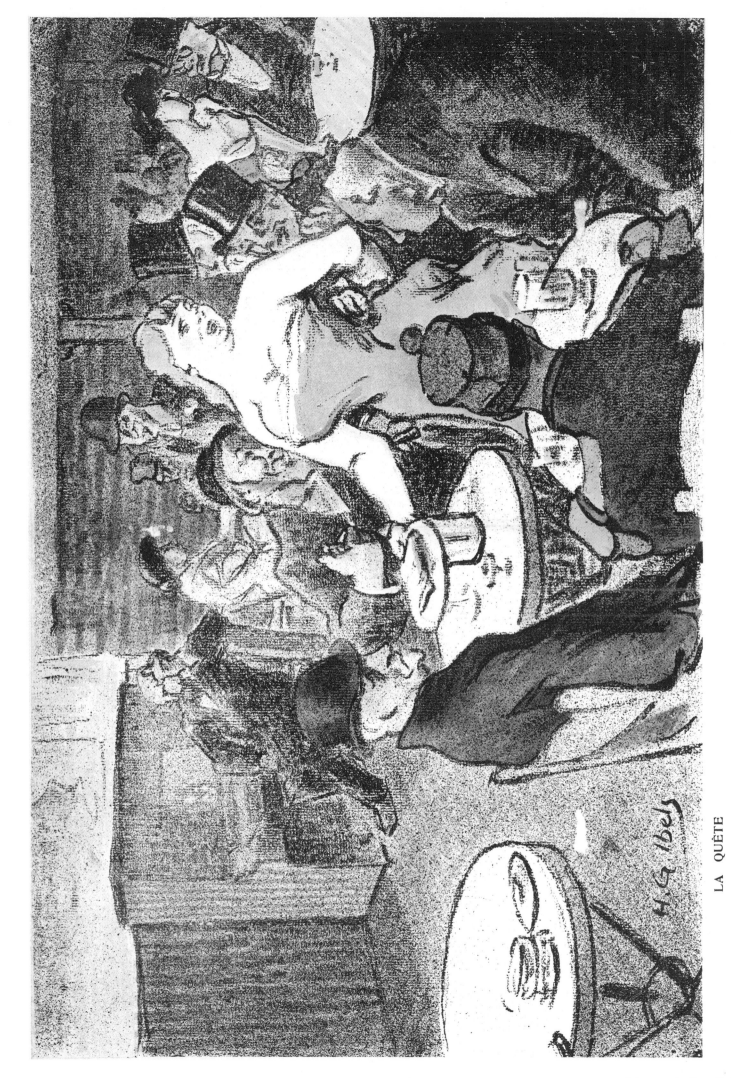

LA QUÊTE

PASSING AROUND THE PLATE. [No. 273, June 23, 1906; issue on provincial cabarets as hotbeds of white slavery]

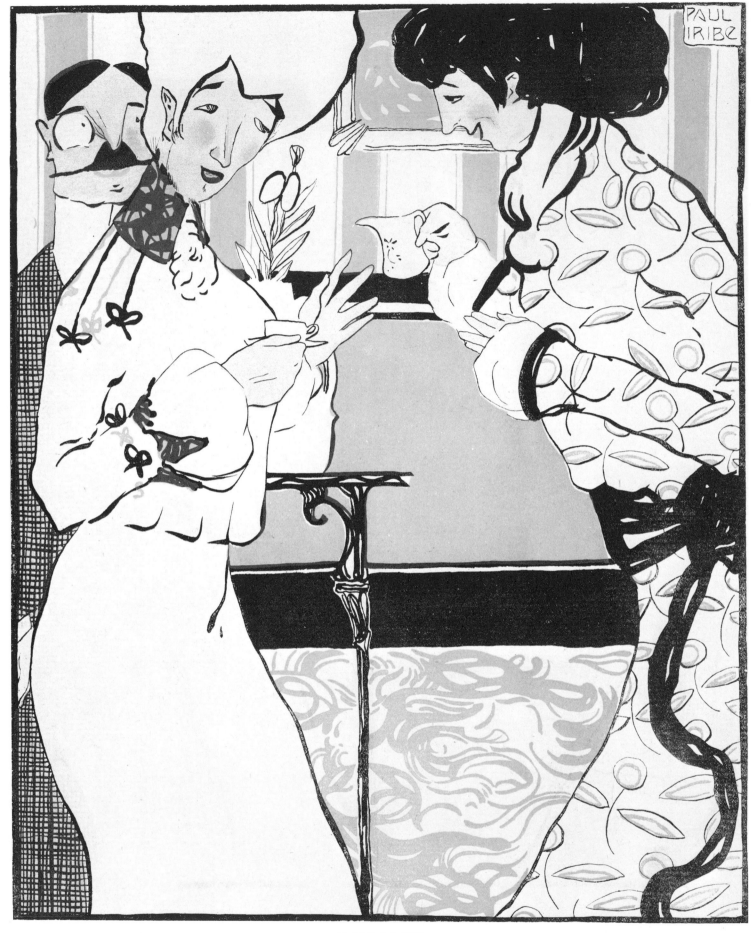

RIVALES

— *Un peu de lait…. chérie?…*
— *Non… merci.* **(A part.)** *Ça y est, défions-nous … elle veut m'empoisonner….*

RIVALS. "A little milk . . . darling?" "No, thanks. *(aside:)* Ah hah, I've got to be careful . . . she wants to poison me." [No. 46 *bis*, Feb. 1902; issue on an adulterated-milk scandal]

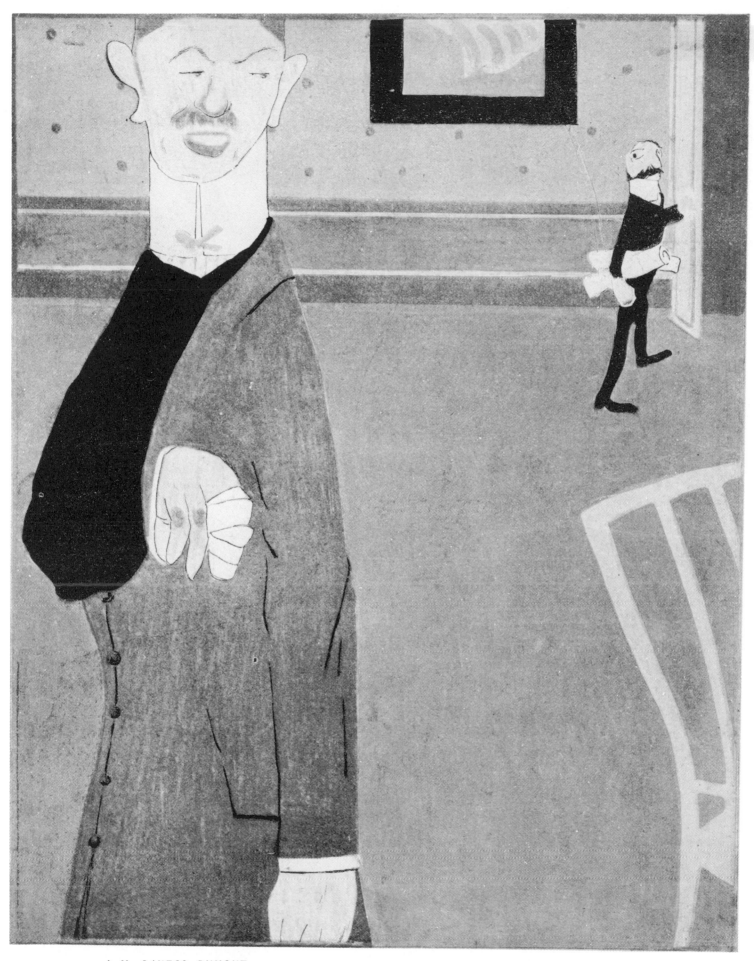

A M. SANTOS DUMONT.

LE MARQUIS DE DION. — Jeune homme, tâchez de trouver quelque chose de mieux.

THE MARQUIS DE DION [the established auto pioneer] TO SANTOS-DUMONT [the young
aviation pioneer, injured in an accident]: "Young man, try to hit on something better."
[No. 108, Apr. 25, 1903; issue on esthetes]

Paul Iribe 89

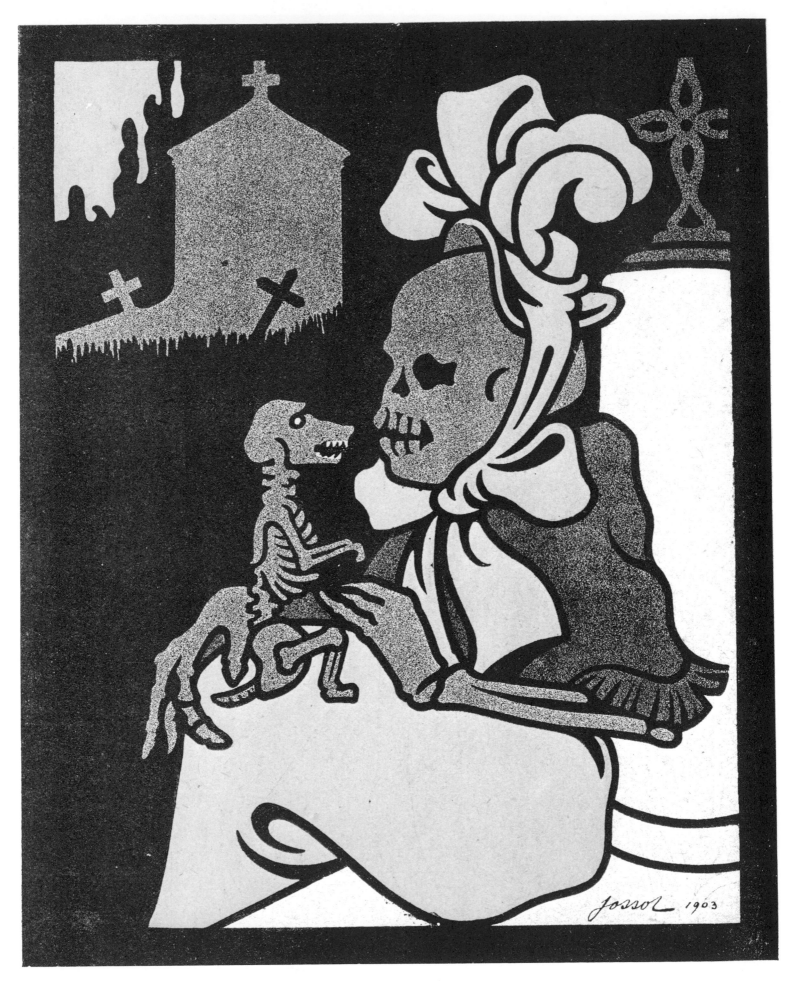

— *Jadis, Azor, nous avions des puces.*

Gustave-Henri Jossot

"Once, Azor, we had fleas." [No. 156, Mar. 26, 1904; issue on animated skeletons; Azor was a very popular name for lapdogs in the nineteenth century]

L'assiette av·beurre·

REDACTION
ET ADMINISTRATION
62, Rue de Provence
PARIS
TÉLÉPHONE :
283-74

LES JEUX

[Cover of No. 307, Feb. 16, 1907; issue on gambling]

Raphael Kirchner 91

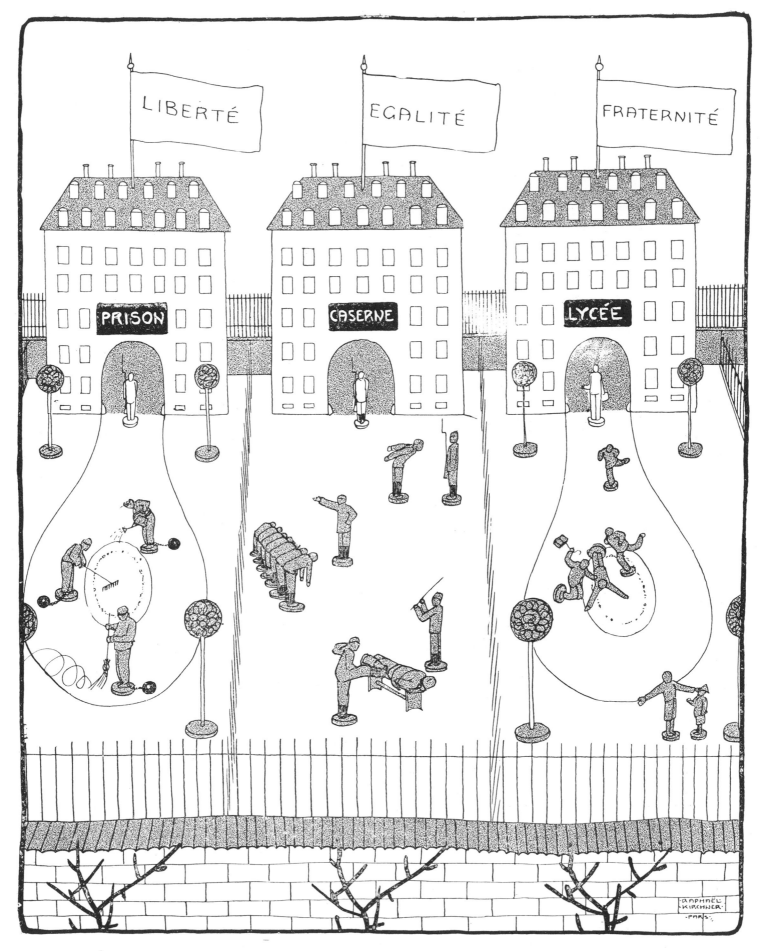

LA RÉPUBLIQUE A CONSTRUIT DES PRISONS, DES CASERNES, DES ÉCOLES...

...qui sont de véritables palais !

THE REPUBLIC HAS BUILT PRISONS, BARRACKS AND SCHOOLS . . . that are real palaces! [No. 319, May 11, 1907; issue on social problems]

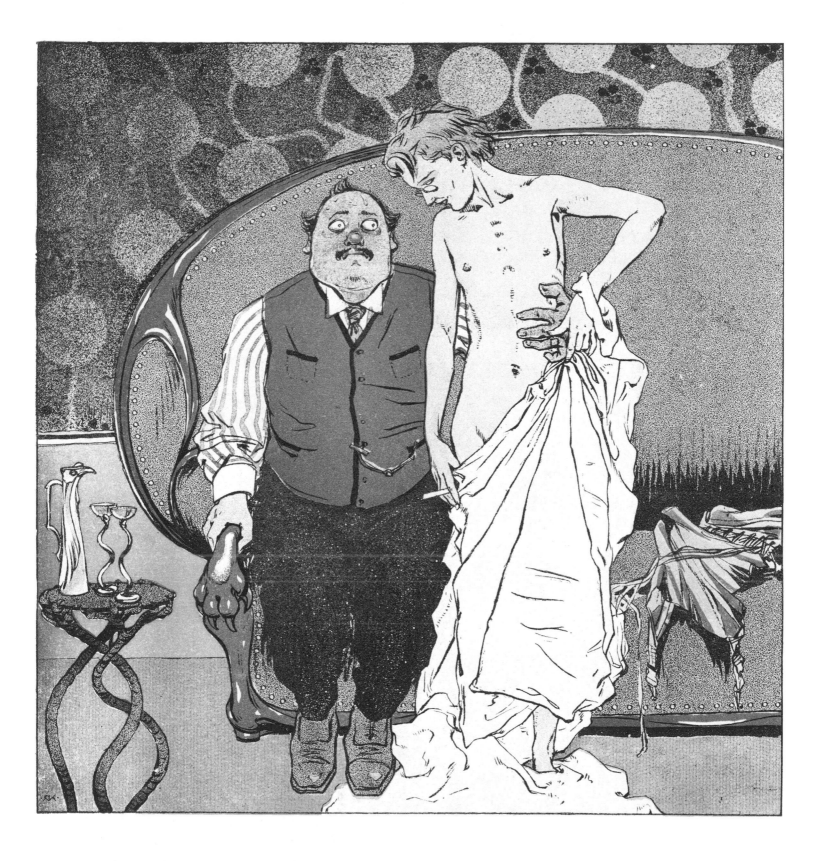

Même l'amour n'arrive plus à les exciter,
car l'objet de leur passion n'est pas
très emballant.

Selbst die Liebe kann sie nicht aufrichten,
da sie sich hierzu ganz ungeeigneter
Objecte bedienen

Even love can no longer stimulate them [those infected with the Art Nouveau sickness],
since the object of their passion isn't very captivating. [No. 339, Sept. 28, 1907; issue
on Art Nouveau]

Raphael Kirchner 93

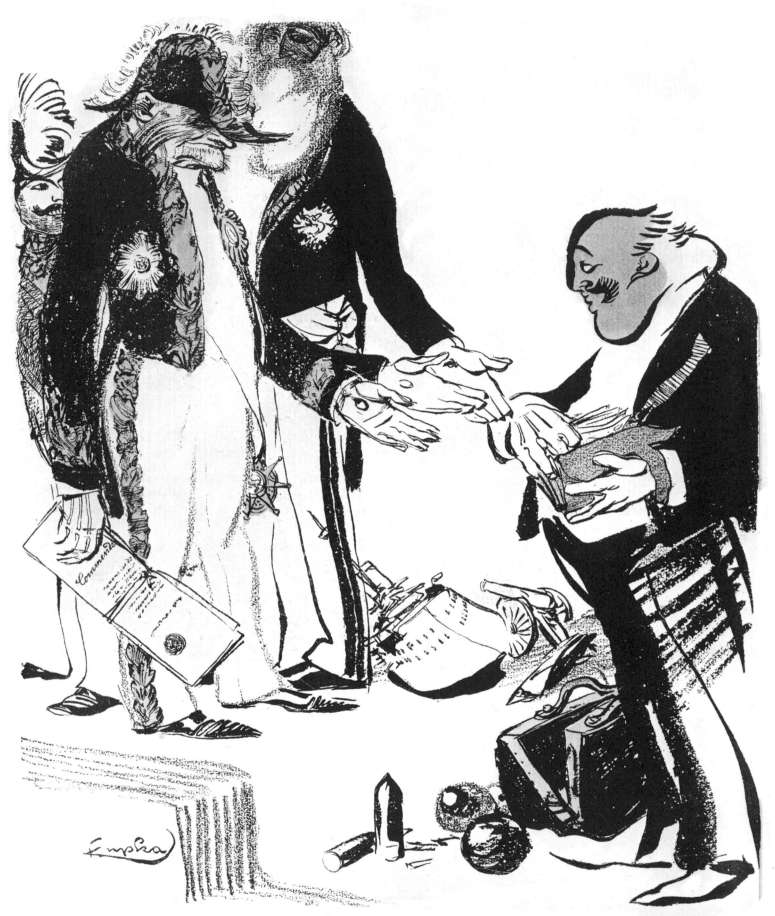

LES BASES DE L'ÉQUILIBRE EUROPÉEN

94 *František Kupka*

THE FOUNDATIONS OF THE EUROPEAN BALANCE OF POWER. [No. 177, Aug. 20, 1904; issue on peace]

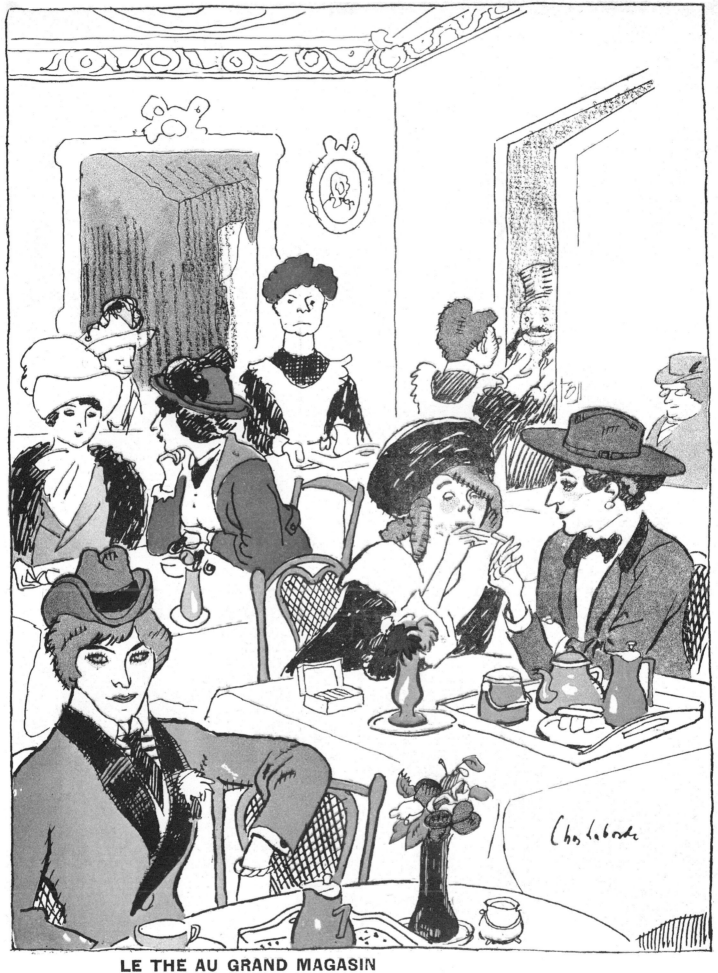

LE THÉ AU GRAND MAGASIN

— Ici au moins pas d'hommes, pas de satyres, le thé est réservé aux dames seules...

TEA AT THE DEPARTMENT STORE. "Here at least there are no men, no satyrs; only ladies are admitted to take tea . . ." [No. 558, Dec. 23, 1911; issue on department stores]

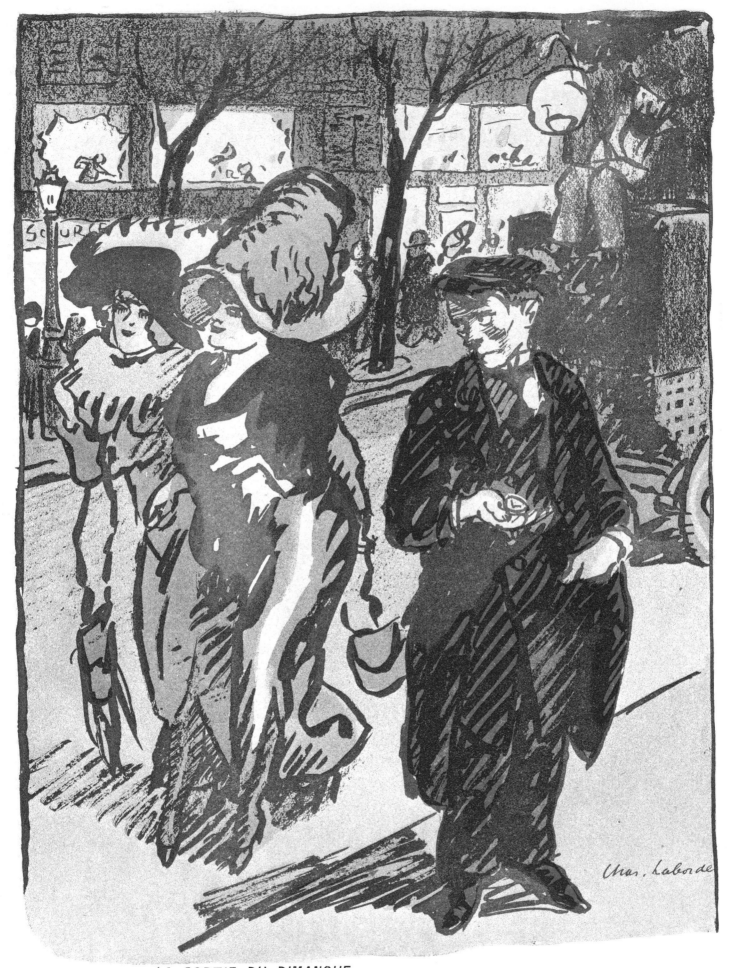

LA SORTIE DU DIMANCHE.

— Ah zut ! 10 heures... il faut rentrer au bahut, hélas !

SUNDAY, THE DAY OFF FROM BOARDING SCHOOL. "Oh, damn! Ten o'clock
... I've got to get back to the dump!" [No. 575, Apr. 20, 1912; issue on schoolboys]

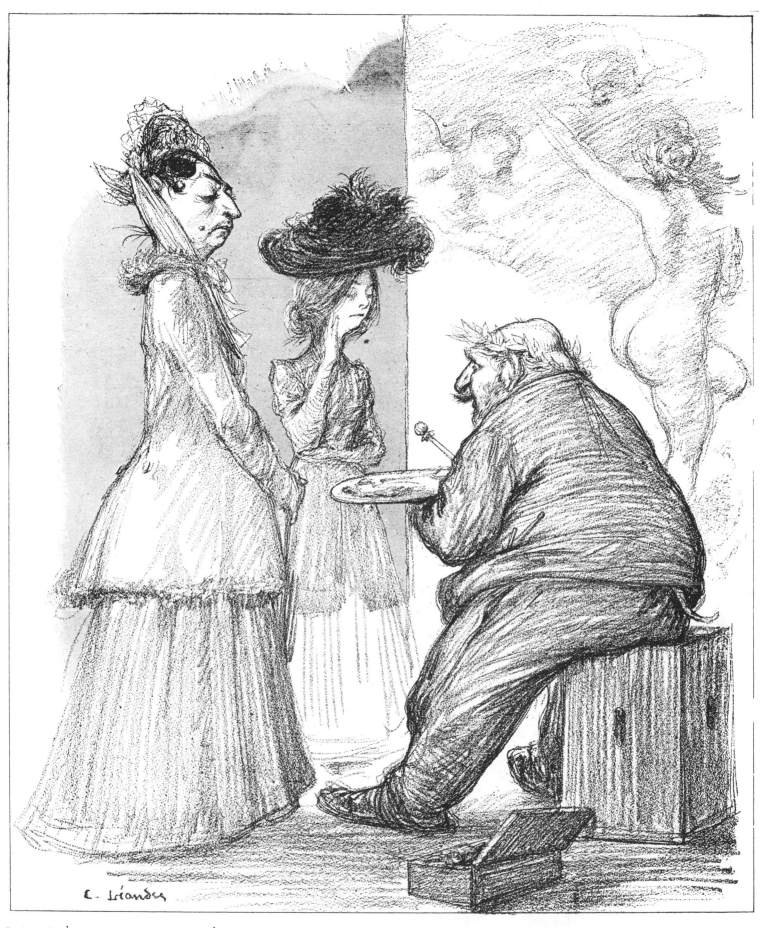

LA MÈRE DU MODÈLE

— OUI, MAÎTRE, PAR CE TEMPS DE MŒURS A OUTRAGES MON DEVOIR DE MÈRE M'ORDONNE D'ASSISTER AUX SÉANCES...

THE MODEL'S MOTHER. "Yes, *maître*, in these days of low morality, my duty as a mother compels me to attend the posing sessions." [No. 2, Apr. 11, 1901]

Charles-Lucien Léandre 97

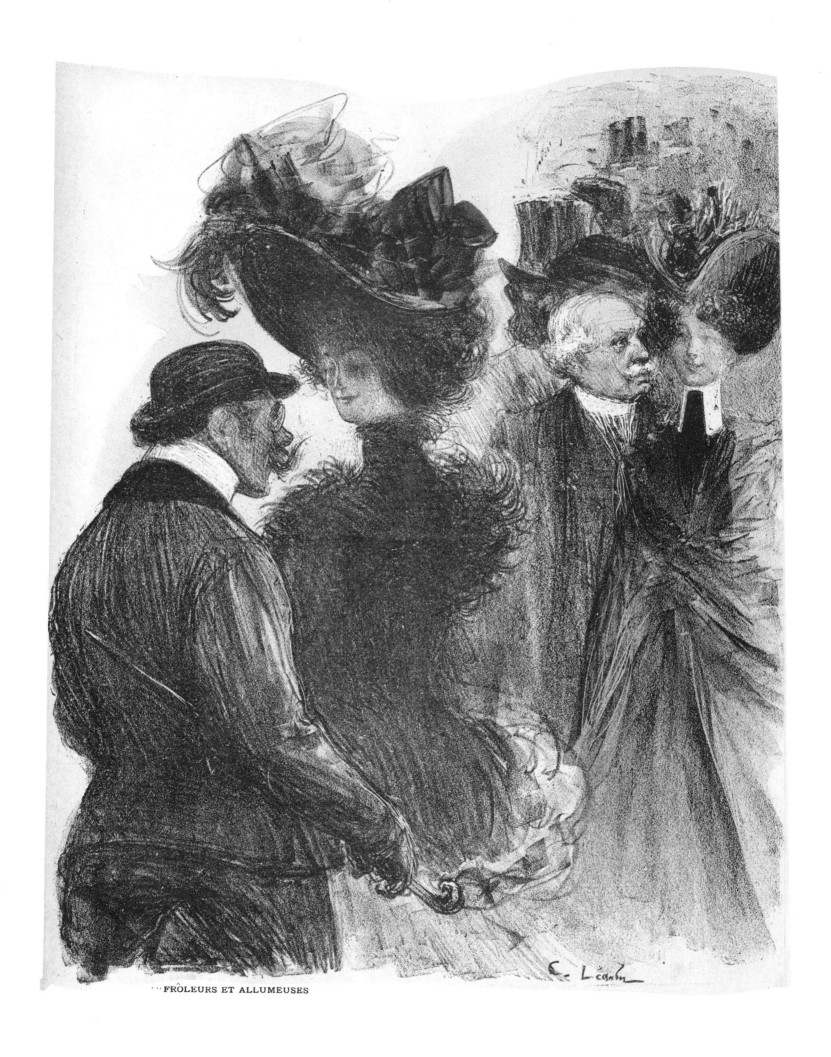

"FRÔLEURS ET ALLUMEUSES"

MEN WHO BRUSH UP AGAINST WOMEN IN THE STREET AND WOMEN
WHO FLIRT BUT DON'T DELIVER. [No. 79, Oct. 4, 1902; issue on "monsters of
society"]

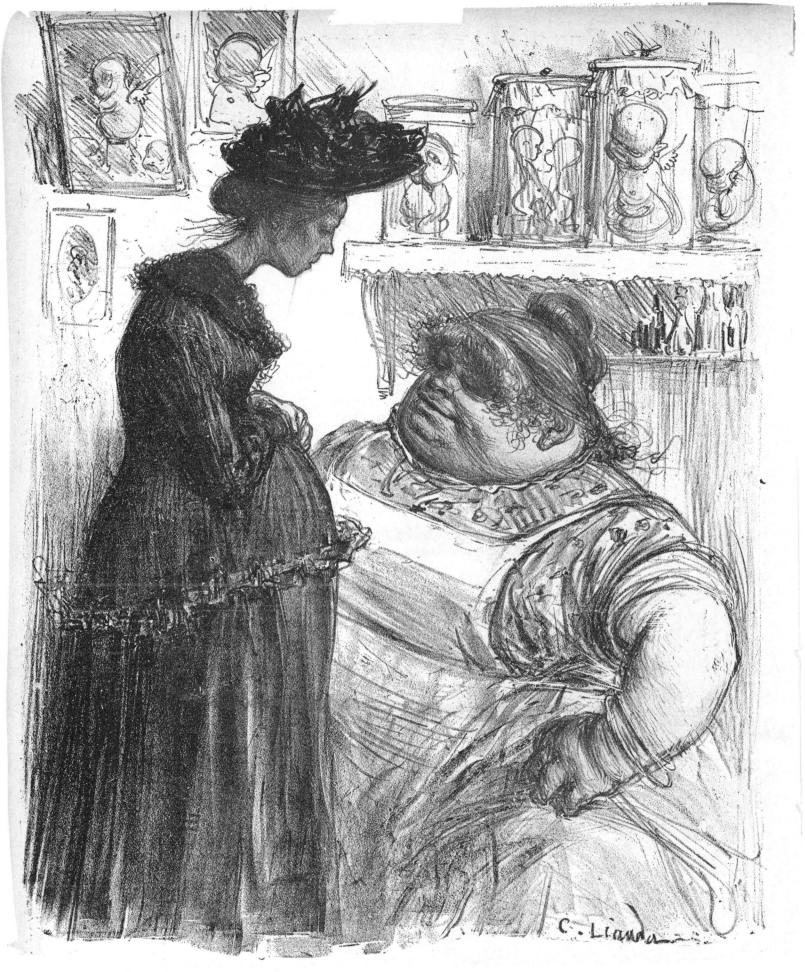

LE MONSTRE DES MONSTRES
Ici l'on fabrique des anges. On fait la concurrence à la maison Bon Dieu.

THE MONSTER OF MONSTERS. Here angels are manufactured. The firm competes
with God and Company. [No. 79, Oct. 4, 1902; issue on "monsters of society"]

Charles-Lucien Léandre 99

— Décidément, c'est idiot, ce service de deux ans! C'est tout à fait insuffisant pour former un brosseur!

THE OFFICER. "This two-year military service is really ridiculous! That's not nearly enough time to train an officer's servant!" [the *fleurs-de-lis* on the wall indicate the officer's monarchist sympathies; No 295, Nov. 24, 1906; issue on the ruling classes]

LE COUP DE L'ÉTRIER.

— C'est rigolo !... c'est moi qui bois et c'est toi qui prends le **cou de l'étrillé !!**

THE STIRRUP CUP. "That's a laugh! I'm the one drinking and you're the one holding
the neck of the fleeced customer!!" [coup de l'étrier and cou de l'étrillé are pronounced
the same; cover of No. 573, Apr. 6, 1912; issue on bars]

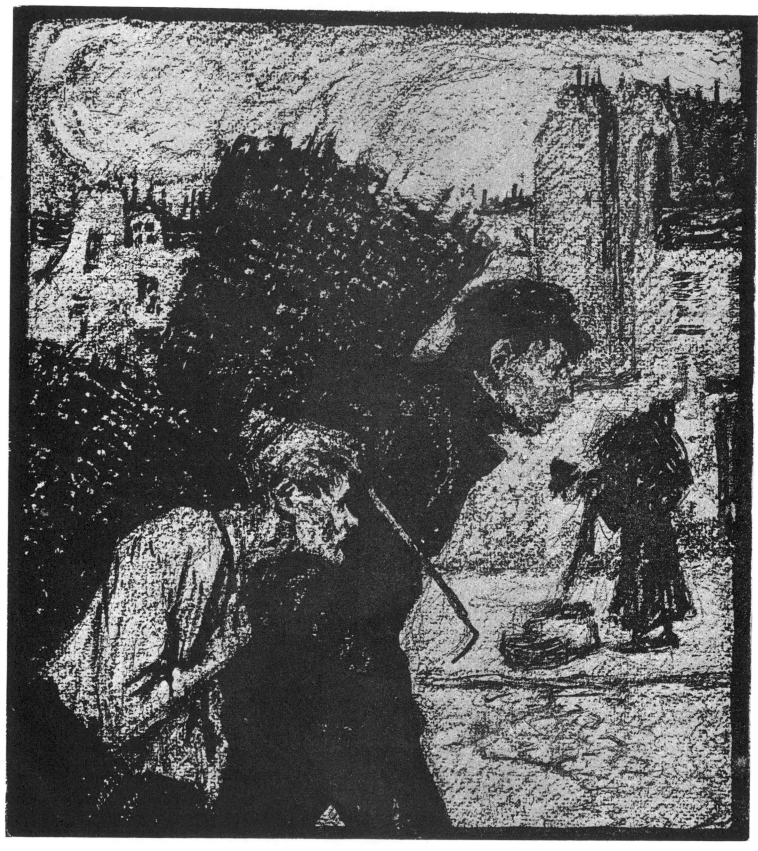

— J'serai rien rupin pour la noce de Titine!... J'ai trouvé une cravate de Le Bargy.

"Won't I be spiffy at Tina's wedding! I found a necktie of Le Bargy's [famous actor of the day]." [No. 8, May 23, 1901]

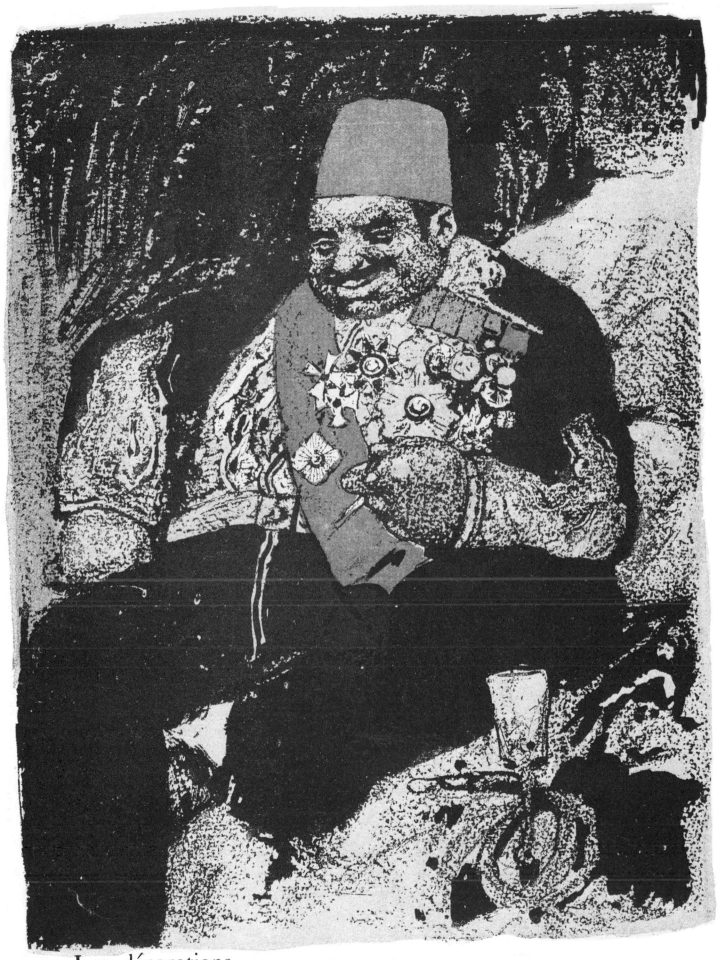

Les décorations

Ici l'on crache par terre et, surtout, sur les poitrines!

MEDALS. Here [in Turkey] they spit on the ground and spatter medals all over
people's chests! [No. 72, Aug. 16, 1902; issue on Turkey]

Michaël 103

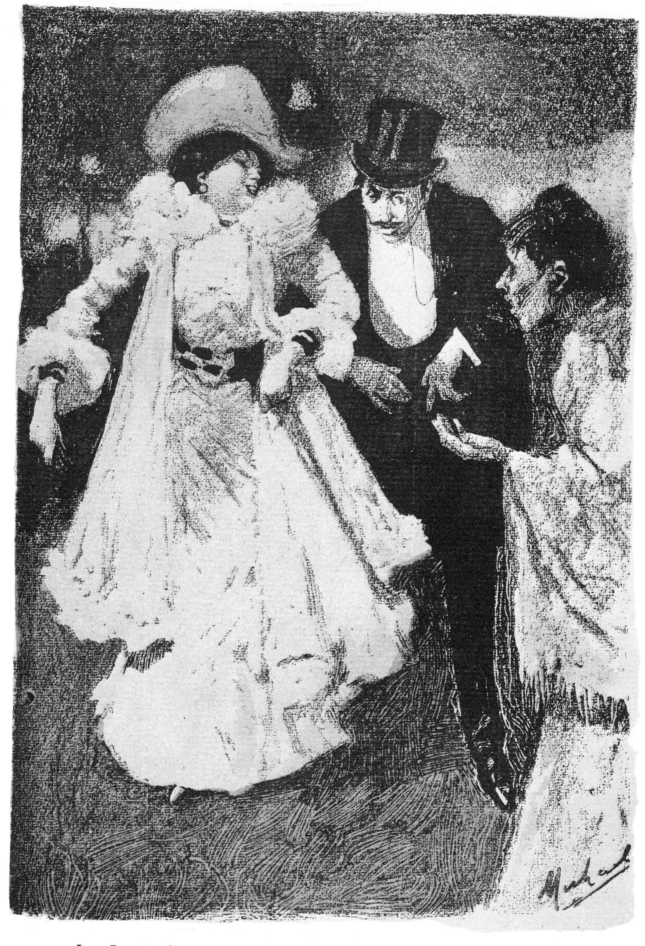

Le Snob fêtard.

— *Cinquante centimes !... Comme tu es bon !...*

THE PLAYBOY SNOB. "Fifty centimes! How generous you are, dearie!" [No. 20, Aug. 15, 1901; issue on snobs]

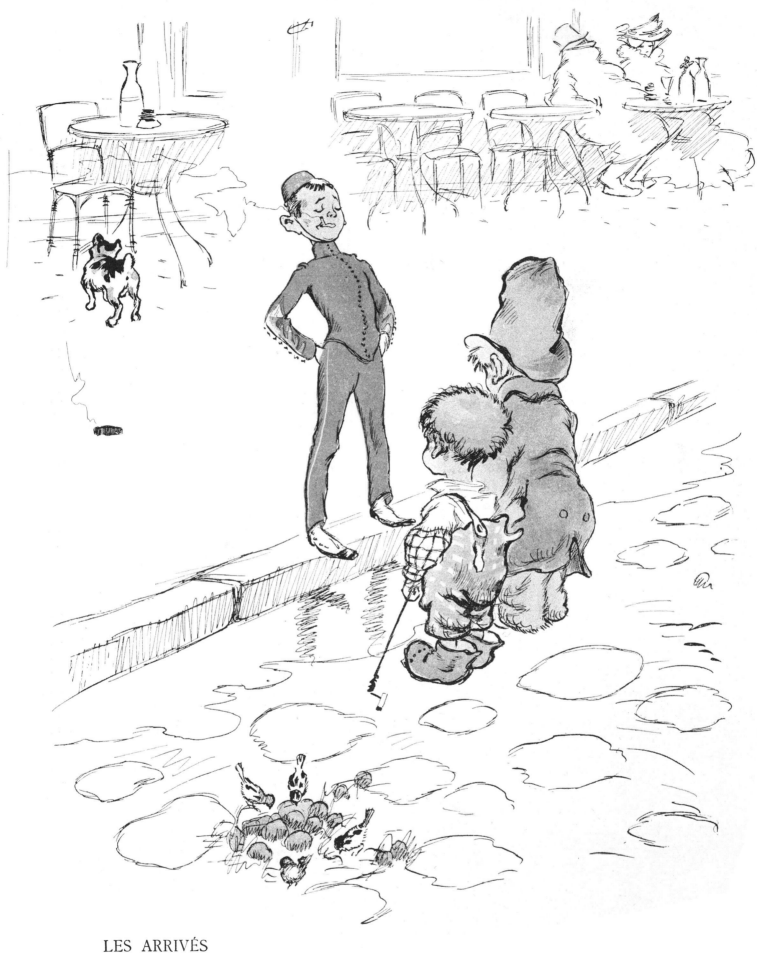

LES ARRIVÉS
— Des mégots? Peuh! moi, j'en ramasse plus... j'en jette!!!!

THOSE WHO HAVE MADE THEIR PLACE IN THE WORLD. "Butts? Ha! *I*
don't pick 'em up any more—I toss 'em away! ! ! !" [No. 69, July 26, 1902; issue on kids]

Henry Mirande 105

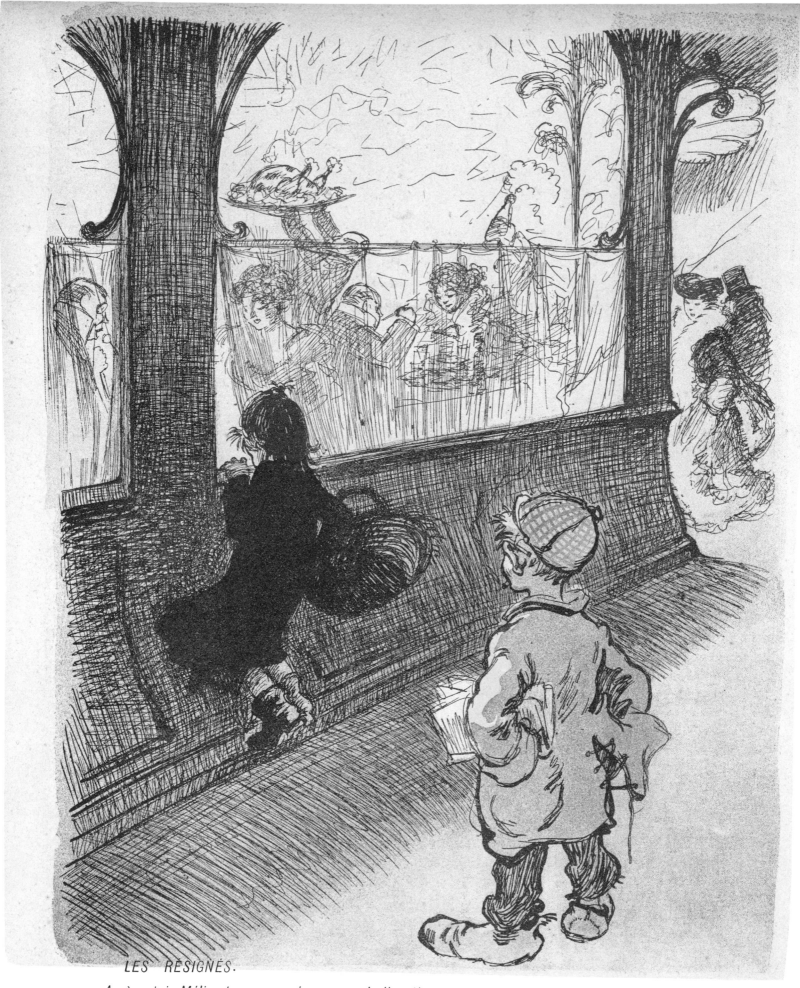

LES RÉSIGNÉS.

— Amène-toi, Mélie, tu vas en choper une indigestion.

THE MEEK AND UNCOMPLAINING. "Come on along, 'Melia, you'll get indigestion." [No. 91, Dec. 27, 1902; Christmas issue]

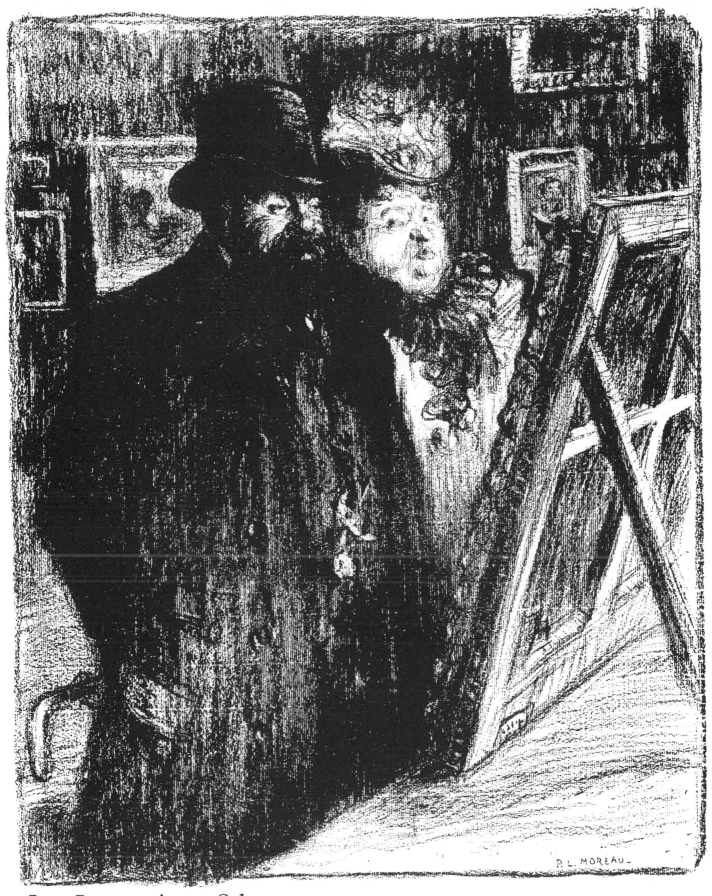

Les Bourgeois au Salon.
— *Tu ne vas pas, j'imagine, en acheter un* tout fait!

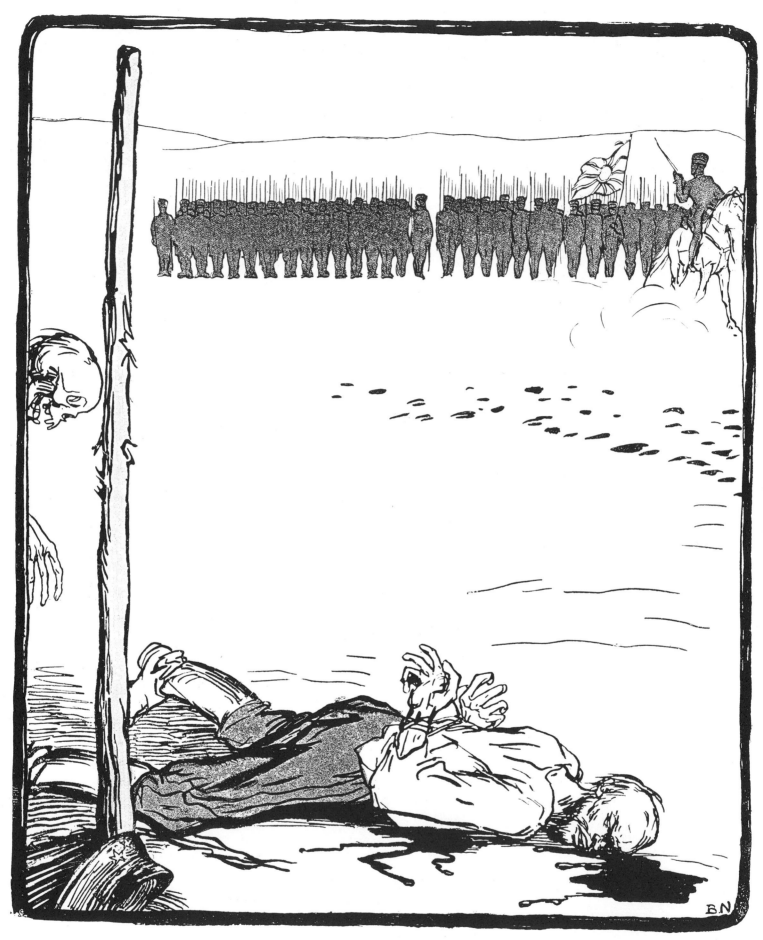

CEUX QUI NE MEURENT PAS A L'ENNEMI.

A l'assaut de Port-Arthur, un colonel japonais dont le régiment était décimé donna l'ordre de battre en retraite. — Le lendemain, il fut fusillé.

THOSE WHO ARE NOT KILLED IN BATTLE. At the attack on Port Arthur, a Japanese colonel whose regiment was cut to pieces gave the order to retreat. The next day he was shot by a firing squad. [No. 192, Dec. 3, 1904; issue on war, titled "Enough!"]

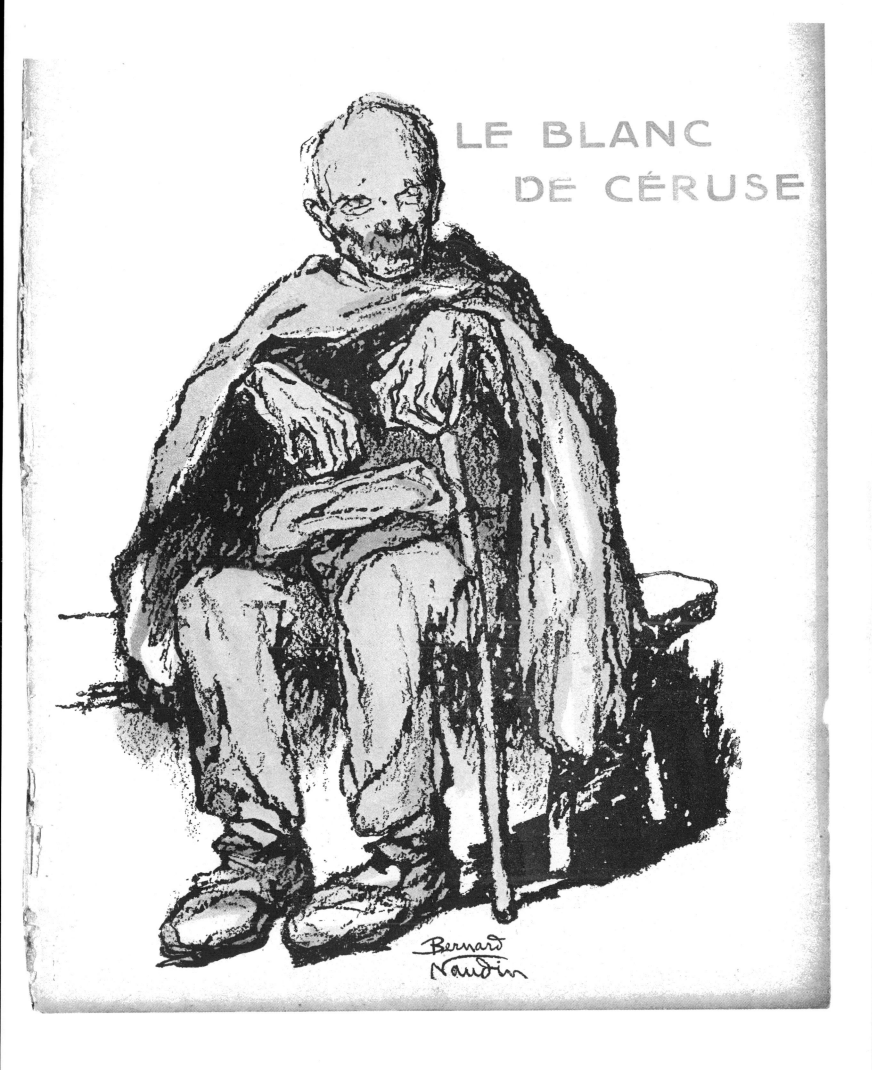

LE BLANC
DE CÉRUSE

[Cover of No. 210, Apr. 8, 1905; issue on workers crippled by white-lead poisoning]

Bernard Naudin 109

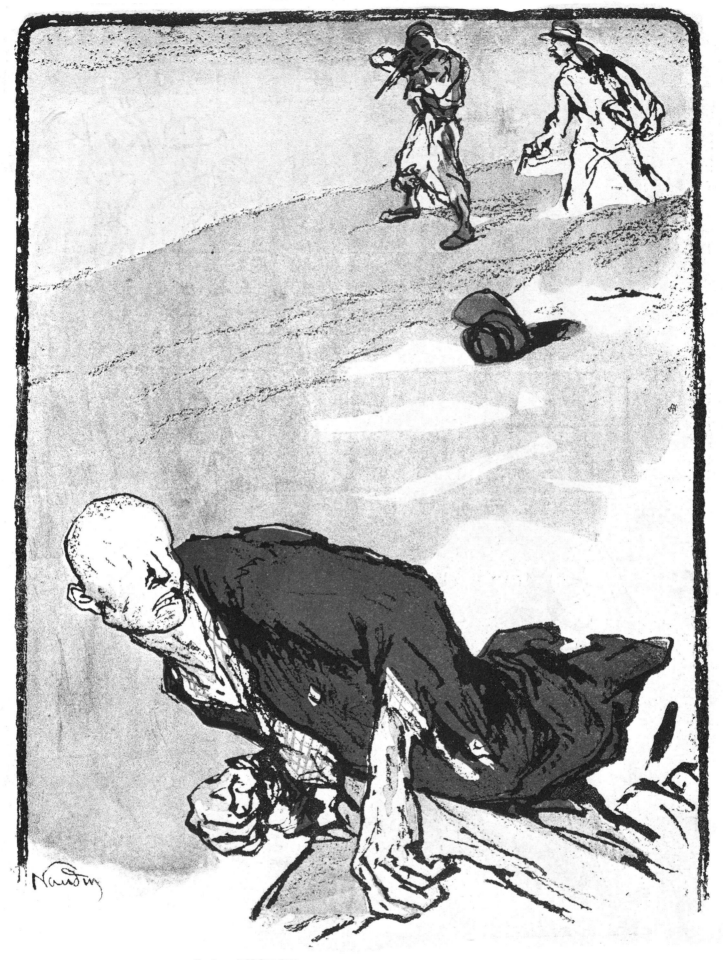

LA FUITE

LE CHAOUCH. — *Vise la tête, chameau ! Troue pas la capote !*

THE ATTEMPTED ESCAPE. THE SERGEANT: "Aim at the head, idiot! Don't make a
hole in the jacket!" [No. 227, Aug. 5, 1905; issue on disciplinary companies of the
French army assigned to hard labor in Algeria]

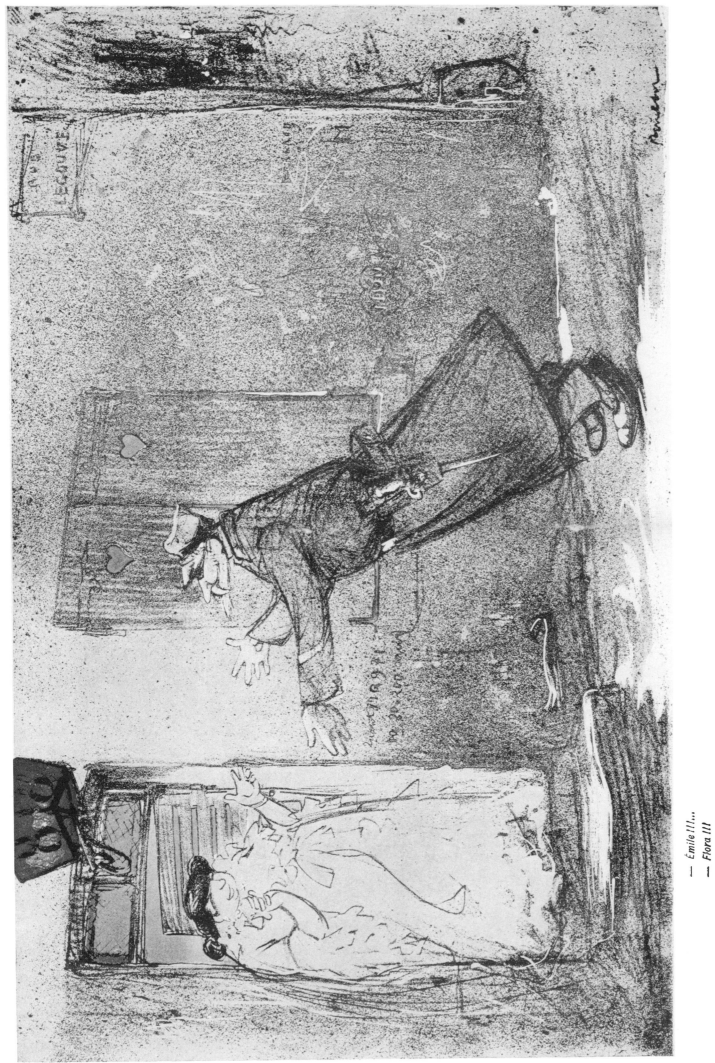

— Émile !!!...
— Flora !!!

"Emile ! !" "Flora ! !" [an aged reserve officer meets an old flame in his summer-training town; No. 281, Aug. 18, 1906; issue on reservists]

LA SAINTE-CATHERINE

— *Et toi, Marie-Louise, tu l'aimes, le champagne?*
— *J'sais pas, j'en ai jamais goûté.*

SAINT CATHERINE'S DAY [celebrated by unmarried millinery girls under 25]. "And you, Marie Louise, do you like champagne?" "Don' know, never tasted any." [No. 272, June 16, 1906; issue on apprentices]

112 *Francisque Poulbot*

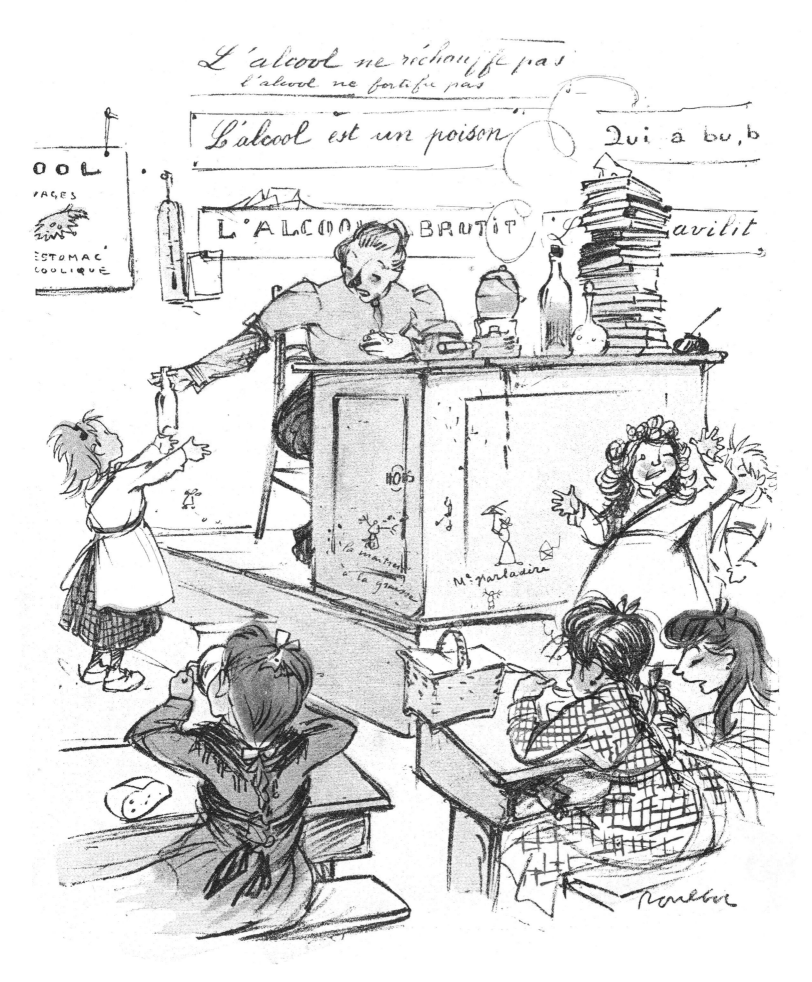

— *Allez chez Pannier chercher dix sous de rhum... et du meilleur !*

"Go to Pannier's for ten cents' worth of rum—and the best brand!" [No. 288, Oct. 6, 1906; issue on alcohol; the signs read: "Stomach of an alcoholic," "Alcohol doesn't warm you up, alcohol doesn't strengthen you," "Alcohol is a poison," "The man who drinks . . . ," "Alcohol brutalizes," "Alcohol lowers a man"]

Francisque Poulbot 113

— *Je donne trois sous à celle qui m'embrasse...*

Francisque Poulbot

"I'll give a nickel to the one who kisses me." [No. 312, Mar. 23, 1907; issue on molesters of children]

« La dans' qui vous aguiche
« C'est la Mattchiche ! »

(Air connu).

THE GIRL IN COMMUNION DRESS: "The dance that turns you on is the maxixe!" (popular
song). [No. 320, May 18, 1907; issue on first Communion]

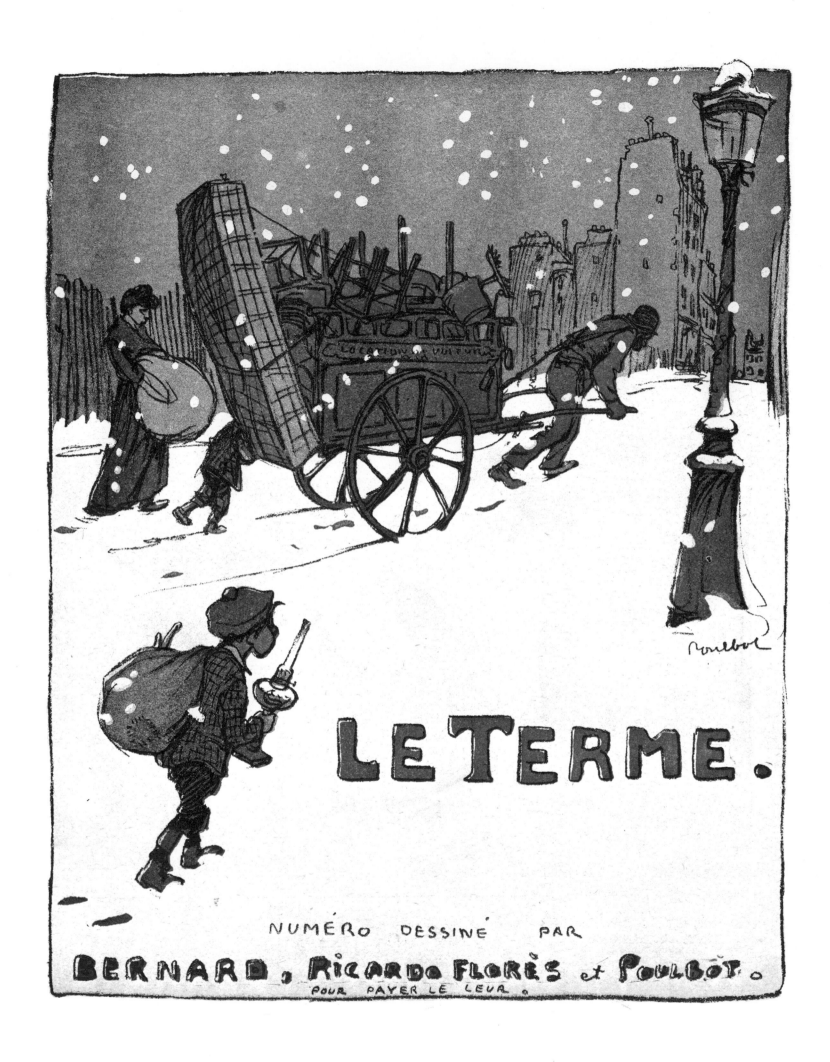

LE TERME.

NUMÉRO DESSINÉ PAR
BERNARD, RICARDO FLORÈS et POULBOT.
POUR PAYER LE LEUR.

[Cover of No. 355, Jan. 18, 1908; issue on quarter day—when the next three months' rent is due; the text reads: "Three Months' Rent; issue drawn by Bernard, Ricardo Florès and Poulbot—so they can pay *theirs*"]

La préposée. — *Je ne m'inquiète pas de l'avenir de mes enfants...*
Ces messieurs du Sénat ne font qu'ici.

THE DOORKEEPER [of the public toilet in the Luxembourg Gardens]: "I'm not worried
about my children's future . . . the senators don't use any toilet but this one." [Cover
of No. 419, Apr. 10, 1909; issue on protectors and protégés]

— Y a des jours, on voit que des brosses à dents; aujourd'hui, j'en cherche une, y en a pas.

— V'là la chaleur qui revient, on va pouvoir quitter son pantalon.
— Moi, ça m'est égal, j'en mets jamais.

"There are days when all you see is toothbrushes; today I'm looking for one and there aren't any." / "It's getting hot again; we'll be able to take off our snuggies." "That's all the same to me; I never wear any." [No. 467, Mar. 12, 1910; issue on the Flea Market]

— Le samedi, c'est un jour qui donne... J'ai toujours peur qu'ils m'foutent ma maison par terre !...

"Saturday is a profitable day . . . I'm always afraid they'll shake my building to pieces!" [No. 483, July 2, 1910; issue on hotelkeepers]

Francisque Poulbot 119

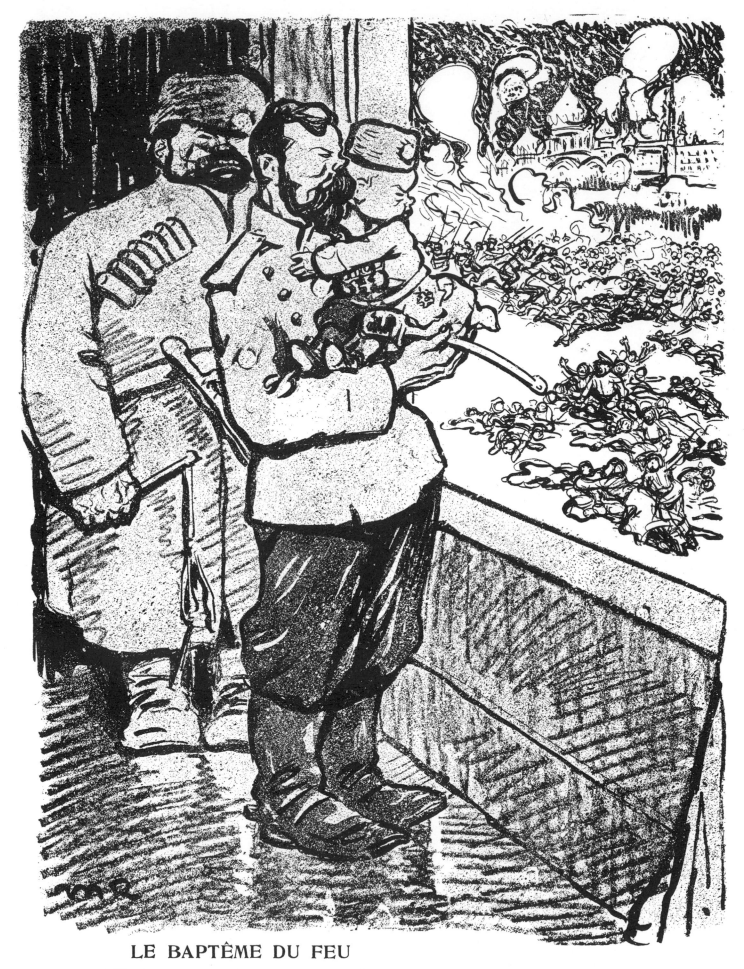

LE BAPTÊME DU FEU

— N'est-ce pas que le sang russe est beau, mon fils… Et ce n'est pas la peine d'aller en Mandchourie pour le voir couler.

BAPTISM OF FIRE. "Russian blood is beautiful, isn't it, my son? And there's no need to go to Manchuria to see it flow." [No. 201, Feb. 4, 1905; issue on "The Bloodstained Tsar," referring to the shooting down of peaceful demonstrators in January 1905, during the Russo-Japanese War, an act of oppression that sparked the revolutionary events of that year]

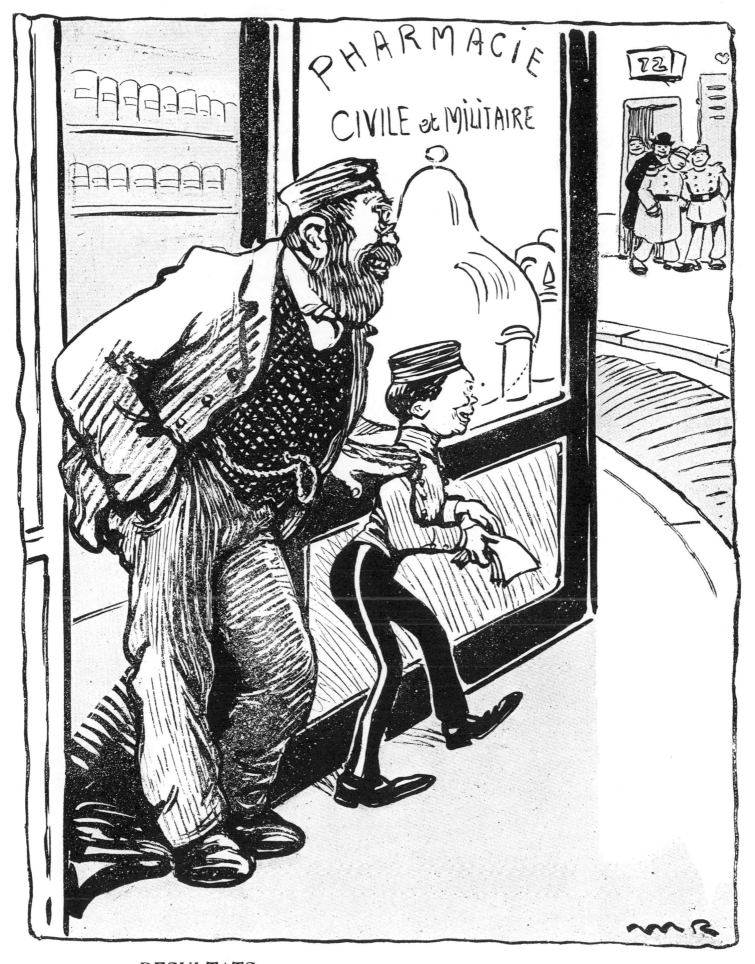

RESULTATS

— *Ouste! Cours donner des prospectus à ces messieurs... ce sont des clients pour la semaine prochaine.*

RESULTS. "Quick! Run and give those gentlemen some brochures—they'll be customers next week." [No. 207, Mar. 18, 1905; issue on syphilis]

Maurice Radiguet 121

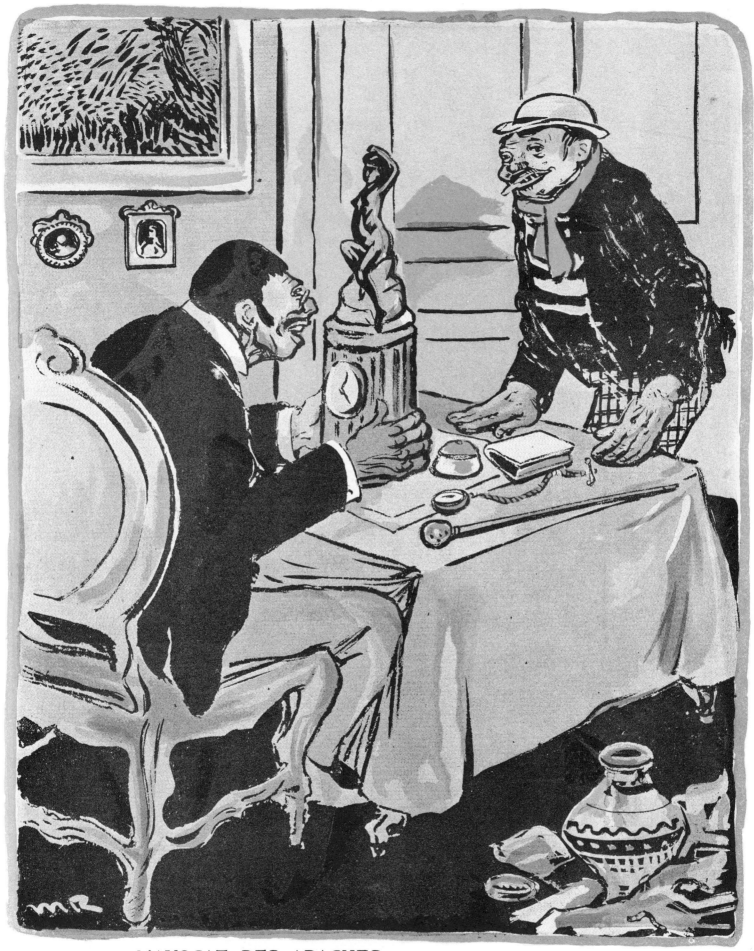

L'AVOCAT DES APACHES

— *Je n'accepte pas un sou de mes clients... je me contente d'un petit souvenir.*

THE CRIMINALS' LAWYER. "I don't take a cent from my clients—I'm satisfied with a little memento." [No. 208, Mar. 25, 1905; issue on lawyers]

La Châtelaine de l'endroit.

Cette sainte et digne femme, si vénérable et si distinguée, bienfaitrice de la commune, a fait fortune en 1855... comme cocotte.

THE LADY OF THE LOCAL MANOR. This pious and dignified woman, so venerable and distinguished, benefactress of the municipality, made her fortune in 1855—as a tart. [No. 74, Aug. 30, 1902; issue on seaside resorts]

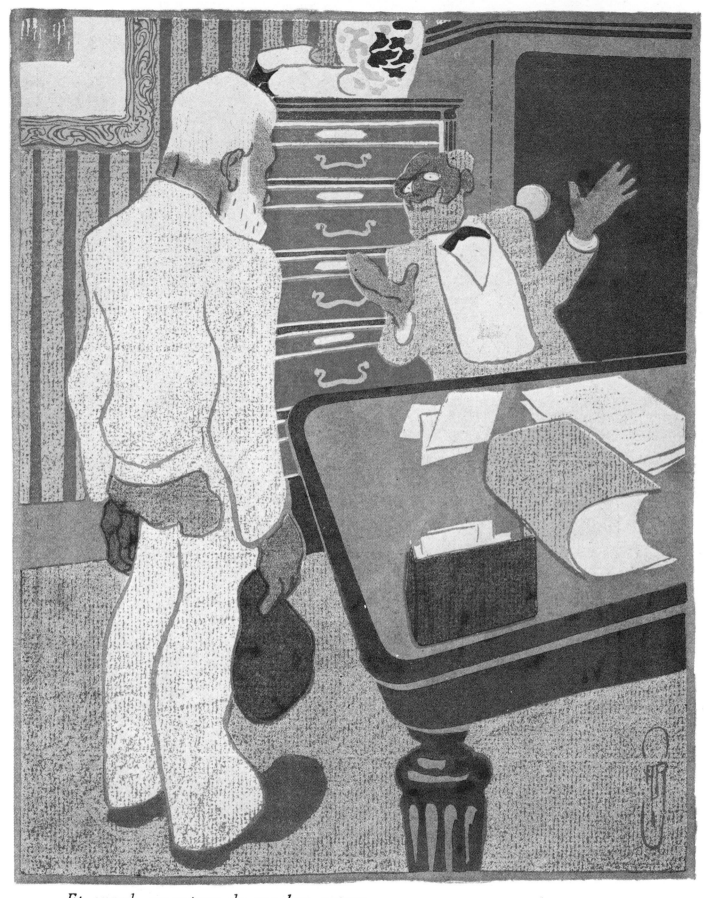

Et quand, au retour de son bon patron,
L'ouvrier demande de l'augmentation :
« Oh ! mon ami, ce n'est pas le moment ;
« Les affaires n'vont pas et n'ai vas d'argent. »

Auguste Roubille

And when his kindly employer gets back [from vacation] and the worker asks for a raise: "My good fellow, this isn't the time; business isn't good and I have no money." [No. 17, July 25, 1901; issue on summer vacations]

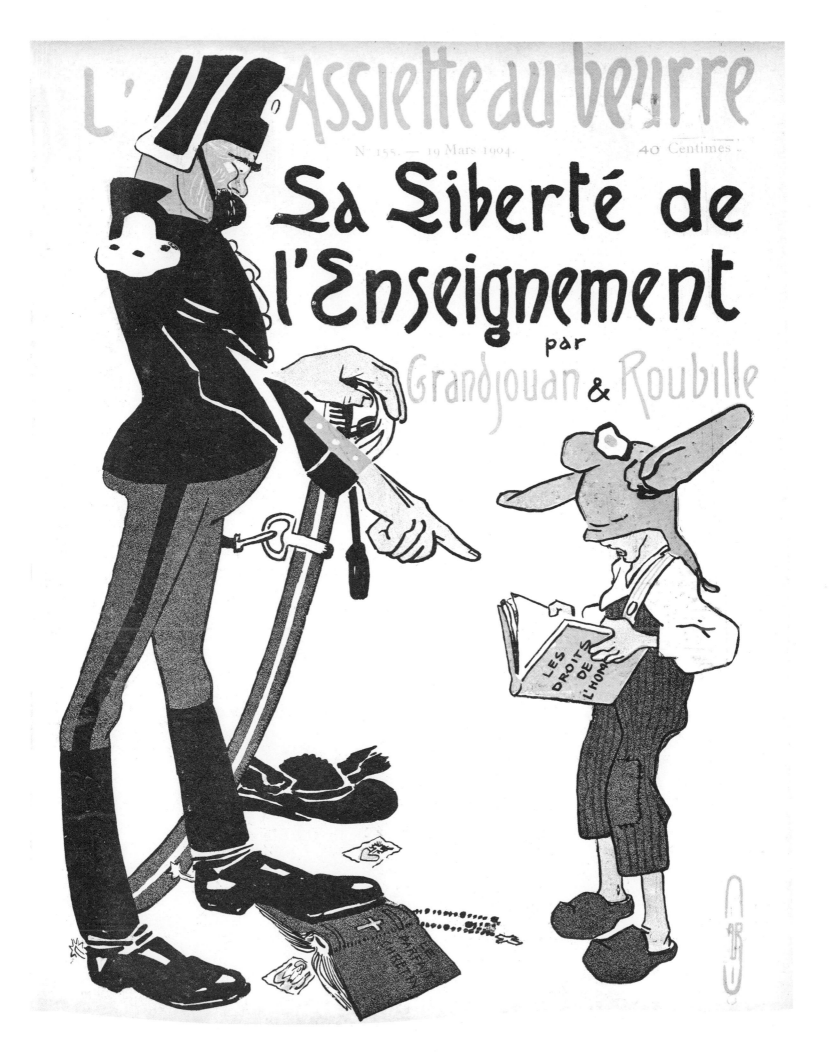

[Cover of No. 155, Mar. 19, 1904; issue on the freedom to teach; the policeman, representative of the secularized state, is treading on *The Perfect Christian*—a priest's hat, a rosary and pious images are on the ground as well—and is commanding the child—who wears a combination Phrygian cap, symbol of liberty and the French Revolution, and dunce cap—to read the libertarian *Rights of Man*]

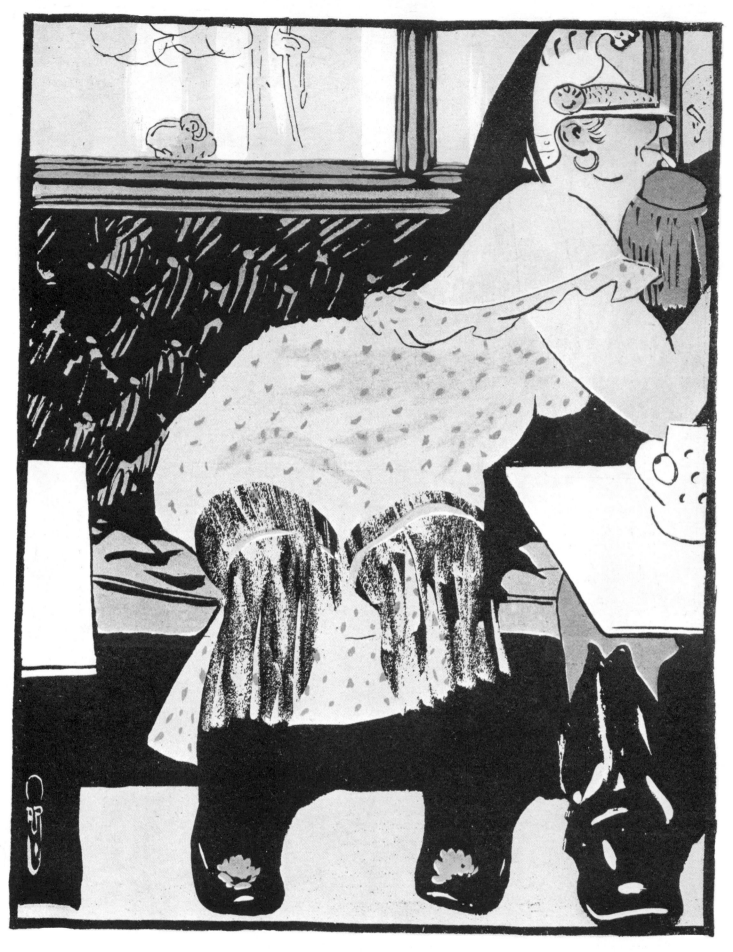

LA REMPLAÇANTE

— *Monte, va, tu regretteras pas ta payse!...*

THE SUBSTITUTE. "Come on up, you won't miss the girl back home." [No. 171, July 9, 1904; issue on temptresses]

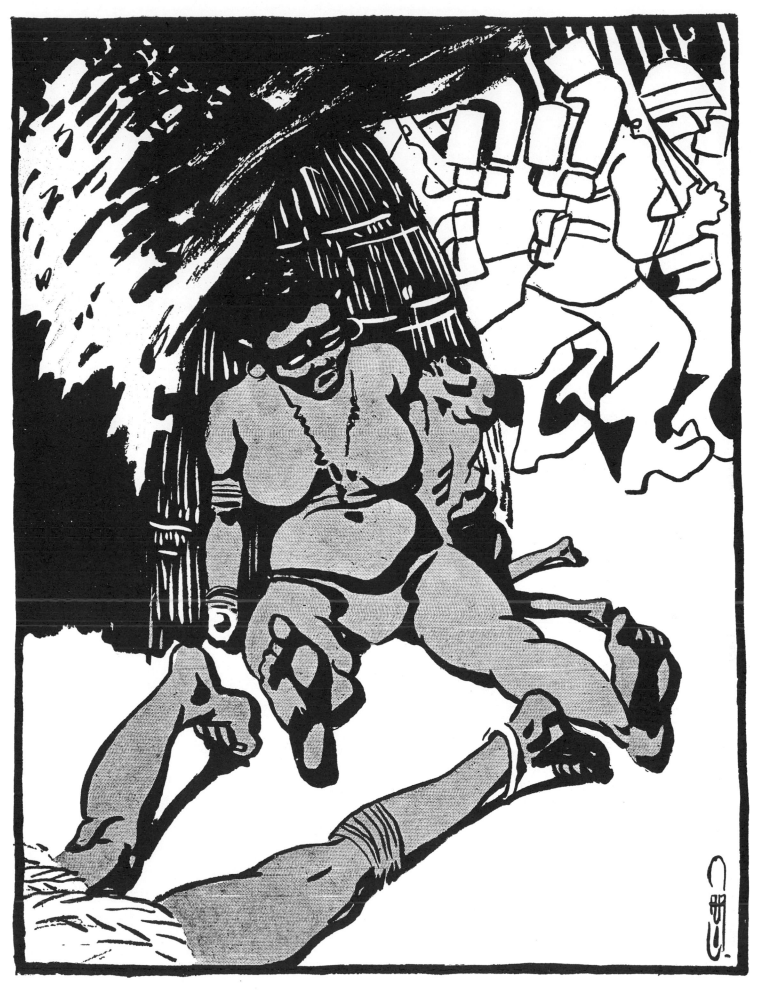

... il est souvent sublime.

["If the workingman is sometimes shameless—when rebelling against authority—] he is often sublime [when in the army and committing atrocities]." [No. 199, Jan. 21, 1905; issue titled "Thoughts of a Pot-Bellied Man," i.e., "Maxims of the Moneyed"; the smug bourgeois is represented as approving colonial expansion at any cost]

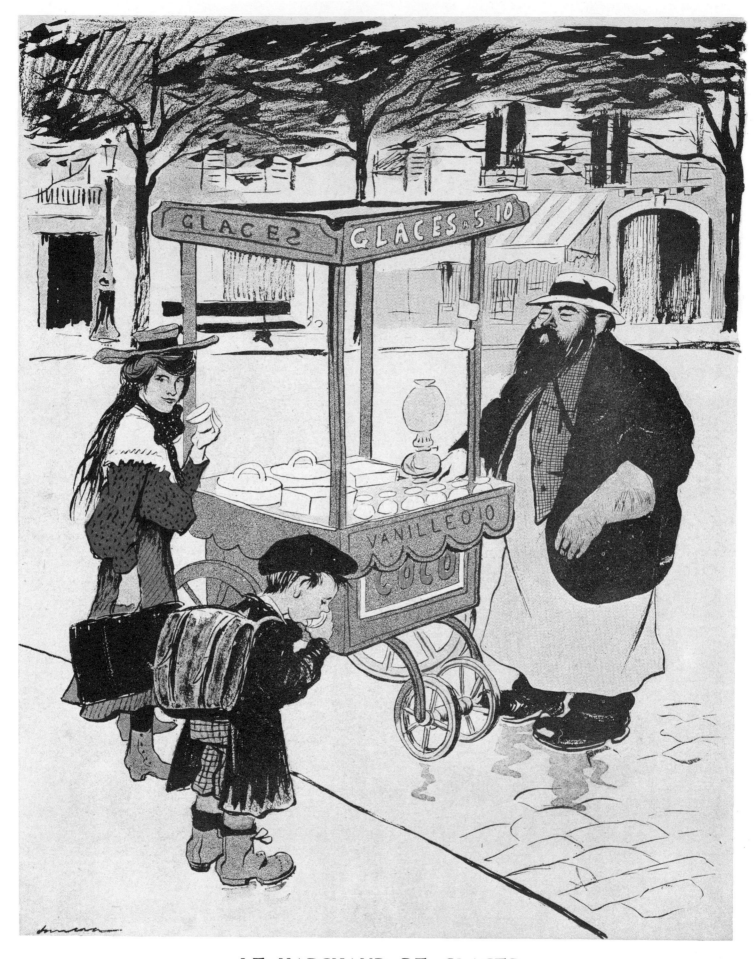

LE MARCHAND DE GLACES

— *A la bonne heure! Monsieur lèche bien son verre : il sera propre pour les suivants.*

THE VENDOR OF ICES. "Good! The gentleman is licking out his glass thoroughly: it'll be clean for the next customers." [No. 226, July 29, 1905; issue on Parisian types]

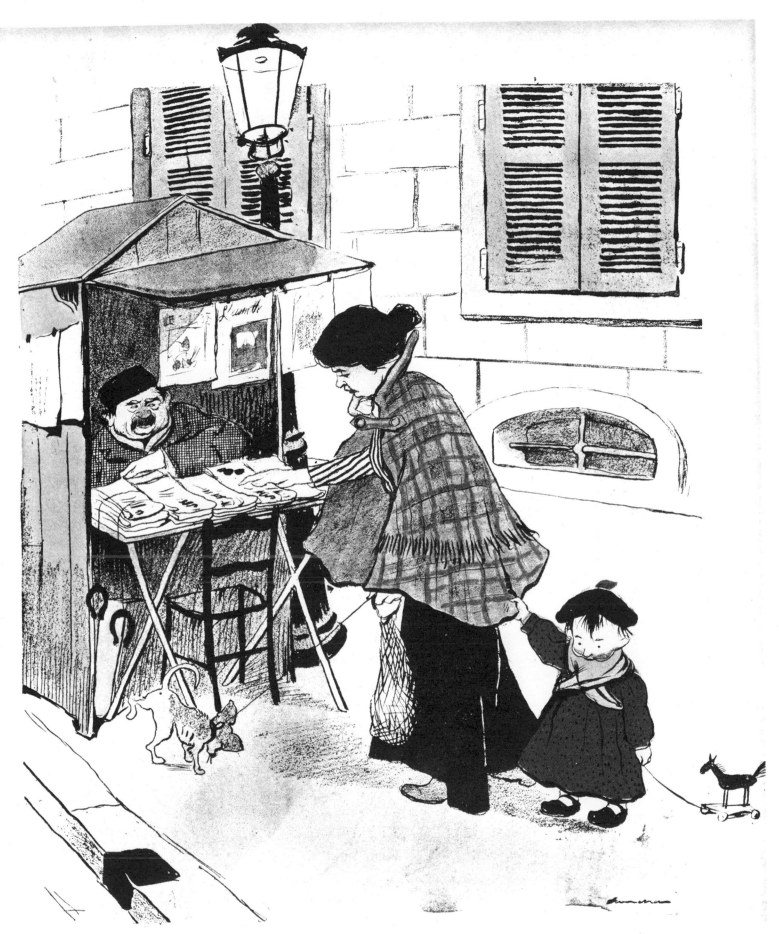

— *Donnez-moi le jornal qu'a huit pages aujourd'hui : maman s'a purgée.*

"Give me the paper that's got eight pages today; Mom took an enema." [No. 226, July 29, 1905; issue on Parisian types]

Francisco Sancha 129

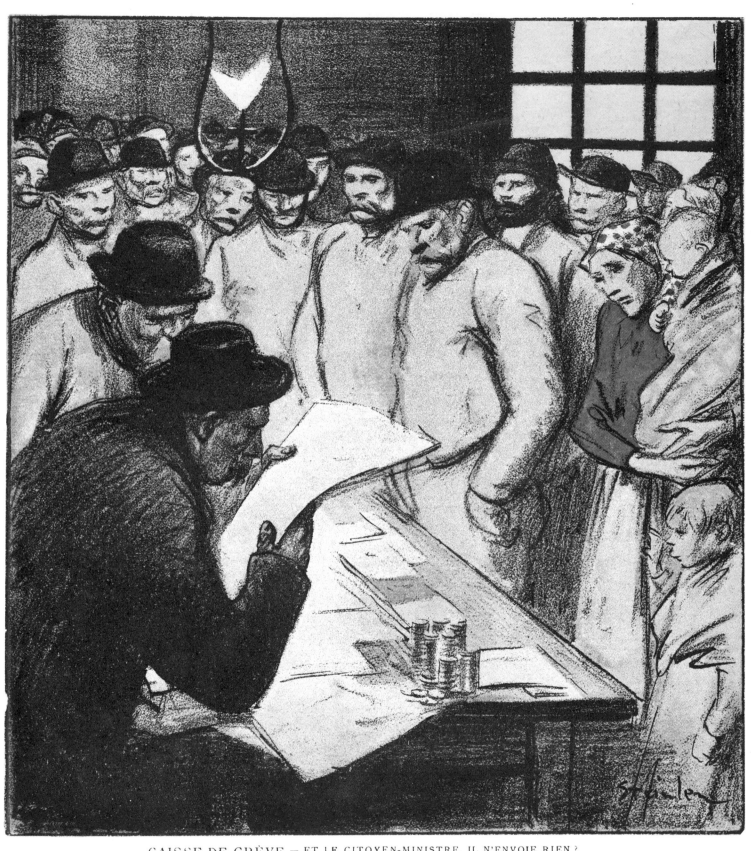

CAISSE DE GRÈVE — ET LE CITOYEN-MINISTRE, IL N'ENVOIE RIEN ?
— SI, 3,000 HOMMES DE TROUPE.

STRIKE FUND. "And isn't the 'citizen-minister' sending anything?" "Yes, 3000 troops." [Cover of No. 1, Apr. 4, 1901; the ministry at the moment consisted of a "left-wing coalition," old-time liberals whose present attitude toward labor did not differ materially from that of their political opponents]

NOS BOURGEOIS

— QU'EST-CE QUI VOUS FAIT RIRE?
— C'EST D'PENSER SI MADAME NOUS VOYAIT.

OUR MIDDLE-CLASS CITIZENS. "What are you laughing about?" "I was just thinking if the Missus saw us." [No. 3, Apr. 18, 1901]

Théophile-Alexandre Steinlen 131

HIVER
– LES PRISONS, EST-CE QUE C'EST CHAUFFÉ?...

WINTER. "Are prisons heated?" [No. 1, Apr. 4, 1901]

FIN DE GREVE
— CHARMₑ DE REVOIR CES GAILLARDS QUI VOULAIENT NOUS FAIRE MOURIR DE FAIM!

AFTER THE STRIKE. "Glad to see you back . . . so you're the fellows who wanted to starve us out!" [No. 6, May 9, 1901]

LES GRANDEURS

— C'QUE C'EST QU'LA VEINE ! MON PÈRE ETAIT MAÇON, MA MÈRE LAVEUSE,
ET MOI, A PRÉSENT, Y A DES PRINCES QUI ME TUTOIENT

THE HEIGHTS. [THE DOMESTIC SERVANT:] "What luck will do for you! My father
was a bricklayer, my mother took in laundry, and now there are princes who call me
by my first name!" [No. 6, May 9, 1901]

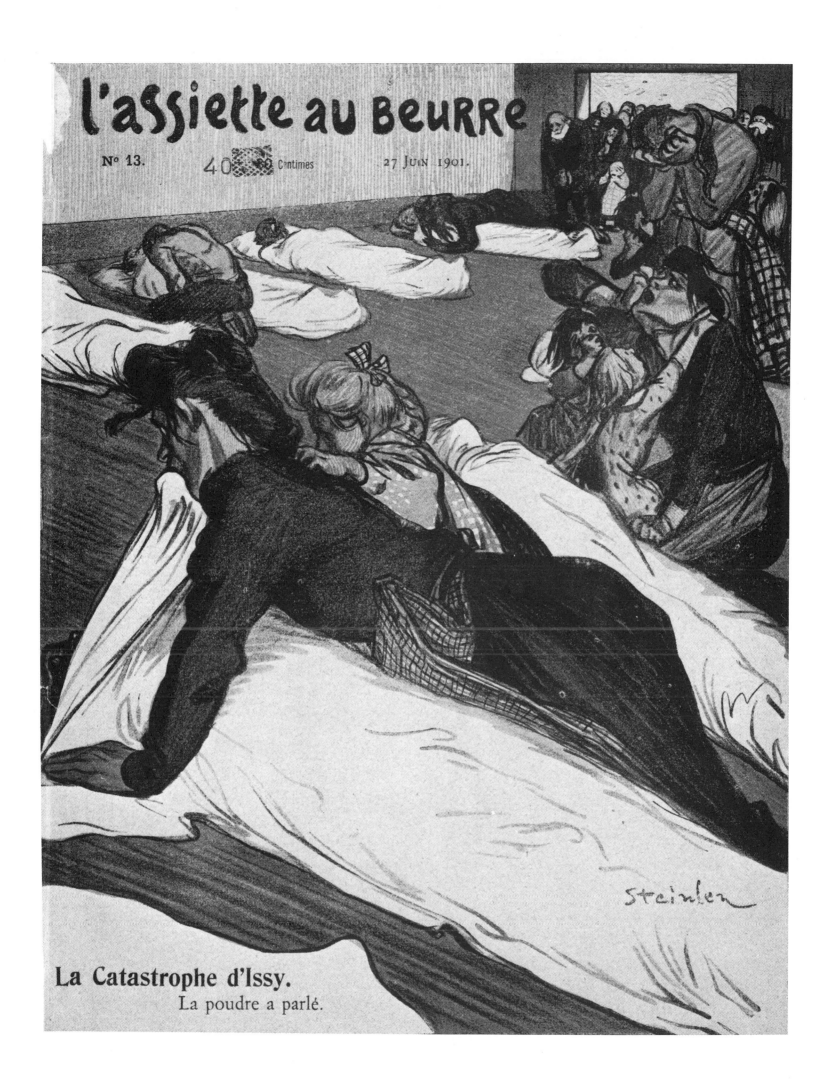

l'aSSiette au BeuRRe

N° 13. 40 Centimes 27 Juin 1901.

La Catastrophe d'Issy.
La poudre a parlé.

THE CATASTROPHE AT ISSY. The powder spoke. [Cover of No. 13, June 27, 1901; relatives are identifying the 17 victims of the powder-factory explosion at Issy-les-Moulineaux, not far from Paris, on June 14, 1901]

Théophile-Alexandre Steinlen 135

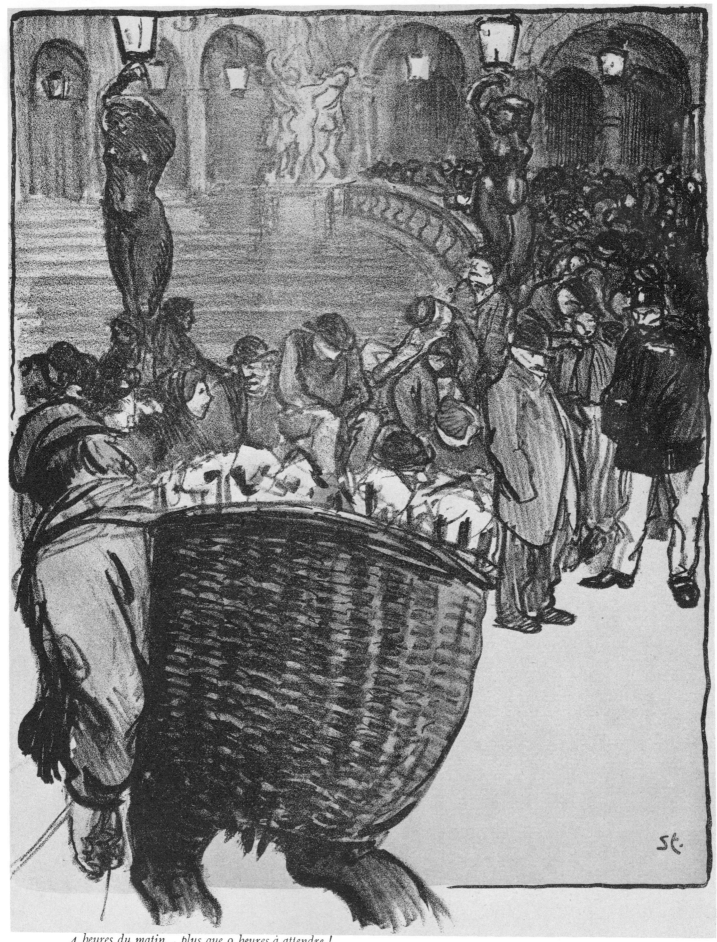

4 heures du matin... plus que 9 heures à attendre !
— *Pauv' populo, ça ne t'entrera-t-il jamais dans la tête que c'est toi, toujours toi, qui paies même le spectacle gratis.*

FREE PERFORMANCE [at the state Opera on the national holiday]. Four A.M.—only nine more hours to wait! "Poor rabble, won't you ever get it into your head that it's you, always you, who pay—even for the free show!" [No. 15, July 11, 1901; issue on Bastille Day]

Représentation gratuite.

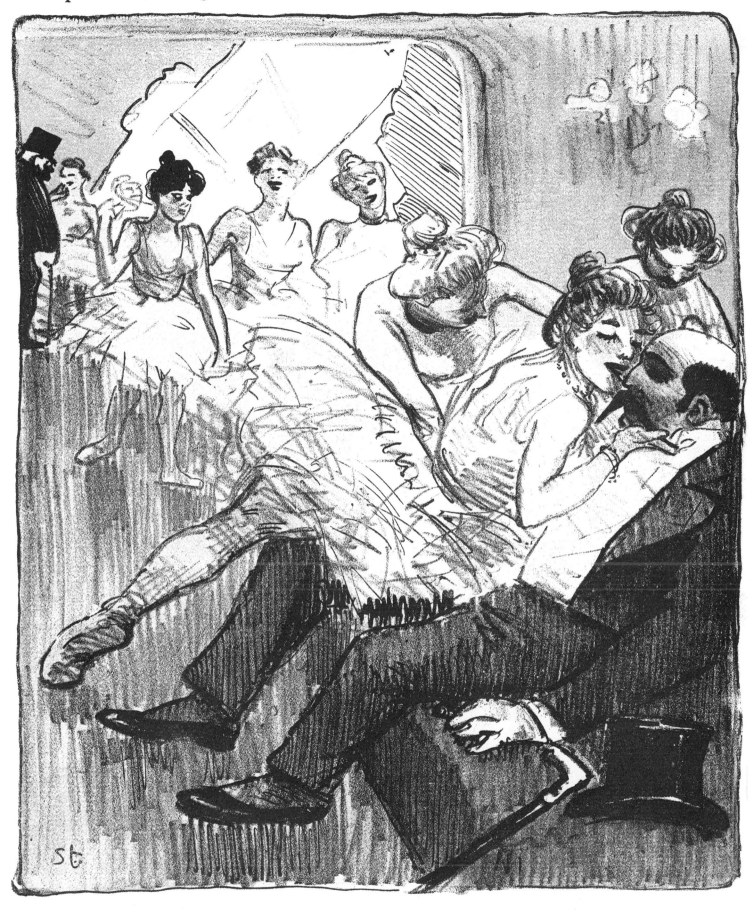

FOYER DE LA DANSE
— *Qu'est-ce que notre petit Georges va donner à ses poupoules qu'ont bien gueulé la Marseillaise pour son sale populo ?*

FREE PERFORMANCE. THE BALLET GREENROOM. "What's our little Georgie gonna give his duckies who yelled out the 'Marseillaise' for his dirty paupers?" [No. 15, July 11, 1901; issue on Bastille Day]

Théophile-Alexandre Steinlen 137

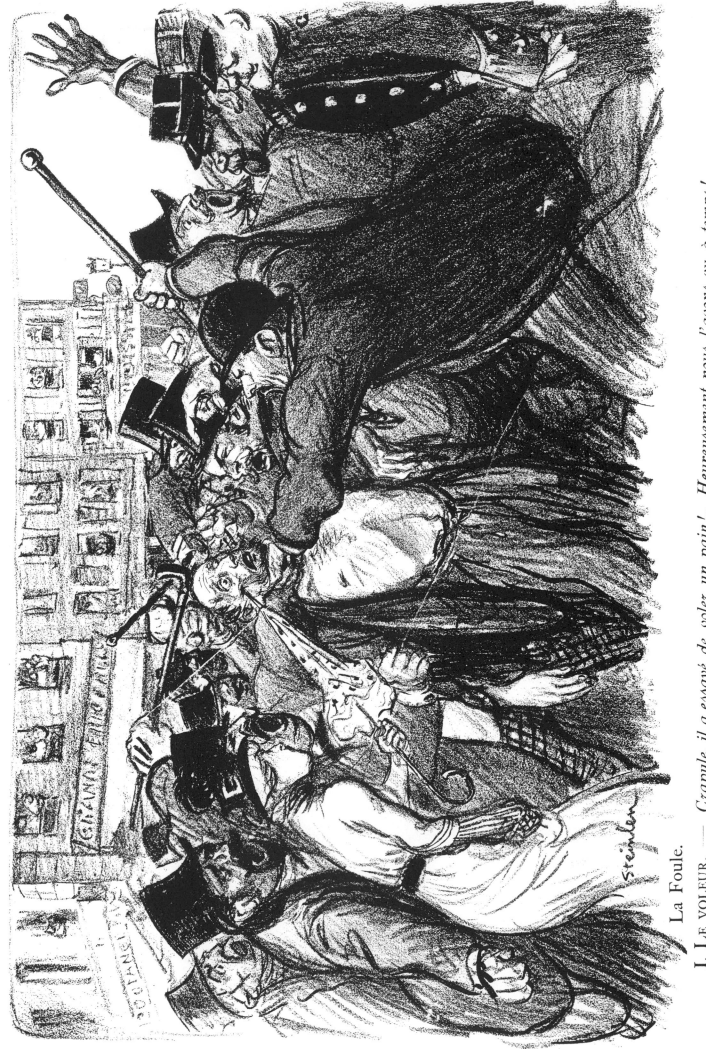

La Foule.

I. LE VOLEUR. — *Crapule, il a essayé de voler un pain!.. Heureusement nous l'avons vu à temps!*

THE CROWD. [I.] THE THIEF. "The scoundrel! He tried to steal a loaf of bread. Fortunately we spotted him in time!" [No. 13, June 27, 1901]

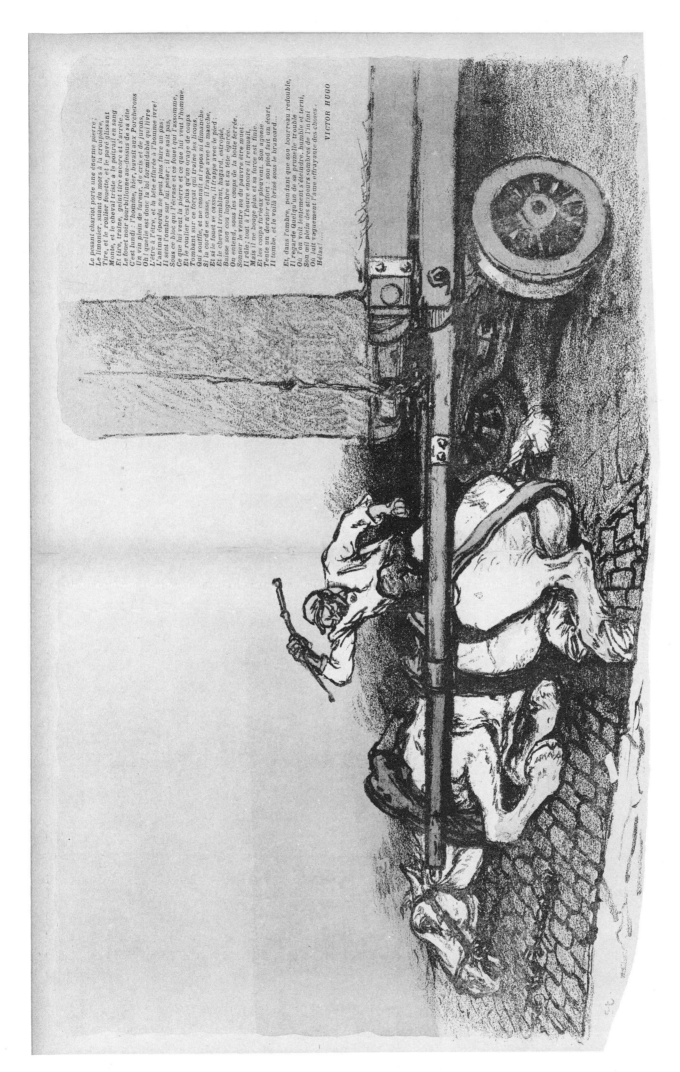

[No. 219, June 10, 1905; issue on mistreatment of horses; the poetic extract is from Victor Hugo's "Melancholia" of 1833, which was included in his volume *Les Contemplations*; the poem treats of various human and animal victims of society; in this section a drunken carter wantonly flogs to death his horse, which lacks the strength to haul an enormous block of stone]

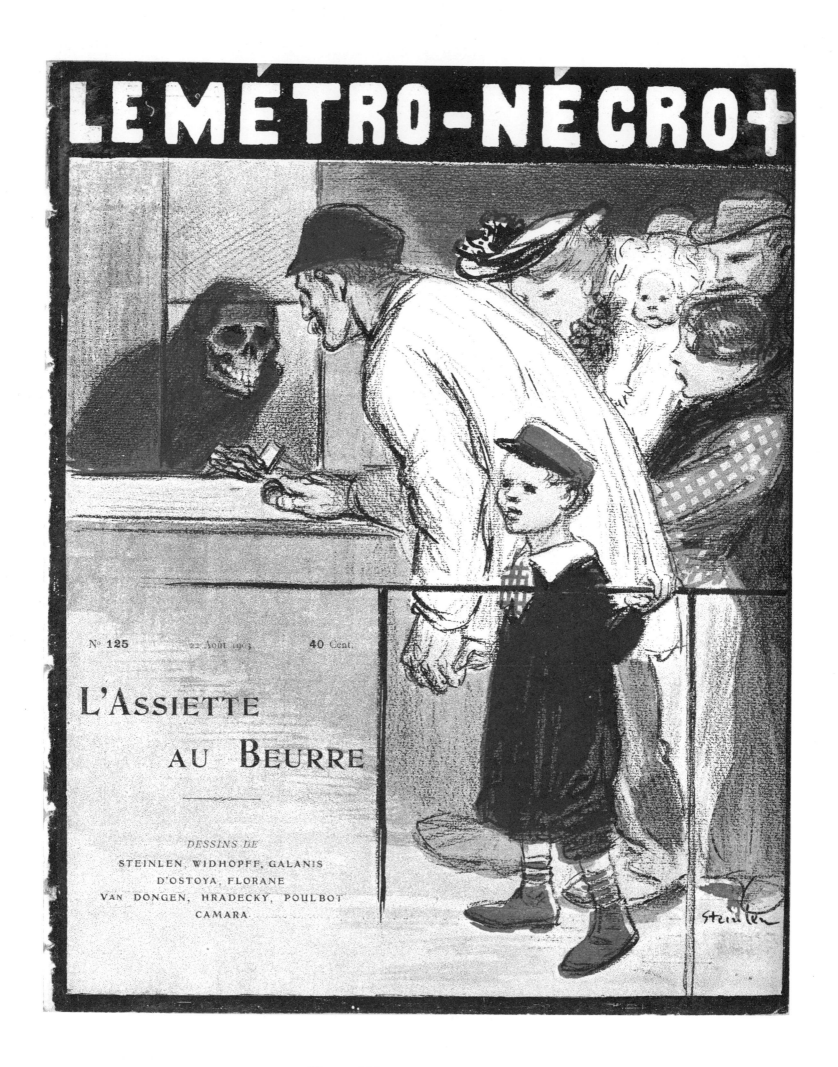

LE METRO-NECRO+

N° 125 22 Août 1903 40 Cent.

L'ASSIETTE AU BEURRE

DESSINS DE
STEINLEN, WIDHOPFF, GALANIS
D'OSTOYA, FLORANE
VAN DONGEN, HRADECKY, POULBOT
CAMARA

[Cover of No. 125, Aug. 22, 1903; issue on the fire at the Couronnes station of the Paris subway on August 10, 1903, in which 84 people were burned or trampled; this station is on the Boulevard de Belleville in the northeastern part of the city]

L'Amour

par VADASZ

Les p'tits jeun' hommes

par M. Vadász

142 *Miklós Vadász* [Cover of No. 422, May 1, 1909; issue on "sweet young men"]

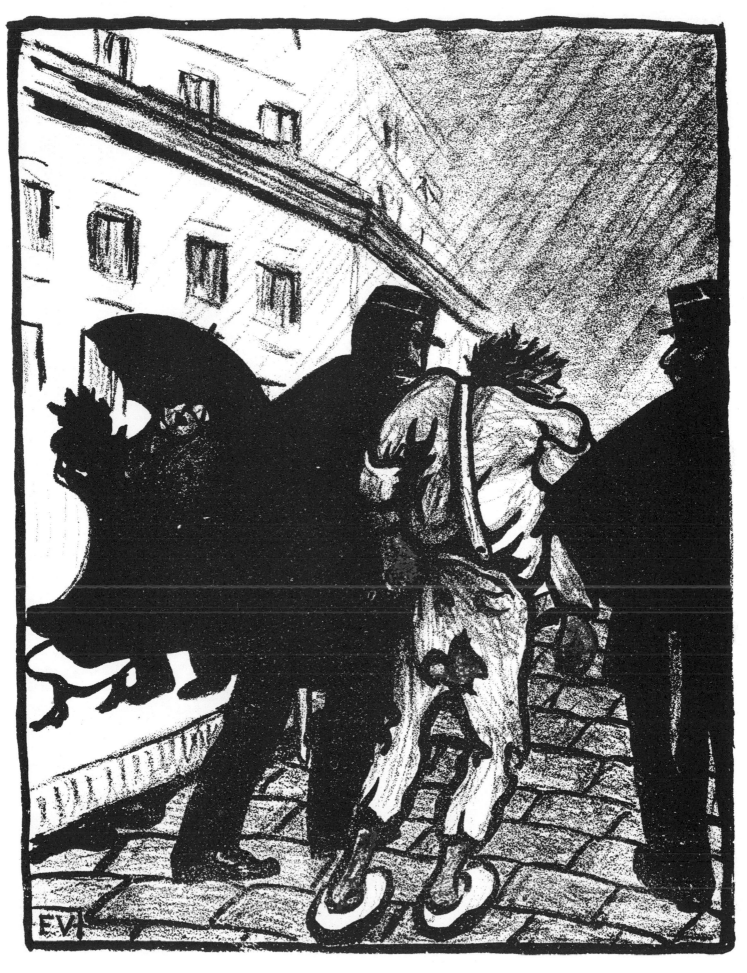

Ah! mon gaillard! Vous montrez votre derrière aux dames!

"Aha, my fine fellow! So you show your behind to the ladies!" [No. 48, Mar. 1, 1902;
issue on "crimes and punishments"]

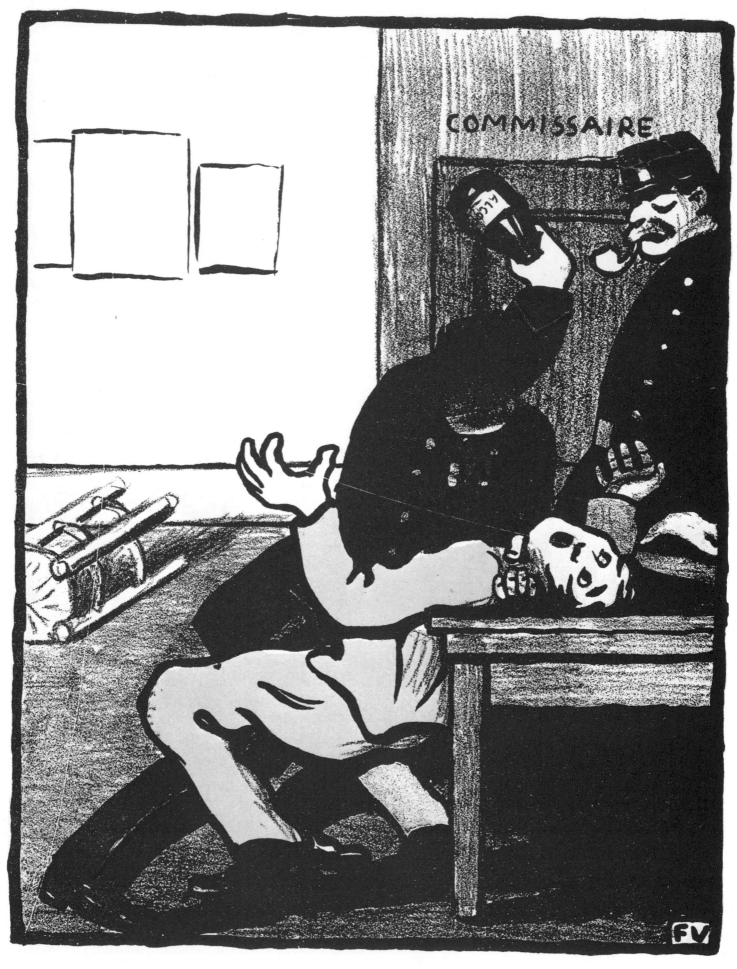

Ah! bougre de salaud, tu m'as appelé vache!.....

"So, you filthy bastard, you called me a pig!" [No. 48, Mar. 1, 1902; issue on "crimes and punishments"]

Traite des blanches.

— *Encore 20 francs... et tu auras fini ta journée!...*

WHITE SLAVERY. "Twenty more francs—and your work day will be over!" [No. 18,
Aug. 1, 1901]

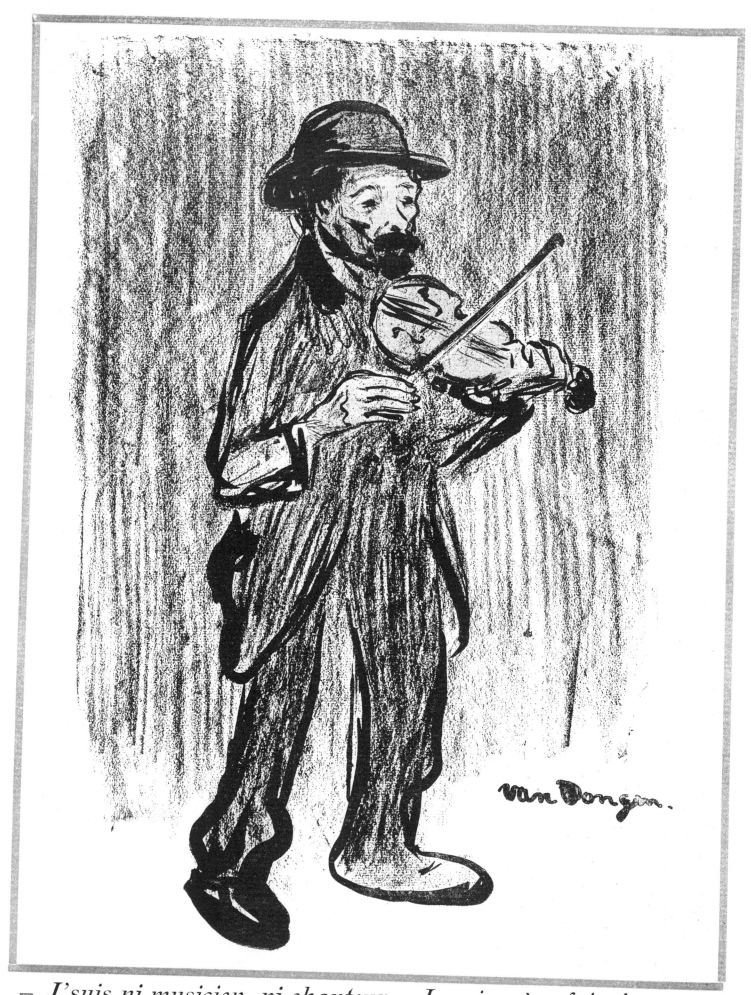

− *J'suis ni musicien, ni chanteur... Je suis crève-faim!...*

"I'm neither a musician nor a singer—I'm a starveling!" [No. 12, June 20, 1901]

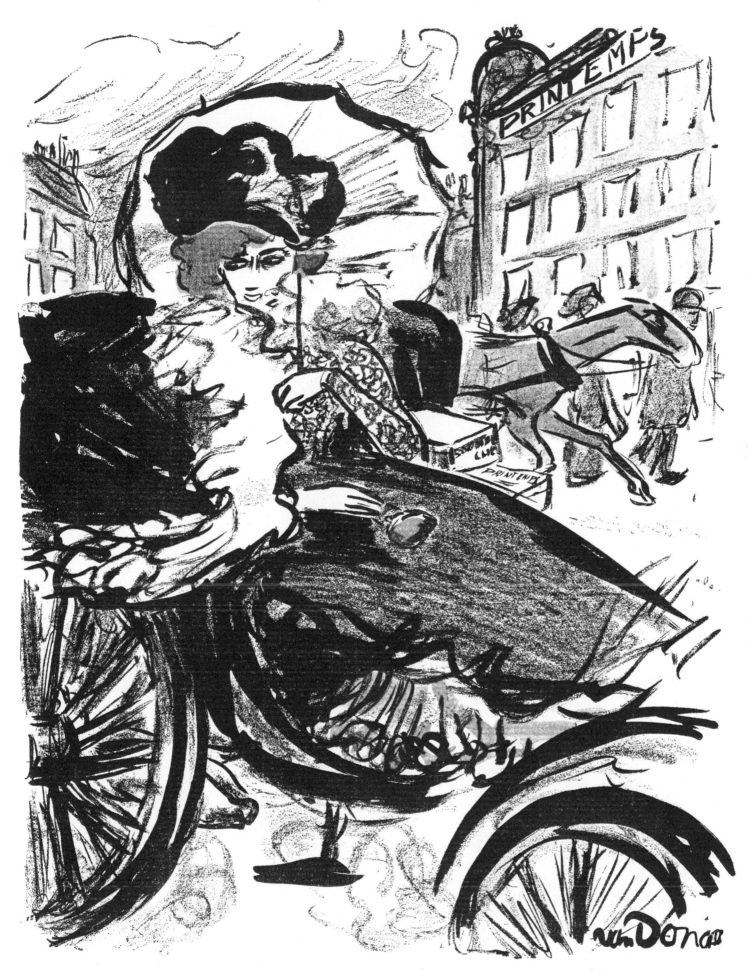

Elle finit par gagner des vingt francs... qu'elle dépense.

Finally she earns twenty francs—and spends it. [No. 30, Oct. 26, 1901; issue titled "Little Story for Small and Big Kiddies"—the story of a prostitute]

LES PROGRÈS DE LA SCIENCE

... Les prisonniers boërs ont été réunis en de grands enclos où depuis 18 mois ils trouvent le repos et le calme. Un treillage de fer traversé par un courant électrique est la plus saine et la plus sûre des clôtures. Elle permet aux prisonniers de jouir de la vue du dehors et d'avoir ainsi l'illusion de la liberté...

(Rapport officiel au War Office.)

THE PROGRESS OF SCIENCE. "The Boer prisoners have been gathered into large enclosures where they have found peace and quiet for 18 months. A wire netting with an electric current running through it is the most healthful and secure kind of fence. It allows the prisoners to enjoy the view outside and thus to have the illusion of freedom" (official report to the War Office). [No. 26, Sept. 28, 1901; issue on the Boer War concentration camps]

— Qu'est-ce que tu attends pour aller mendier devant la fenêtre de l'hôtel ?
— Y n'en sont encore qu'aux hors-d'œuvre ; ce n'est qu'au moment de la viande que mon bras les dégoûte vraiment...

"Why aren't you already begging in front of the hotel window?" "They're only up to their appetizers; it isn't till the meat is served that my arm really makes them sick . . ." [No. 282, Aug. 25, 1906; issue on seaside resorts; the misspelled sign on the ground reads: "Ex-sailor"]

THÉORIE SUR LE SERVICE EN CAMPAGNE

— Et, si vous toussez, prenez des pastilles Peraudel...

TRAINING LECTURE ON SERVICE IN THE FIELD. "And if you cough, take Peraudel lozenges . . ." [the reserve officer is obviously carrying over his regular job into the summer training period; No. 230, Aug. 26, 1905; issue on reserve officers]

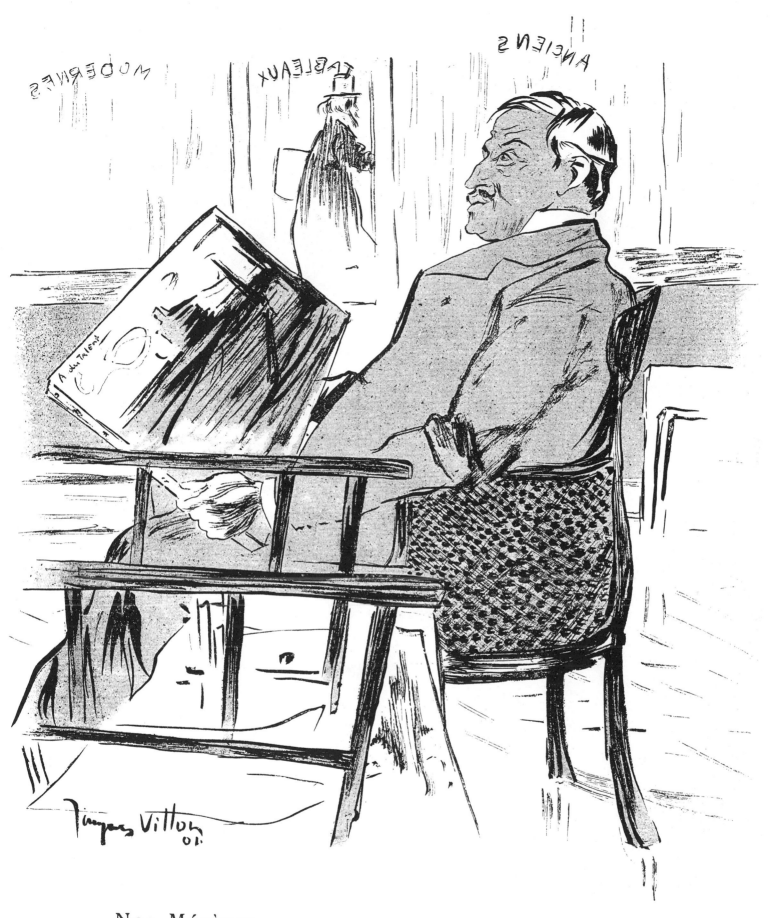

Nos Mécènes.

— *Cette vache-là, y va donc pas crever !*

OUR PATRONS OF THE ARTS. "Isn't that animal ever going to drop dead?" [the artist's signature on the canvas can also be read as "Has talent"; No. 16, July 18, 1901]

Les imbéciles.

— *Mon vieux, le Ministre veut bien s'intéresser à toi, il te donne le choix entre une augmentation et les palmes... tu préfères?*
— *Les palmes.*
— *!!!*

FOOLS. "Listen, the cabinet minister is willing to help you out. He gives you the choice between a raise and a decoration. Which do you prefer?" "The decoration." [No. 10, June 6, 1901]

DANSE MACABRE. — DÉMÉNAGÉS!..

DANSE MACABRE. "They've moved out!" [the mother has asphyxiated herself and her children on the night before eviction; No. 5, May 2, 1901]

H. Vogel 153

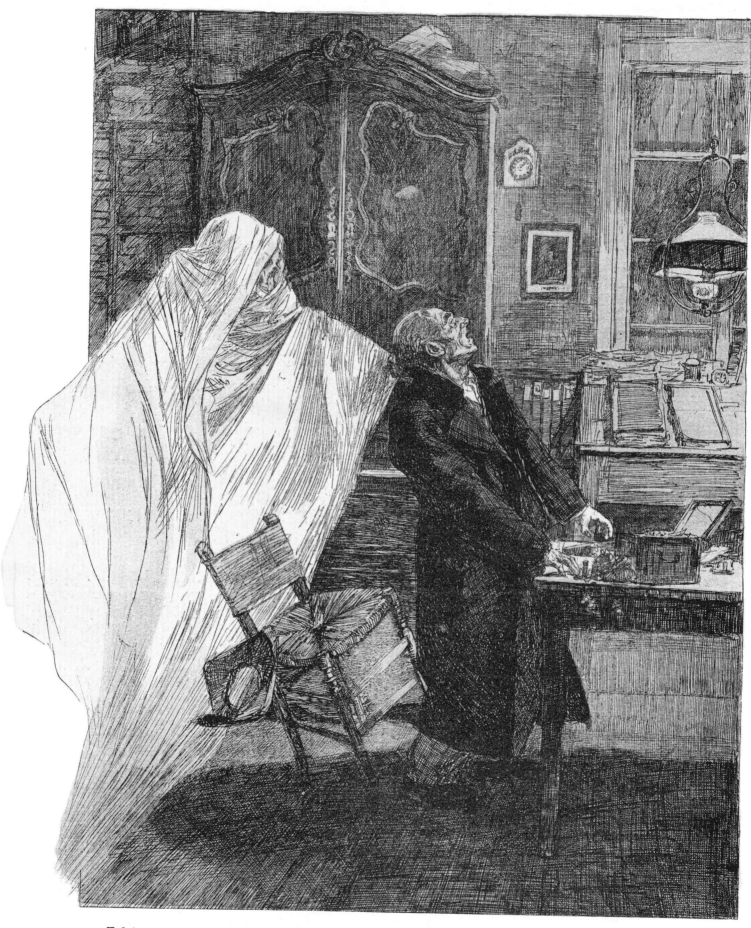

L'Avare.

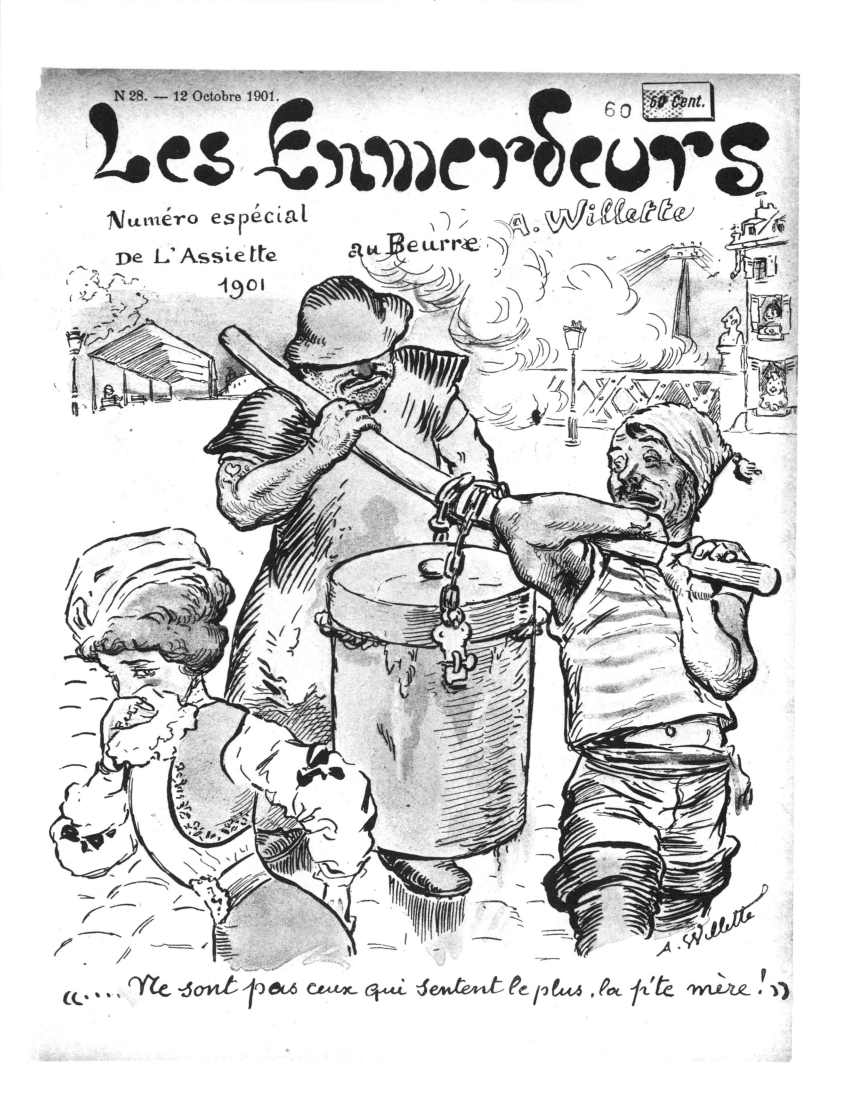

"We're not the ones who stink the most, Missus!" [Cover of No. 28, Oct. 12, 1901; issue on people who make life miserable for you]

Eh ben, mon salaud !.. tu ne vas pas t'embêter !

Les amis !

THE FRIENDS! "Well, you lucky dog! You're not going to be bored!" [No. 28, Oct. 12, 1901; issue on people who annoy you]

Nota bene. — *Le Singe n'est pas toujours un Bourgeois.*

N.B.: The boss isn't always a capitalist. [No. 90, Dec. 20, 1902; issue on different types of "bosses"]

— Tiens, un dessin du dessinateur que j'ai condamné hier!

"Look, a drawing by the artist I sentenced yesterday!" [No. 123, Aug. 8, 1903; issue on judges; the magazine titles are "The Toilets," "The Underpants" and "The Bowwow"]

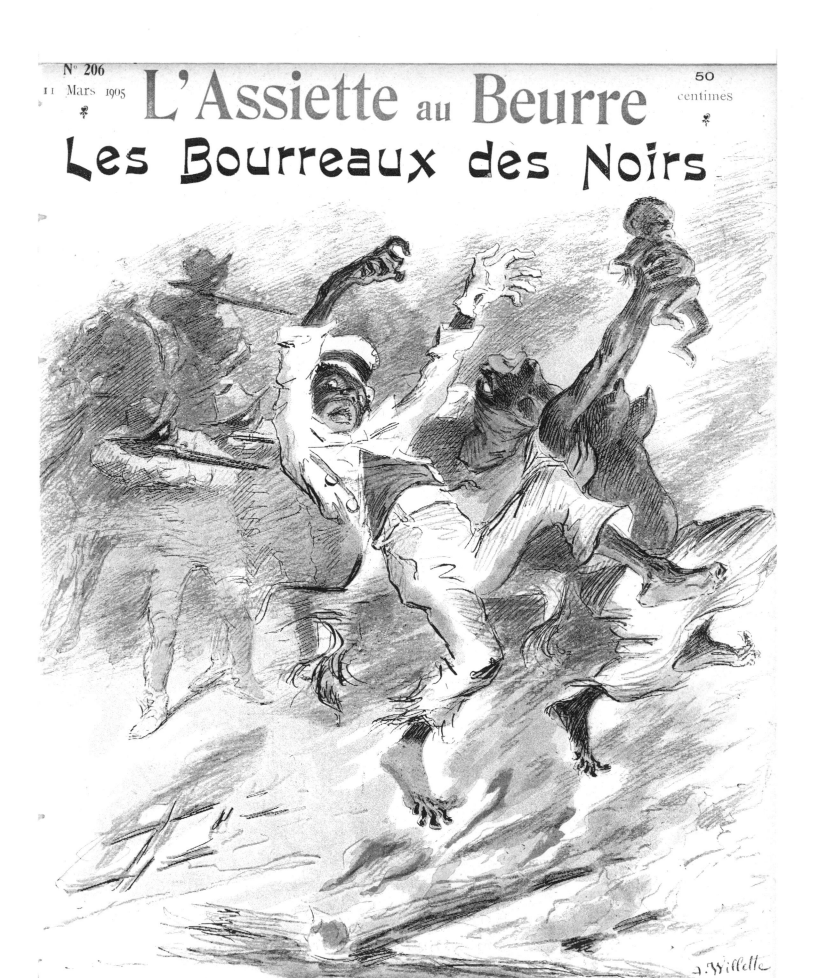

L'Assiette au Beurre
Les Bourreaux des Noirs

LE JOYEUX CAKE-WALK

THE JOLLY CAKEWALK. [Cover of No. 206, Mar. 11, 1905; issue titled "Torturers of the Blacks"; concerns colonial crimes in Africa and lynchings in America]

Adolphe Willette 159

— Dans le temps, les hommes prenaient moins de boissons américaines ; ils étaient moins abrutis et plus galants avec les dames.

"In the past men didn't drink so many cocktails; they were more polite and lovable to ladies." [No. 440, Sept. 4, 1909; issue on nightclubs]

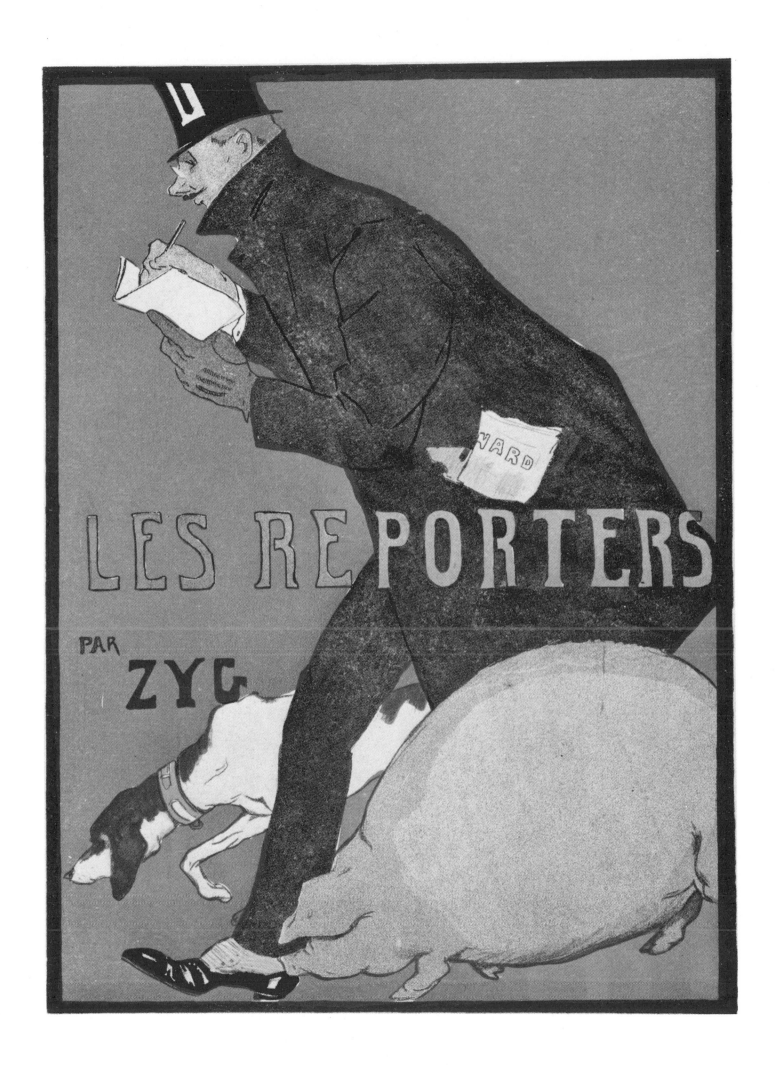

[Cover of No. 459, Jan. 15, 1910; issue on reporters; the name of the newspaper in the reporter's pocket is *Le Canard*, meaning "false report"]